10/29/18

AUTHOR

THE PORTRAITS OF BEOWULF SHEEHAN

BLACK DOG
& LEVENTHAL
PUBLISHERS
NEW YORK

To Karola, Leopold, Dorothy, Walter, Margitta, Christopher, Amy, Leif, Parker, Mackenzie, and Madison

From, in, and through you, my life is given meaning, inspiration, aspiration, and joy

FOREWORD

I met Beowulf Sheehan in the earliest days of the PEN World Voices Festival, and he quickly became established as the festival's photographer-in-residence. His tall, benign presence, sharply observant yet unobtrusive, quickly became a familiar part of that annual New York gathering of writers from around the world. (How could a photographer named Beowulf not become a chronicler of the literary world?)

Writers are not the easiest of subjects for a photographer. Many of us are uneasy in front of a camera lens, seeing ourselves as observers, not the observed. Many of us, used to looking inward, don't find it natural to project ourselves outward. Some of us are stiff, or secretive, or unwilling to smile, or excessively, awkwardly smiley. Writers often dislike seeing themselves in photographs or on TV. But writers can also be as vain as anyone else, as anxious to put our best side forward. We can be a distrustful bunch.

A photographic portrait involves a kind of surrender, the sitter briefly giving up all agency to the person with the camera, agreeing to do as instructed, the chin a little higher, please, turn a little toward the light, open your eyes as wide as possible, do you ever take your glasses off?, maybe something with your hands?, don't move.

Don't move. This loss of control doesn't come easily to people accustomed to being the ones making the creative decisions. Writers usually—maybe always—try to limit the photographer's time, to make the surrender as brief as possible.

A photographer working with such a skittish lot must have a clear, quick eye. He must know what he wants and seek to achieve it with the minimum amount of fuss. He must, if required, be able to stroke a literary ego or two. He must earn the trust of the distrustful, calm the agitated, coax people who aren't easily coaxed.

Beowulf's gentle ease soothes even the toughest literary spirits. Over the past decade and a half I've seen him photograph dozens, maybe even hundreds of writers, and he's so relaxed, so easygoing, that he evokes the same qualities in his subjects. They go easy. They relax. They come out from behind their protective scowls, lions emerging from their private undergrowth, and they begin to show something of their true natures. And snap! He captures them.

I know many of the writers portrayed in this book. Some of them are my close friends. Others I have known for years, worked with, had a drink with, run into at the many pit stops

on the literary circuit. In Beowulf's photographs of these friends and acquaintances, I see the people I know: Christopher Hitchens's determinedly pursed mouth, Margaret Atwood's quizzical strength, Patti Smith's serenity, Paul Auster's eagle eye. Here's Philip Roth ready for Mount Rushmore, Roberto Saviano hunted but resolute, the mischief of Tom Wolfe, the power of Toni Morrison seen in the set of her jaw and a thick braid of hair. Eco's sadly departed kindliness, the wisdom of Adonis. Quite a collection, and I haven't even mentioned Ben Okri's signature beret or Amélie Nothomb's equally iconic top hat.

Here's what I know about Beowulf. Not only does he have the most epic, most unforgettable name in the world of photography, but also, if you mention that name to any of the writers he's worked with, they will speak highly of him. They will like the pictures he took. And so will you.

Salman Rushdie, 2017

INTRODUCTION

Mistaking me for a boy, the security guard ruffled my hair, laughingly telling me "that thing" was almost as big as me. He was guarding an entrance to the Orange Bowl stadium in Miami. "That thing" was a long lens connected to a Konica 35mm camera, both otherwise sitting unused in a drawer in my father's home in the fall of 1985. My friend and I took our seats some twenty yards from the closed end of the stadium. As Dan Marino slung the football from one end of the field to the other, I photographed his teammates and him from my seat. I later shared prints of those photographs with my high school classmates. Hallandale High School was unique. A public school with a magnet program for foreign languages, it was where foreign students in my county were taught English and integrated into the community. I was a magnet student, traveling thirteen miles each way every school day.

In my young teens, the stories many of my male classmates told were about girls or the Miami Dolphins. Small and a bit shy, I didn't have my own girls or sports stories to share just yet. Dolphins tickets were cheap, and I was able to get them. Sharing prints from the games connected me to students and helped me make friends. And the camera connected me to my father, who had been out of my life for a bit. My world was growing.

Before high school, my world felt a bit small. I was asthmatic, unable to play with other children when my lungs began to fill if I over-exerted myself. At the age of seven, I was bitten by an alligator, as my feet dangled off the edge of a canal dock behind a neighbor's home in the brackish water of southwest Fort Lauderdale. My brother, twenty months younger than me, lifted me off the dock, my mother and her friend following quickly behind him. I don't remember how much time passed from then to my father driving me to the emergency room. I remember not being able to walk for much of the summer that remained, not getting on the bus again to get to day camp at Hugh Taylor Birch State Park.

As a boy not on the playing fields, I found my playground in books. In comic books, I could leap as high, fly as far, and fight for justice with as much strength and resolve as my superheroes. I drew them, too, giving them new stories. Superheroes took me to places my body couldn't. In time, however, both my body and my reading would strengthen. In middle school I lived in *Choose Your Own Adventure* books. I discovered monster action figures on mantels

in my cousins' rooms on a holiday visit to them in New York—and I read Shelley, Stevenson, Stoker, and Wells. High school introduced me to Adams, Connell, Fitzgerald, Hemingway, Herbert, London, Poe, and Norton anthologies. Literature was becoming less of an escape from the world and more of a teacher of the lessons I'd need to participate in it.

In my first year at the University of Notre Dame, a seminar entitled Fiction as History: 1914 to 1985 cemented the vitality of books for me. My copies of *The Catcher in the Rye* and *Less Than Zero* are still on my shelf. That and Introduction to Sculpture were my favorite classes. And, once each of my first two years of college, I photographed a football game from the field, this time with a Minolta Maxxum 35mm camera given to me by my mother. I gave prints to my roommates.

Photography wasn't part of my formal education and wouldn't be until years later. Discouraged from a career in the arts by my father and with concerns expressed by my mother, I worked administrative and management positions in the fashion industry in Miami Beach. The years were fun but restless. I wanted to be closer to the visual arts. Thinking it too late to be an artist myself, I thought I'd be happy with a life of supporting other artists. I envisioned becoming a gallerist and prepared for a career in arts administration by studying at the Gallatin School of New York University. In my second year, I used my one elective to take a darkroom printing class—and I fell in love the first day. I'd never made a print before then.

I endeavored to pursue photography as my career, studying at the International Center of Photography after finishing at NYU, quietly telling people of my aspirations, photographing and printing nights and weekends as often as I could outside of my work, still in fashion, but with greater responsibility and demands. For six years I was the business manager of New York Model Management, one of the world's largest such companies. We represented several hundred fashion models from around the world, working with an international clientele and photographers such as Avedon, Meisel, Newton, and Penn. I never met them. When I was lucky enough to be on set, I did a lot of looking around and asked a lot of questions. I continued to study, using my annual two-week paid holidays to take photography workshops with the likes of masters such as Greg Gorman, Antonin Kratochvil, and Platon and assisting established photographers on weekends when they'd let me.

When my time was up at ICP, I needed to find a new darkroom. I found one and, more importantly, a welcoming community in The Camera Club of New York, founded by Alfred Stieglitz in 1884. Members shared darkrooms but also gave of their time to support the club. In time I was asked to take over the direction of its lecture series, which I did from 1999 to 2005. The series gave me the freedom to invite the best photographers of the day to share their stories and, thinking selfishly, teach me something. I learned from each one.

In the summer of 2001, I began making calls for the 2001–2002 fall-winter lecture series from the desk of the club. I telephoned the home of Inge Morath, the Magnum photographer who had worked with Marilyn Monroe and James Dean. A man answered, "Hello?" and I dove into my pitch. "Hello, my name's Beowulf Sheehan,

and I'm calling on behalf of The Camera Club of New York. May I speak with Inge Morath please?" "Who?" I repeated myself. "Hang on." The man put the phone down, but I could hear every word. "Honey, some asshole named Beowulf is calling you." Inge and I spoke, and she accepted my invitation for the fall of 2002. I thanked her and told her I'd reach out the following spring. I put down the phone and told a neighbor seated near me what had happened. "You should be honored," he said. "Why?" "Because Arthur Miller just called you an asshole." I hadn't done my homework enough to learn that he was Inge's husband. Unfortunately I wouldn't speak to Inge Morath again. She passed away in January 2002.

In 2002 I was humbly invited to participate in the Eddie Adams Workshop, a week of 100 photography students from around the world taught by the master himself and twenty other stellar photographers. At the end of that week, my teacher Michael Williamson, Pulitzer Prize–winning photojournalist for the *Washington Post*, told me, "You're going to get a lot of work, and a lot of it will be chicken shit. But you're good at making chicken salad out of chicken shit."

My last day at a desk that wasn't my own was November 4, 2003. For all my studies, I felt very green as a photographer, my salad days still ahead of me. I'd saved a little money and had a roof over my head. I had the sudden surprise of my father's support. In December, he sent me a copy of Helmut Newton's *Autobiography*. In it he wrote, "I have taken the liberty of reading this book prior to sending it to you. It has given me a wider understanding and appreciation of your quest! Best of luck! All my love, Dad."

Salad days were ramen days those first years. (Punjabi in the East Village, you saved me again and again.) In time, NYU, my past day job, and ICP all introduced me to the world of writers themselves. Three wonderful things happened: Deutsches Haus, the cultural arm of the German program at New York University, asked me to photograph the participants of its writer-in-residence program. My connections at my past work led to an opportunity to photograph a series called Fashion Biography for *Vogue Nippon* (the Japanese edition of *Vogue*). And a former fellow student at ICP was asked to photograph the first PEN World Voices Festival of International Literature. She was unavailable and recommended me.

Deutsches Haus introduced me to a new writer every few weeks, and one of them was Daniel Kehlmann, who would go on to write *Die Vermessung der Welt* (*Measuring the World*), one of the most successful works in the history of Germany. Photographing Daniel introduced me to his publisher Rowohlt Verlag, located near Hamburg, the city of my mother's birth. Rowohlt has commissioned me to photograph writers ever since then.

My first shoot for *Vogue Nippon*'s Fashion Biography feature was with Susan Fales-Hill, daughter of the late singer and actress Josephine Premice and author of the memoir *Always Wear Joy: My Mother Bold and Beautiful*. After the picture was published, Fales-Hill's publisher HarperCollins asked me about photographing its writers.

The first PEN World Voices Festival in 2005 was an adventure, forcing me to negotiate New York City as events ran concurrently in venues uptown and downtown, teaching me to

photograph reactively, quietly, invisibly. I chased after the best moments of what the audiences saw. Salman Rushdie presented at The Great Hall at Cooper Union, where in 1860 President Abraham Lincoln spoke out against slavery. The eyes and ears of 850 guests were locked on Salman. In running from end to end of the hall to see other writers and him anew, I often distracted many of them.

PEN (Poets, Essayists, and Novelists, the U.S. and world's largest and oldest champion for freedom of expression, literature, and human rights), invited me back for its second festival, and I was also invited to photograph backstage. It was there that I finally met Salman and, with each passing year, more and more literary luminaries from around the world. I was introduced to advocates, agents, editors, educators, publishers, and publicists in the literary community. My world was growing again.

The world of my childhood interests was turning into the world of my adult passions. The opportunities given to me by PEN, HarperCollins, and NYU expanded into opportunities from other publishers, publications, universities, and cultural and literary organizations. And I was back to reading a lot, learning who all these new people were.

Life lessons came not just from books, of course, but from the writers themselves. They taught me (and keep teaching me) the power of language, agility, empathy, humility, patience, positivity, and vulnerability. Some degree of each needs to be shared to help make a successful portrait.

. . . .

In 2007, at PEN's third World Voices Festival, I was in the green room at New York's 92nd Street Y, photographing the writers participating in the PEN World Voices Festival of International Literature. Tasked with making a photograph of the great **Umberto Eco**, I stumbled in poor Italian toward him, polite, open.

"*Piacere, Dottor Eco, io mi chiamo Beowulf.*" ["Pleased to meet you, Dr. Eco, my name is Beowulf."]

"*Piacere.*" ["Pleased to meet you."]

"*Sono il fotografo di PEN. Poi farle suoi foto?*" [I meant to say, "I'm PEN's photographer. May I make your picture?"]

"*Sì.*"

And we made our pictures.

"*Grazie, Dottor Eco.*"

"*Prego.*" Then Eco stops me, saying in English, "You know, I'm not a '*dottore*.'"

"My apologies, Mr. Eco."

He continues, "In Italy, anyone with a degree is a '*dottore.*' Anyone who has an advanced degree as I do is an architect. Do you know how to tell the difference between a doctor and an architect?"

"No, please tell me."

"A '*dottore*' drives a Mercedes. An '*architetto*'"—he begins to gesture wildly with his right hand—"drives a Saab."

. . . .

Days later I had a moment to photograph **Nadine Gordimer**, the South African writer and winner of the 1991 Nobel Prize in Literature. I introduced myself, and she replied, "Young man, there's nothing I hate more than having my picture taken." Smiling, positive, I answered with, "And I love your honesty. Let's get started." The image was simple, the moment when her laugh of surprise at my words began to recede yet her smile remained full. I thanked

her after only a few frames, and she asked me, "Is that it?" "Yes, thank you so much." And she smiled again.

· · · ·

In the winter of 2008, PEN honored the Nigerian writer **Chinua Achebe** at Town Hall. I had a moment to photograph him, in a back room at the end of the evening, his family waiting to my side. Achebe was expressionless. One of his sons said to me, "Are you almost done? It's my father's birthday, and we're going to be late to dinner." I responded by saying that was wonderful and began singing "Happy Birthday" to Achebe. He grew a surprised, bemused smile on his face—and then we were done. I later learned that it wasn't his birthday, but I was grateful for the chance to inspire a more animated Chinua Achebe.

· · · ·

In the fall of 2010, I was given the honor of making portraits of participants in the 25th annual Melbourne Writers Festival. The journey from New York was three flights and sixteen time zones long. I was as much a wreck upon arrival as I was thrilled to be in Australia for the first time.

"Dirty But Clever"—or **DBC Pierre**—was my first subject, at about 10:30 A.M. my first morning in Melbourne. DBC was enjoying his whisky when I met him. I marveled at his ability to drink so early, to which he told me that he was having "breakfast." He offered me some, and I politely declined. I also declined his offer of a cigarette. We got on well, making pictures in a quiet alley near Federation Square. He invited me to his reading at The Toff that night. After a long day of photographing writers and discovering a bit of the city, I arrived. As DBC nodded to me as he read, I set my camera at the bar—and passed out from jet lag and exhaustion. The next

day, a festival representative told me a blogger had seen me at DBC's reading and wrote that I was such a rock star that I passed out at the bar. It was hard to tell if this was celebratory or mocking. She asked for an explanation. I told her that I'd just arrived after more than a day in the air, energized to be in Melbourne and work with so many great writers, but my body overrode my enthusiasm at a bad time. And I said DBC was the rock star.

· · · ·

Hours after photographing DBC Pierre, I had a few minutes with the Scottish writer **Val McDermid**. I knew only that her genre was crime thriller. I walked the blocks surrounding her hotel and found one location. Meeting her moments later, I asked her about her work. She laughingly mentioned "death" as a theme, and I proposed the location: the back of a church, its wall covered with dead, thorny vines, right opposite the hotel. She said she loved it. I photographed away, my body lying in the dirt to better see the scale of receding vines as she looked down at me. My time was up, and we said our thanks to each other.

The next day I paid my first visit to the festival's pop-up Readings bookstore. There, next to the cash register, was a paperback edition of Val McDermid's (I believe) *Beneath the Bleeding*. The cover was an illustration of a dead, thorny vine.

A few nights later I found myself in yet another alley, this time off Flinders Lane. With me was playwright and author **Barry Dickins**. Sixty years old at the time, he had just said goodbye to his young son before giving his time to me—but I did get in a quick hello to his son before he left. Barry told me my accent was

funny. I replied that I was from New York.

I asked Barry his feelings for Melbourne. He told me it was his home, that he'd been a paperboy on this very street. He wore a sweater that read Melbourne across its back in bold block letters. His kind eyes betrayed some fatigue, but the word across his back was as broad as he was. I asked to photograph him over his shoulder so the viewer could read "Melbourne" as part of his pride. I complemented him on his strength, suggested his back supported Melbourne better than Melbourne had perhaps ever supported him. I asked him to love his city with his eyes and to wear that love on his face and back. His face lowered, I made another frame or two, and I thanked him for his time.

Barry stopped me, saying, "I want to thank you for the support you just gave me. Nobody's spoken to me that way in years. My wife just left me, writing's been hard, and all I have in this world is my boy. I love him very much and want to take good care of him."

I replied, "Thank *you*, Barry. You showed me how to see you. You're a good soul. I'm sure your son loves you just as much. You'll be wonderful."

"And I need to thank you for making me feel good, too. My girlfriend just left me, too."

My goal with each photo shoot is not to make a new friend or have a hug at its end. It is to see (and then share) some of the best of the subject. Barry's vulnerability was his strength. Our unexpected empathy was my comfort. I'd like to think it was for him, too.

· · · ·

In 2011, in New York, a writer (who I won't name out of respect) told me she wasn't beautiful. I answered that I wasn't there to argue with her. I told her paparazzi followed her and that her work was read across the globe for a reason. I said her beauty was rare; it was right in front of me, yet she shared it every day with so many who might never see her face. We made a few photographs, took the subway together to her next appointment, and there made a few more. When we finished, she thanked me for what she said was the nicest experience she'd ever had with a photographer.

· · · ·

In 2012, PEN asked me to photograph **Etgar Keret**, perhaps the most innovative voice to ever come out of Israel. Etgar dove in quickly, asking me, "What else do you photograph?" I answered that I loved to photograph music and dance. "Do you like jumping?" I told him Philippe Halsman's *Dalí Atomicus*—featuring an airborne Salvador Dalí, easel, and cats—was among my favorite photographs, told him I loved that aspect of dance, told him I loved basketball for the game's resistance to gravity. Etgar said, "When people jump, you can see their souls through their eyes." He opened the door to me. "Then can we jump together?" Etgar jumped a few times for me, outside on a street corner. I photographed with my chest on the sidewalk so the lens' perspective would see him even higher in the air. I showed him the pictures. He loved them.

Twenty minutes later, Etgar was on stage at Symphony Space, sharing the news that his father died days before, telling the story of his father's shoes. He had brought them with him from Israel so that his father would be with him. Etgar was weeping openly. I was, too. He was so light, so joyous moments before, sharing the exuberance of his soul. And here he was, touching my heart again, sharing his deepest pain.

· · · ·

Later in 2012, PEN recognized **Vanessa Veselka** for her debut novel *Zazen* and gave me a few minutes with her. Her daughter at her side before we made our pictures, Vanessa exuded pride at her moment. Before me, she was even stronger, showing off her tattoo of the New York Public Library's lion Fortitude on her right shoulder. "Tell me about your tattoo, Vanessa! What are the numbers below the lion?" She answered, "It's the Library of Congress catalog number for my book." "You must be so thrilled." "Hell yes, I am."

. . . .

In 2013, the literary agent Binky Urban and publisher Little, Brown and Company gave me the tremendous opportunity to photograph **Donna Tartt** for *The Goldfinch*, her first novel in over a decade. By then I'd established the practice of reading the writer's work ahead of the shoot to learn the writer's voice and inform picture ideas as part of my workflow. This time, my request to read the work was politely denied as a security measure for the book—so instead we talk. Donna told me bits about the new novel and suggested I reread *The Secret History* to glean her aesthetic. She called herself a "dandy." Indeed, when she arrived at my studio days later, she was singularly yet timelessly beautiful. The locations I scouted, all attempts to balance the coarsely urban with the timeless, met with her approval. I asked Donna for her poise and grace indoors and on the street, but she was already more than delivering. The winning photograph was made in a parking lot. The experience with Donna Tartt taught me that sometimes the subject needs nothing drawn out. Sometimes the gift of a special persona just needs to be accepted. And then cherished.

. . . .

My work with Donna inspired my confidence to make better pictures for my subjects and clients. I also recalled the advice given by Nigel Parry at his Camera Club of New York lecture in 2001: "With each shoot, make the picture the client needs and, if you can, the picture you want." When given the time to prepare and enough time to create, I'd do my best for both.

Character, I learned, drove not only so many writers' works but also the writers themselves. In the summer of 2013, I photographed **Scott Cheshire** for his debut novel *High as the Horses' Bridles*. The story focused on a young man coming of age. Raised in an evangelical family and world, he discovered that there was another world out there—and he wanted to live in it. With Scott's story in my head, I sought to light him dramatically for his author portrait (the picture his publisher needed) and arrive at a strong concept for an editorial image (the picture I wanted). How to speak to a story of a man with one foot in one world and another in another?

I found many locations of strong metaphor for Scott, but one—of a building façade in New York's Lower East Side—seemed perfect. Its brick wall had some graffiti, had no windows, and had in it the impression of a door, perhaps six feet above the ground. On the day of our session, I showed the location to Scott and said I loved the idea of one foot on the wall and one foot in the air. He loved it, too. As high as the bottom of the impression was, though, Scott would need a foothold from me to reach it. As fate would have it, the streets of New York offered us the "gift" of a used mattress for him to land on safely. It was on the block. Scott declined my offer to carry and set it on the

ground under the impression. I told him I wanted him to be safe. He could try to roll his body when he landed—or we could just skip the idea and move on to the next one if it was too great a risk. Scott said let's go for it, and we did. He landed with both feet planted on the ground and then fell to one side. He said he was okay. We tried a few more picture ideas in the neighborhood, went back to the studio, and said our thanks and goodbyes.

Two weeks later, Scott's chosen author portrait already retouched and delivered, I visited Scott with a print of the moment when he indeed walked in two worlds. He answered the door with one foot on the ground—and one in a cast, his leg turned at the knee. Scott had broken his ankle. I thought my career might be over. Laughing, he told me not to worry. He had reading and writing to do, and now he could do nothing but read and write. I had read and scouted to help myself better see Scott for our work together. And through his gesture he taught me so much more about how to see life.

· · · ·

My photo sessions with **Salman Rushdie** were many over the years, and we grew comfortable with each other. In 2014, I photographed him in the backyard of his friend's home in the West Village. Salman smiled and asked, "Do you know whose home we're working in?" "Your friend Francesco's," I replied. "Yes, but before him?" I did not. "This used to be Bob Dylan's house." I answered, "Salman, photographing you on this hallowed ground would be a great way to go out on top, but I'm not ready to retire yet." "No, you have much more ahead of you." Each of us needs a champion and a friend. Salman has been both in my journey,

among many to welcome me, give me opportunity, and help me grow in community. It indeed takes a village.

· · · ·

Many, many writers have become champions to individuals, of course, but also to communities, countries, continents, and generations. In 2008, I photographed the Kenyan writer **Binyavanga Wainaina** at The New York Times Building. He was colorfully attired and friendly, but he said little, his gaze in the picture stoic. In January 2014, the government of Uganda made homosexuality a crime punishable by life imprisonment (originally punishable by death), following the decrees of better than thirty other African countries, his native Kenya among them. His camel straw broken, he responded by publishing an essay, coming out as gay. He spoke out against his and other countries' policies. The story struck chords around the world. *Time* named him to its 2014 list of the 100 most influential people in the world. Photographing him again in 2015, Binyavanga looked markedly different: His head now bald, his royale beard now a slim goatee, above it a knowing smile.

· · · ·

Penguin Press asked me to photograph the North Korean refugee turned human rights activist Yeonmi Park for her memoir *In Order to Live*, published in the fall of 2015. The request was for a simple, striking headshot that showed her inner strength. Yeonmi visited me in my studio a week before the shoot. We had a lovely talk. At the end of it, she said, "May I tell you? I'm scared." "Of what?" "Of how my life will change after the book is published." Yeonmi told me she'd already received death threats, and she

feared those would grow. I reminded her of her own journey, her family's and her own suffering, and how her neighbors back home continued to suffer. I thought of what my years working with writers had taught me. I told Yeonmi that she had a responsibility to write and share her story, said her mission was to embolden those in need of her light. I told her yes, challenges would certainly come, cowards living to undermine the liberty all should have would be after her. And I said that however many such people will attack her, the number of people who love her for courage and be inspired by her will grow exponentially. Yeonmi left excited for our work together.

Yeonmi was the face of courage when we made our pictures. At the end of the shoot, as my assistant and I broke down equipment, Yeonmi screamed. We all leapt to help her, and her scream turned to elation. Her best friend had just written to her via Facebook to tell her she was alive and out of North Korea! (Yeonmi was 22 when I photographed her; she fled North Korea at 13.) Love was growing very quickly.

When the work was published, a Western critic in the employ of the North Korean government denounced Yeonmi's memoir, defamed her, and doubted the validity of her story. Nevertheless, *In Order to Live* went on to be published in ten countries.

· · · ·

On September 10, 2015, the Consulate General of Germany presented an exhibition of my photographs of *Kontakthof*, a dance piece by the late choreographer Pina Bausch. My mother and her husband attended the opening. During remarks I thanked my mother for all she'd done to encourage who I became and for sharing her culture with me. At the end of the

night, she told me I was a great photographer and that my path was clear.

For all its turns, my path was perhaps clear from the beginning. It was my mother and maternal grandfather who lit it. Though my father loaned me the first (his) camera I ever used, my mother gave me the first camera I ever owned. And my maternal grandfather, an engineer, fencer, pianist, poet, and photographer, offered the first camera I ever held. Leopold Boehm's 1931 Zeiss Ikon Ikonta 520/18 sits on my shelf today. Watching my grandfather lower and steady his body to catch what he saw through his rangefinder piqued my curiosity. Minutes later he'd be at the piano, enlivening the home with songs I didn't understand then but with an energy that was captivating. He had survived the First World War, the Second World War, the passing of his first wife, the loss of his first son. He found new love and created new life. He was a renaissance man. He was my first role model.

My parents divorced when I was in the fifth grade. In the years that followed before my father returned to my life, my mother sacrificed much of her moving on to support my brother and me. She sponsored and took me to art classes after school. She did the same for piano lessons. She took me to museums. She took me to the opera. She stayed late one night at Fort Lauderdale's War Memorial Auditorium after *La Bohème* was long over to introduce me, then nine years old, to Luciano Pavarotti. She encouraged me to attend a magnet school for foreign languages.

As we left the consulate that night, I recalled the last time my mother visited me in New York: May 23, 2011, my mother's birthday

and, coincidentally, the night of the New York Public Library's centennial celebration. Leading up to that moment, I had photographed more than 100 notable New Yorkers for the library's centennial book, published by Penguin Classics. Watching my mother dance with writers at the celebration, to see her jubilant following the years she gave my brother and me, was among the best sights I didn't photograph.

· · · ·

With two assistants, in the spring of 2016 I drove to the great **Neil Gaiman**'s home to photograph him for his coming *Norse Mythology*. As I stepped out of the car and walked to the house, his wife Amanda Palmer approached me. I'd never met her before. "Is that the sexy photographer?" I replied, "Is that the beautiful artist?" She said yes, I said yes, and she led me to the house. Neil soon came out, and we were off and running. We had met before, so hellos were easy. When I first met and briefly photographed him in 2007, at my announcing myself he said, "That's great. We were destined to work together." I asked, "How's that?" He replied, "Because I wrote the screenplay for *Beowulf*." I didn't do my homework in 2007—but I did in 2016. My team and I made seven different looks (props, locations, lights and all) with Neil in the hour he gave us.

· · · ·

Seven years in the making, **Ron Chernow**'s *Grant* would be his second biography since his 2004 *Alexander Hamilton* (which the world saw interpreted as the musical *Hamilton* in 2015). Ron and I spoke to discuss the type of photograph he wanted. We both had the idea to make the editorial picture at the General Grant National Memorial (at the north end of Manhattan, in case you knew who was buried at Grant's Tomb but didn't know where he was buried). We picked a date that worked for both our schedules. Upon our arrival at the memorial that day, Old Glories were strewn about everywhere, adding vivid color to its majestic yet neutral columns. Ron laughed at his having forgotten the significance of the date of our shoot: April 27, 2017, Ulysses S. Grant's (195th) birthday.

· · · ·

By the summer of 2017, I'd photographed close to 700 writers, some for hours, others for just a moment. I still had much to learn about light, the camera, and people—but twelve years of celebrating special voices had taught me and given me volumes. In August, I photographed Mark Morris, dancer, choreographer, national treasure, and his dancers at his beautiful studio. On the second day of our two-day production, Mark was back, wearing different clothes from the first day and being groomed. One of his dancers came in and started speaking with him. I could hear them across the space. "What's Beowulf like?" she asked. "He knows what he's doing, and he's not an asshole." Thinking back to my unknowing conversation with Arthur Miller sixteen years before, I felt I'd come a long way.

· · · ·

That same month I photographed **Leslie Jamison** for *The Recovering*, her memoir and study of the history of addiction. Reading her book ahead of the shoot was a punch to my heart. Through her words, I was getting to know my own father, better understanding his disease, reconciling parts of my childhood. I shared with Leslie how much we had in common, and our work together was all the stronger for it. We had

time. We made the picture needed for her book. In addition to the author portrait, there was the editorial image speaking to her journey that I wanted to try. Leslie was an alcoholic, yes, but also a brave, elegant, mature adult. I photographed Leslie, graceful in her colorful, flowery dress, against a gray concrete wall. The wall was as mute as she was radiant, its pattern constant excepting the seams and hinges revealing a door in it. Leslie stood before the door. The abyss of addiction remains close for all who face it, the darkness opening and enveloping if we let it, the beauty of a new day welcoming us if we don't.

· · · ·

I first met **Tom Bodett** in October 2013. Four years later, I sat in the Latchis Theater in Brattleboro, Vermont, watching David Sedaris do his thing. As the seats cleared at the end of the show, there were Tom Bodett and his wife in my row. Two days later, I made Tom's promotional photographs at his home. Comfortable with me and me with him, Tom told me about a storytelling project he was working on with some of his colleagues from *The Moth* called *Scar Tissue*, an occasion for people to speak metaphorically and literally about personal trauma. Then he showed me his scar. And we made more pictures.

It was 2,400 volts that entered his body at his then twenty-year-old hand as he scaled a power pole in Applegate Valley, near Medford, Oregon. The electricity coursed through his arm and shot out his body, just before his shoulder. He had fallen thirty feet, unconscious but seen by his friends and taken to a hospital. Doctors worked to save Tom's life. With second-degree burns on his face, neck, and chest, he was told his right arm couldn't be saved, but it was. He was told his hand couldn't be saved, but it was. Six weeks after entering the emergency room, Tom Bodett began life anew. He rebuilt the muscles of his body and mind, fashioning both as tools for a journey through life as a fisherman, carpenter, logger, radio host, spokesman, writer, husband, and father.

· · · ·

Looking at my journey, I find it remarkable that my lacking confidence as an artist led me instead to explore a way to support artists, only to find artists giving me confidence, inspiring me to go forward, grow as an artist, and support them with my work. To discover and embrace one's passion is among the secrets to a happy life. To the many, many storytellers—writers, poets, playwrights, musicians, dancers, choreographers, directors, actors, dignitaries, and humanitarians—who shared a bit of their hearts and time with me, you have given me as much purpose as you've given me joy. You are my superheroes. You've empowered me to do my thing. I thank you for the chance to celebrate your stories.

Here is what I have learned about writers: Balancing private and public selves, they need solitude as much as they need community. They know they're entrusted with recording and imparting history. Though a fearful few would have many of their voices silenced, they speak their hearts. Their vulnerability is their strength. They reflect and help shape societies and cultures, calling attention to their ills and dangers, celebrating their wonders and triumphs. They are you. Me. Us. And they are beautiful.

SALMAN RUSHDIE

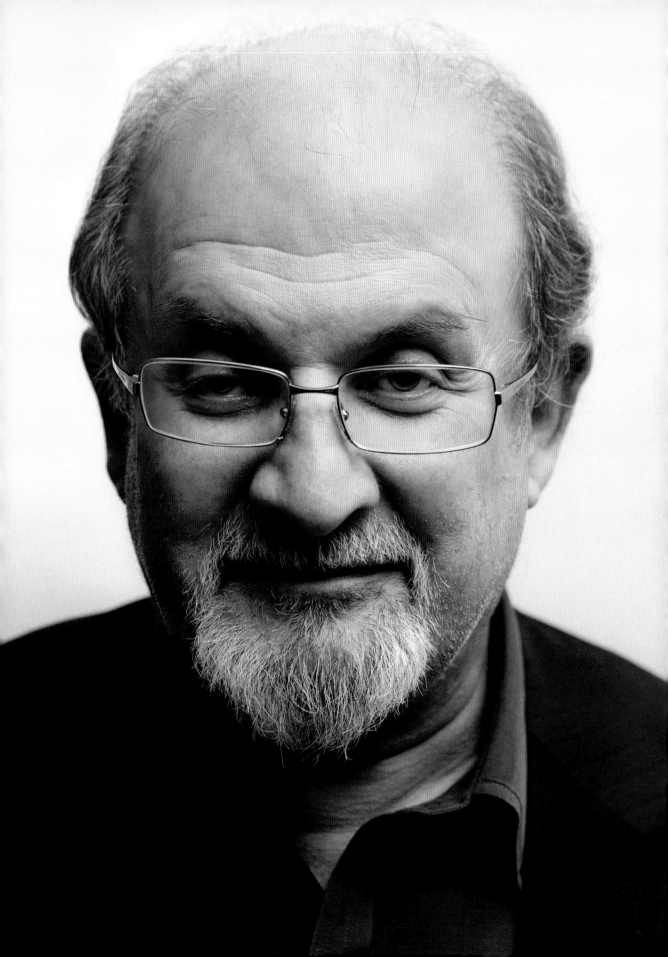

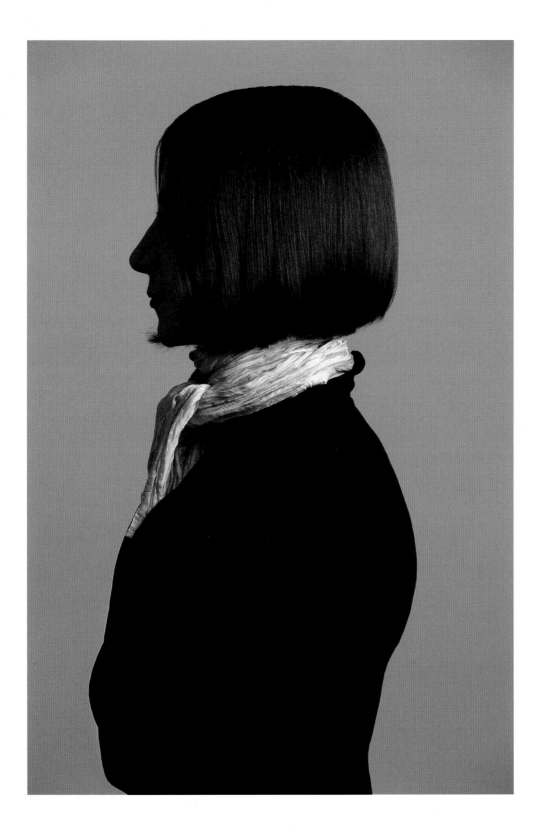

DONNA TARTT

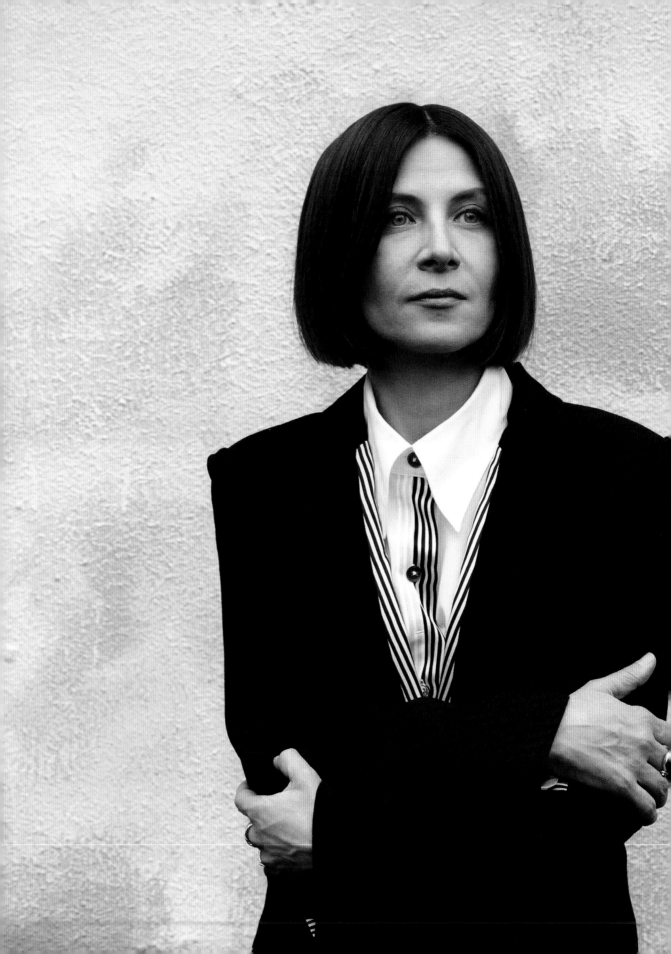

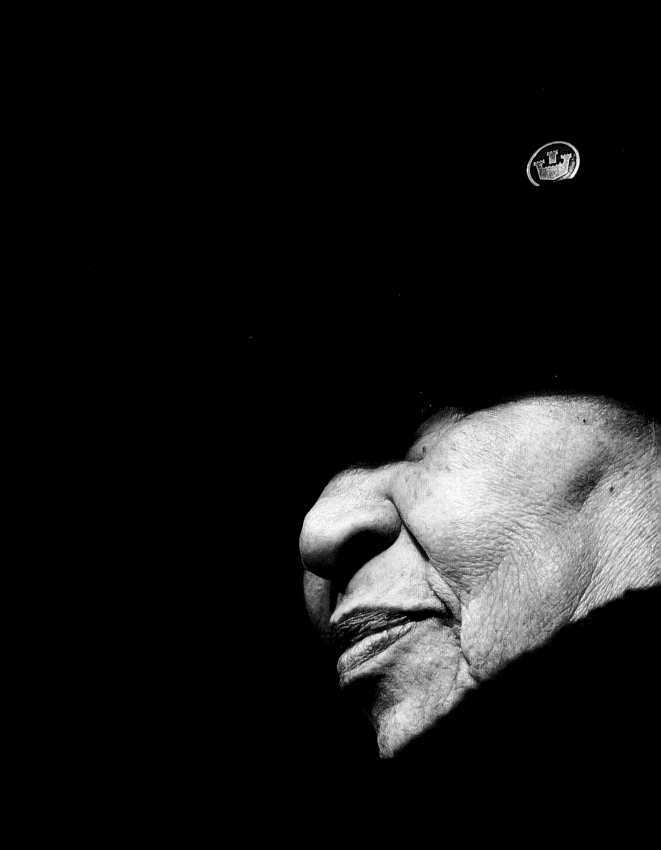

CORMAC McCARTHY

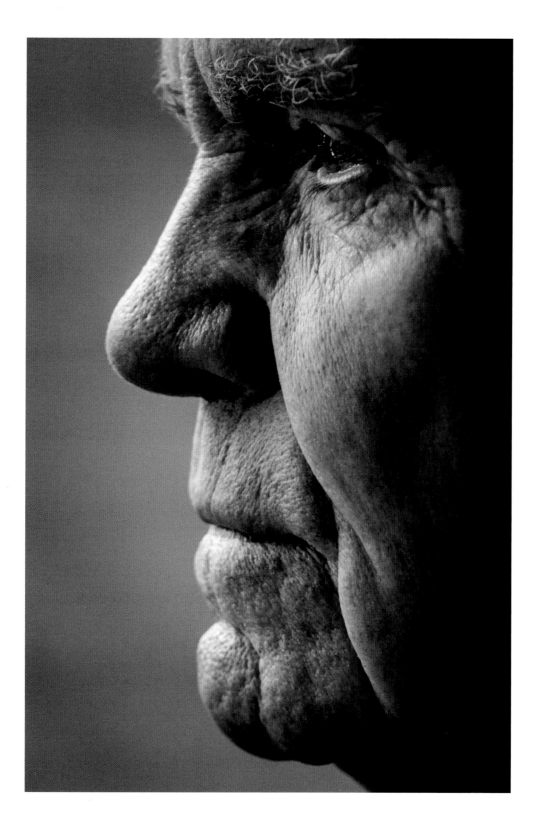

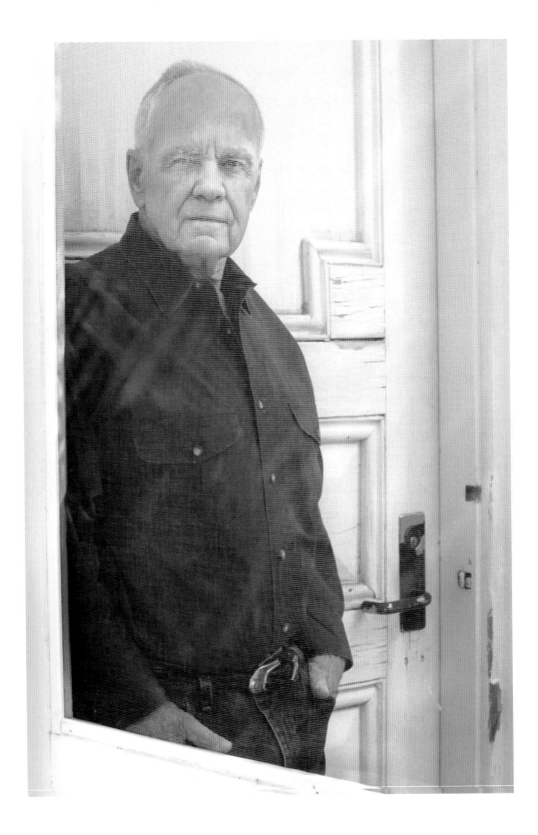

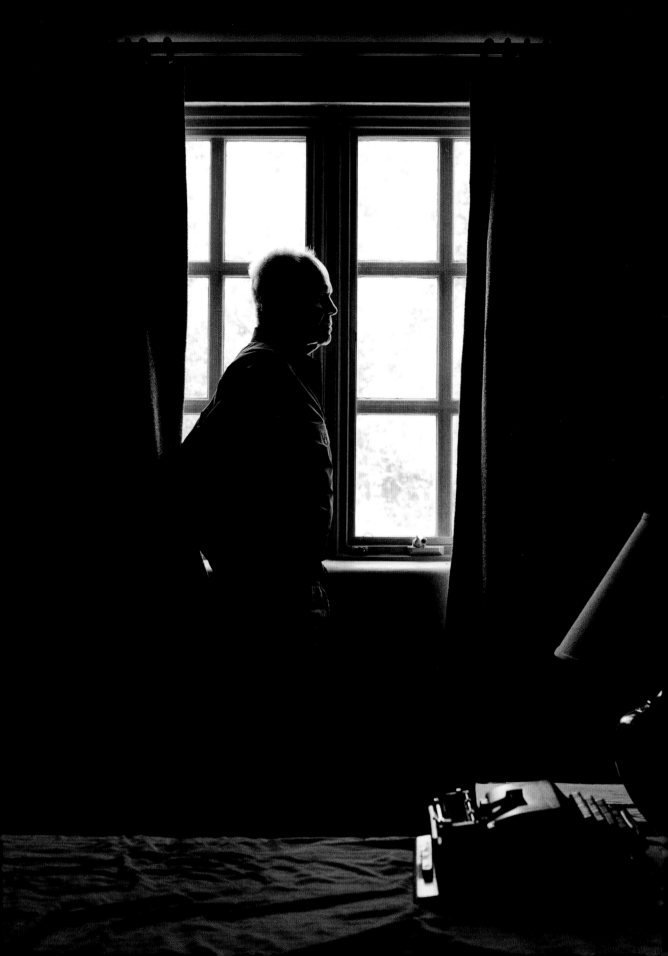

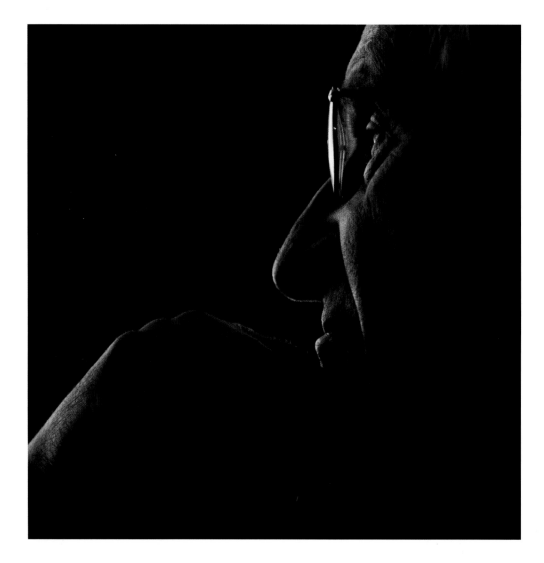

NOAM CHOMSKY · DAVID BALDACCI

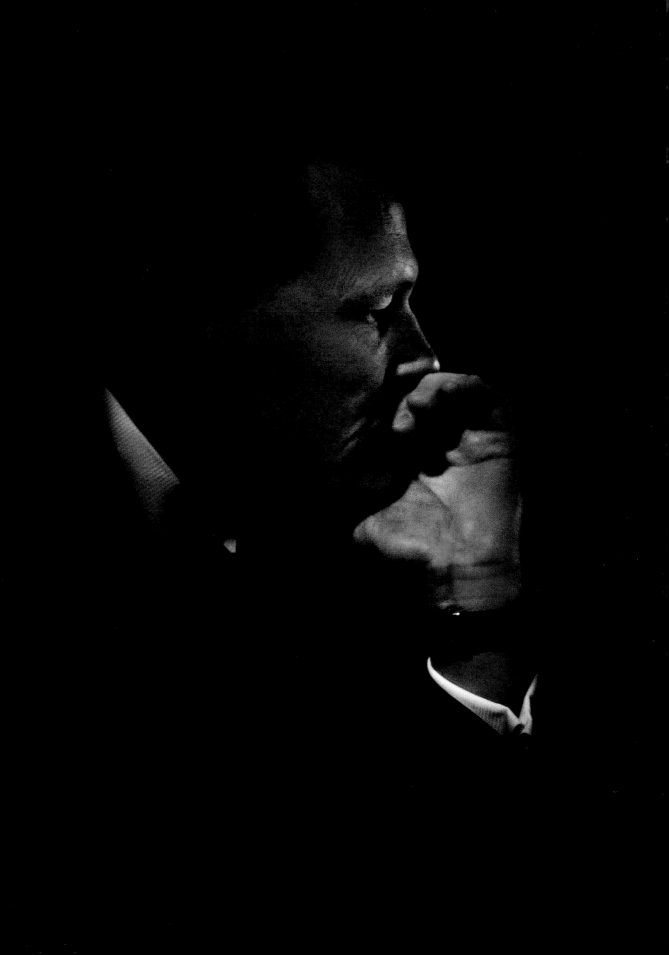

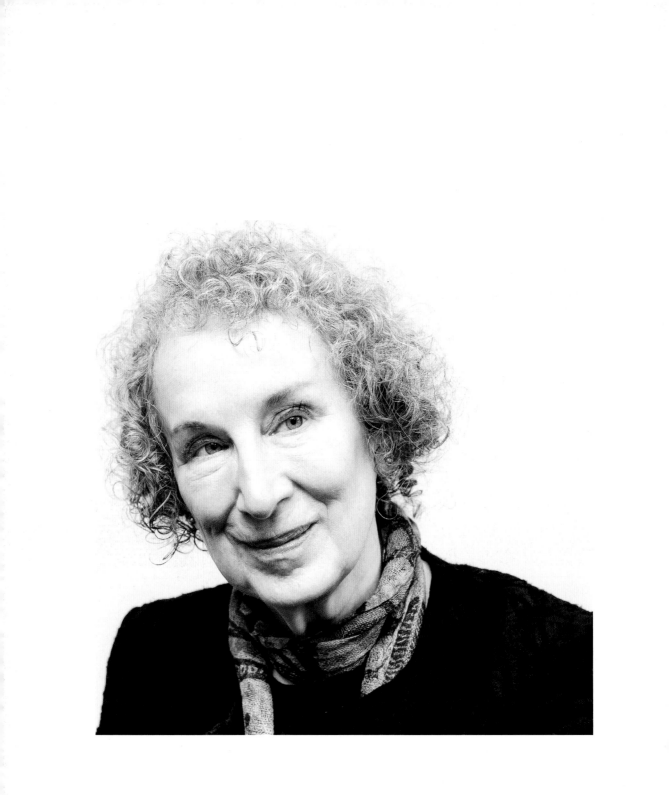

MARGARET ATWOOD · J.K. ROWLING

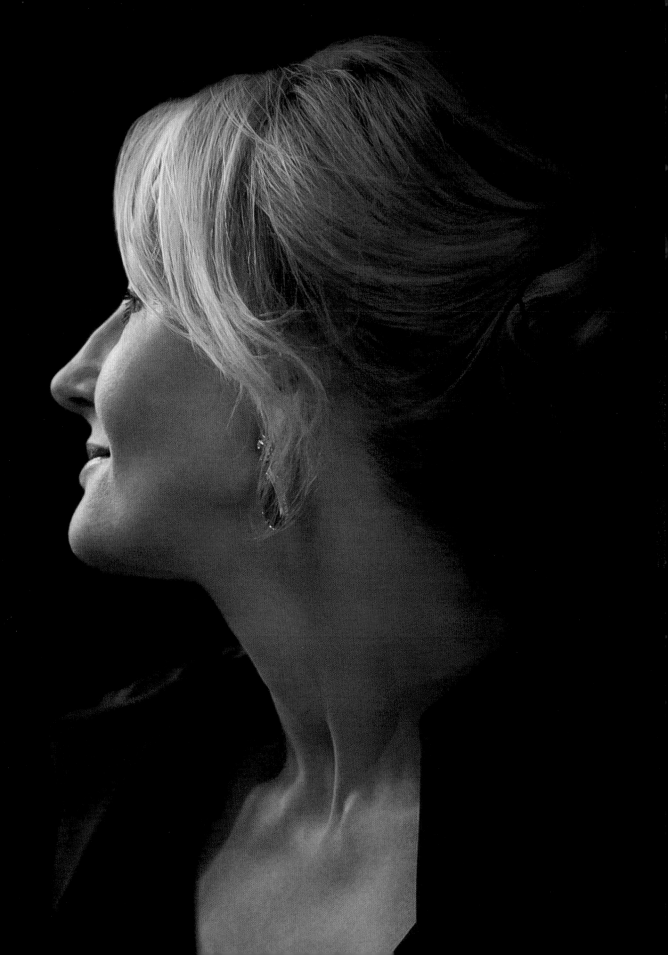

PATTI SMITH

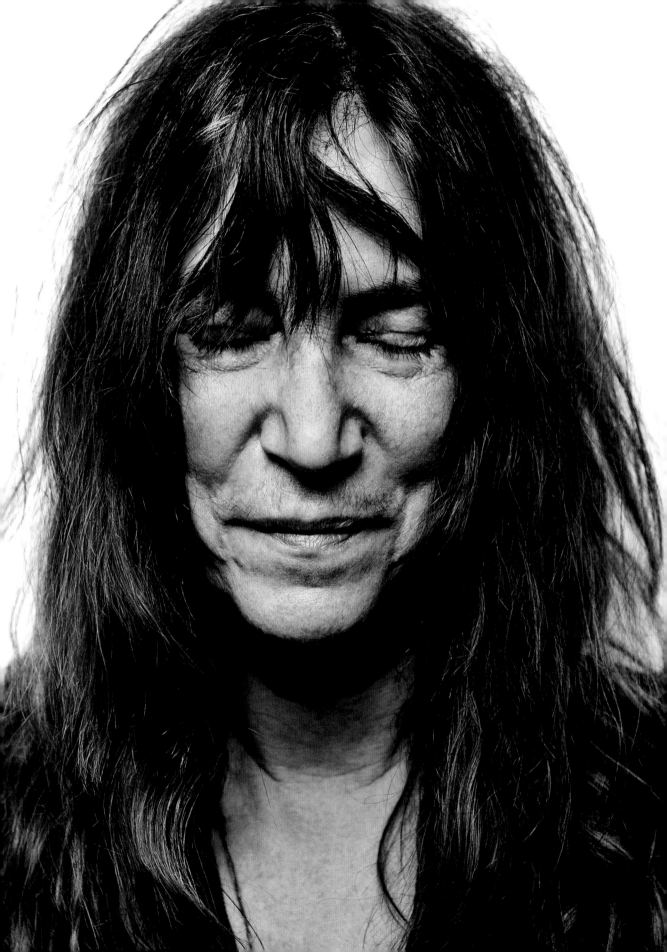

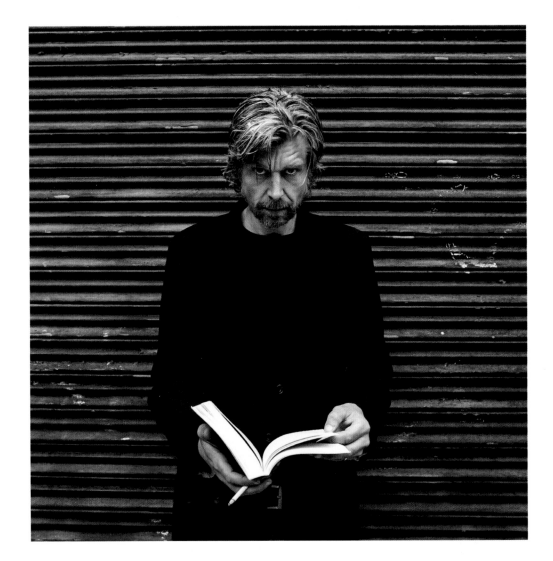

KARL OVE KNAUSGAARD

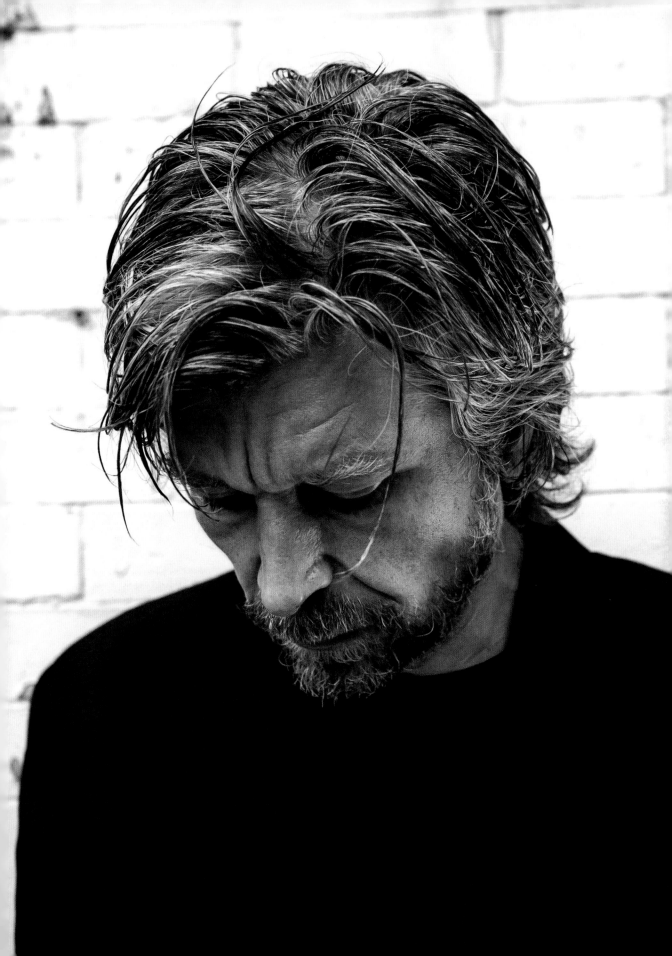

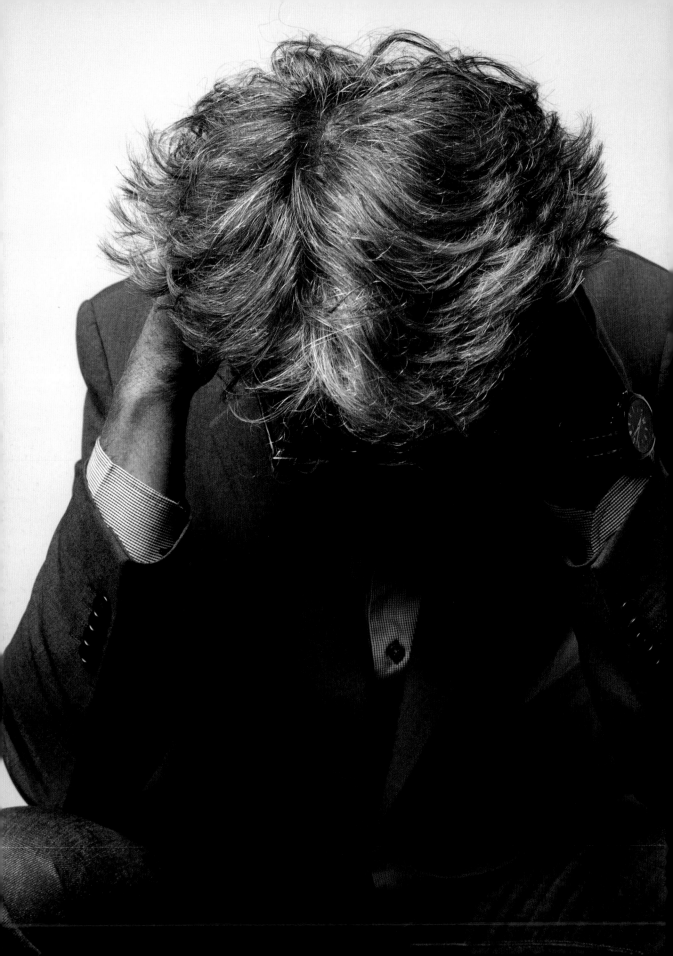

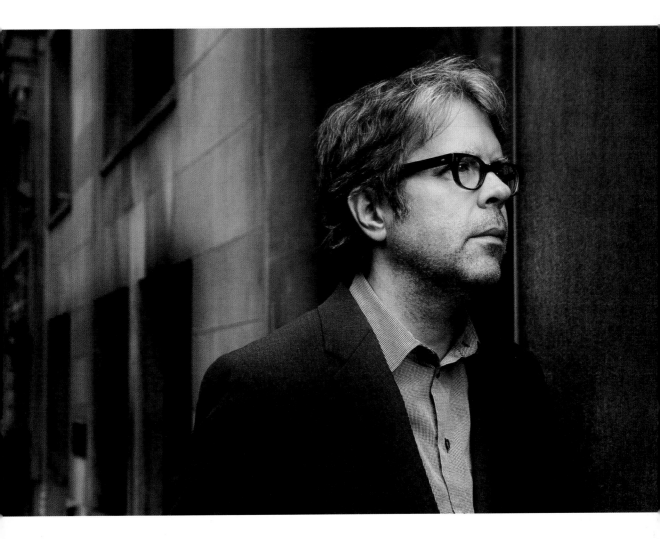

JONATHAN FRANZEN

CHIMAMANDA NGOZI ADICHIE

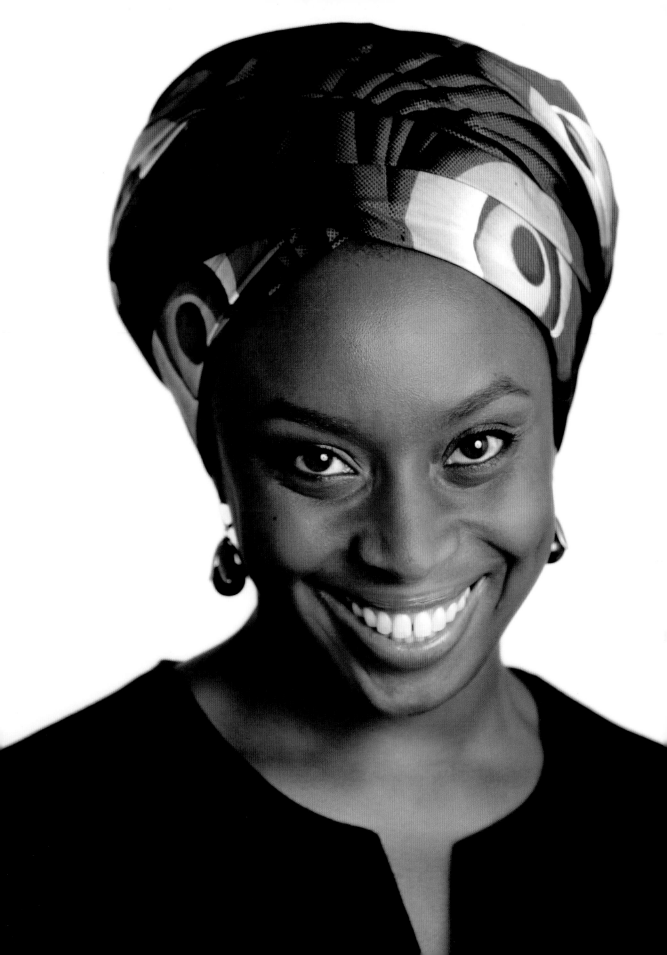

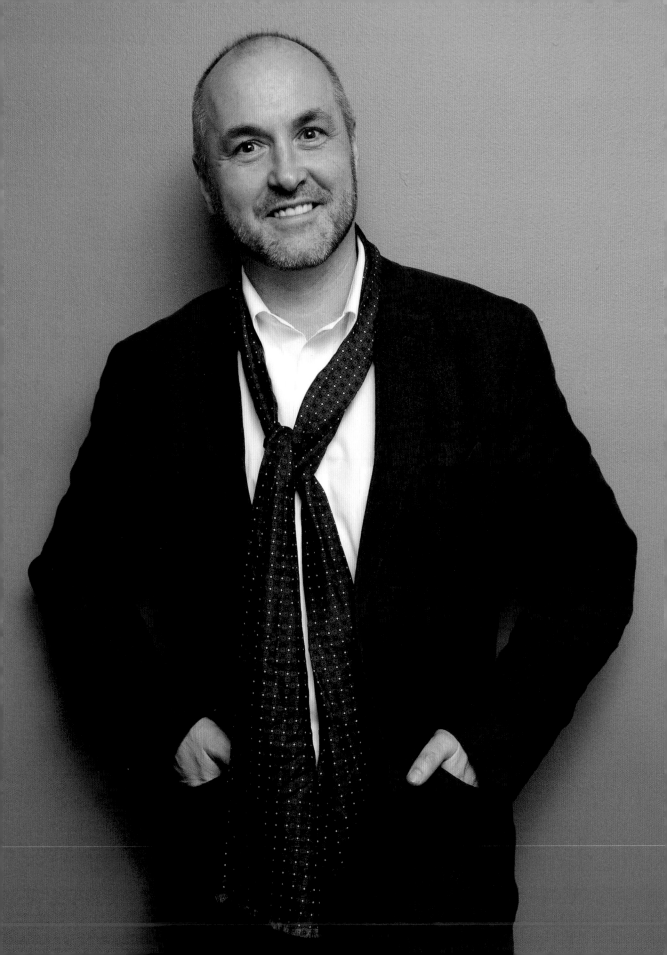

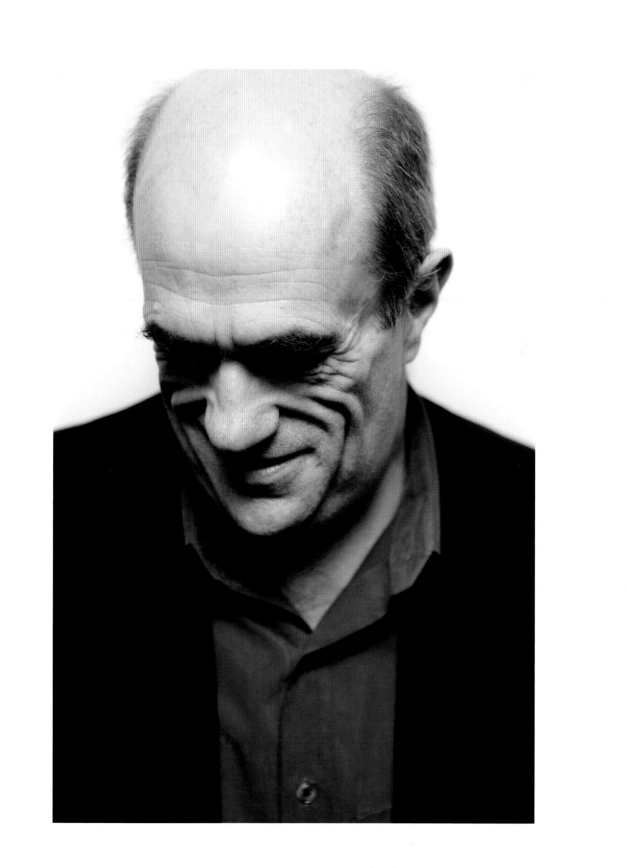

COLUM McCANN · COLM TÓIBÍN

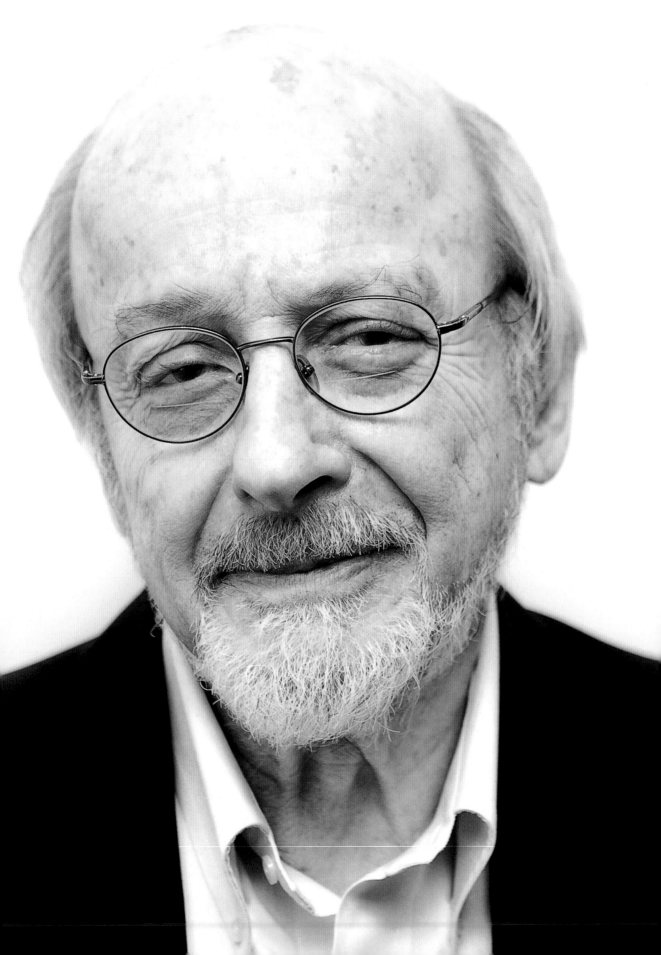

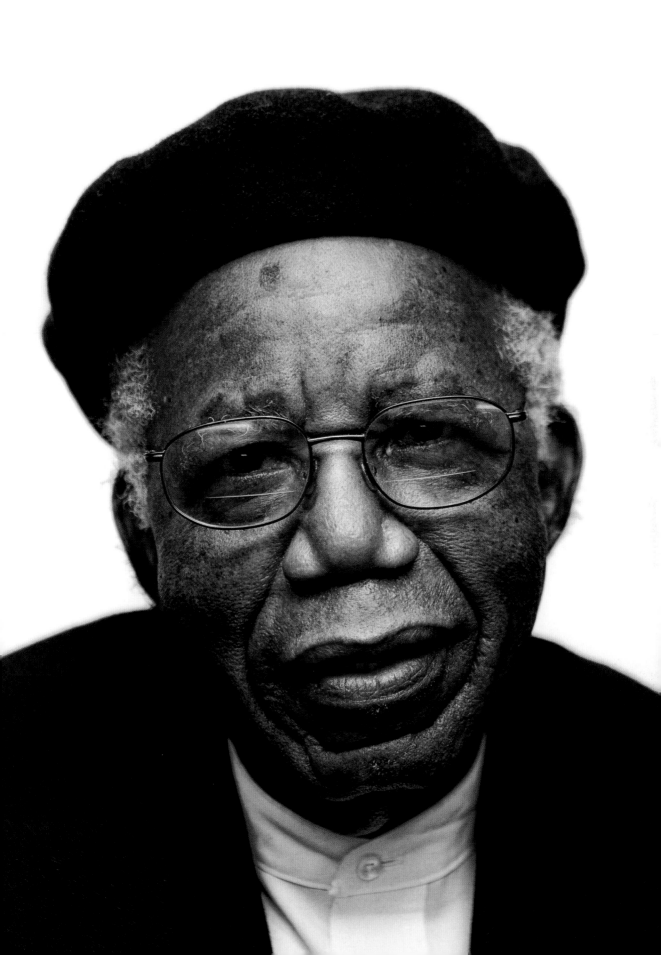

RON CHERNOW · WALTER ISAACSON
PREVIOUS: E.L. DOCTOROW · CHINUA ACHEBE

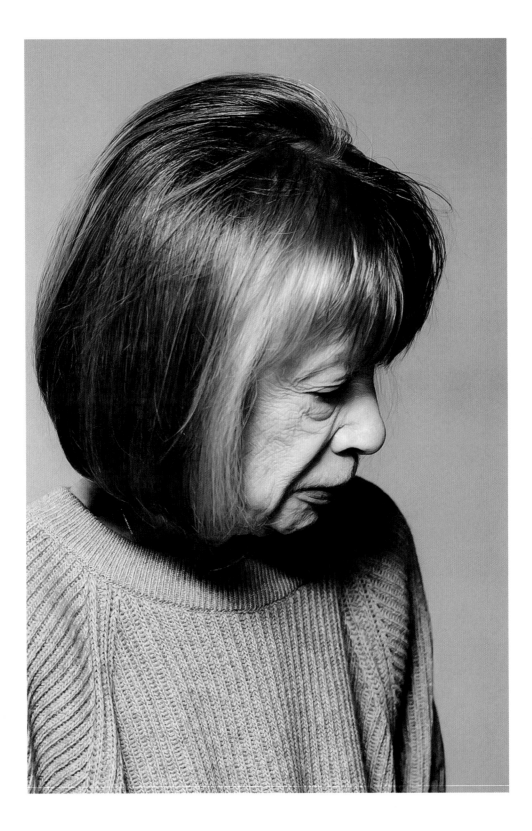

JOAN DIDION · JUNOT DÍAZ

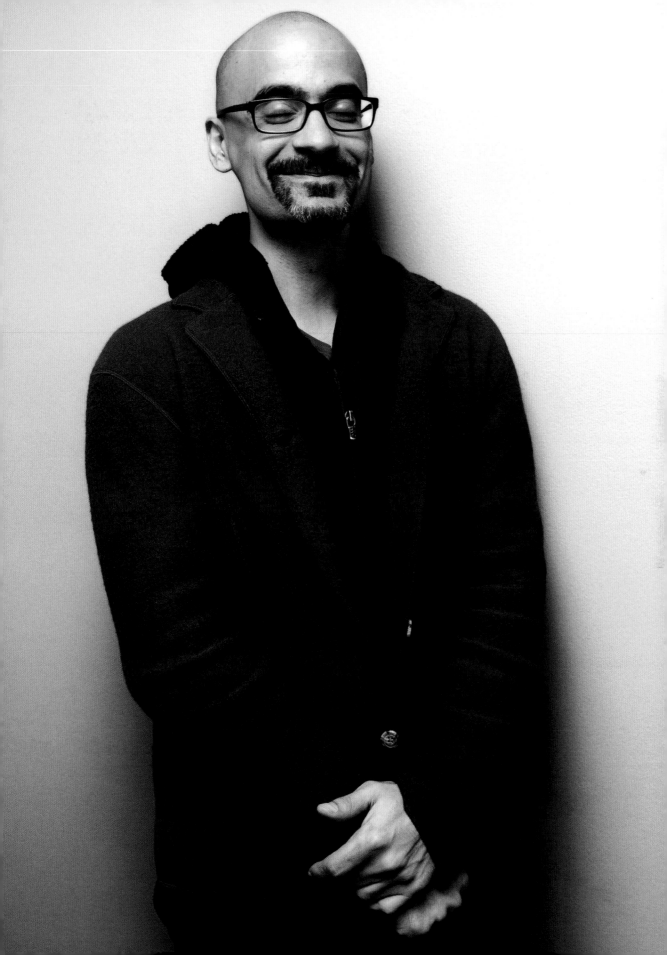

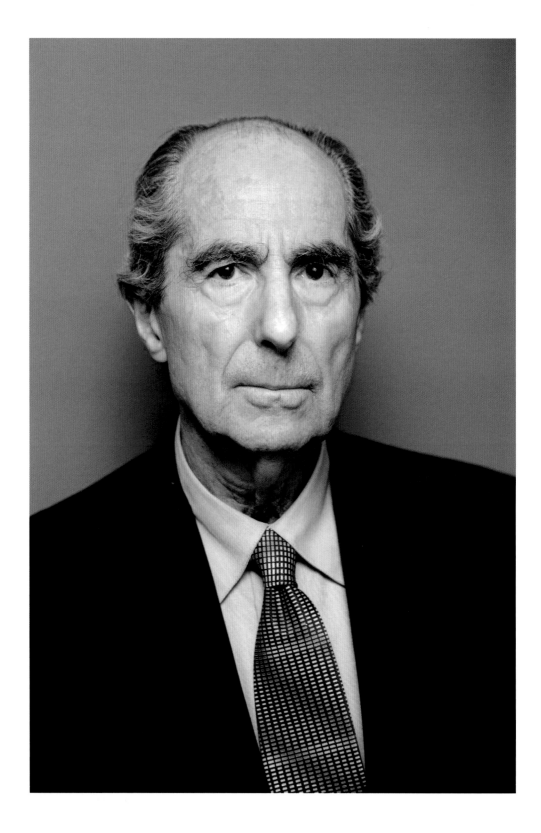

PHILIP ROTH · ELIE WIESEL

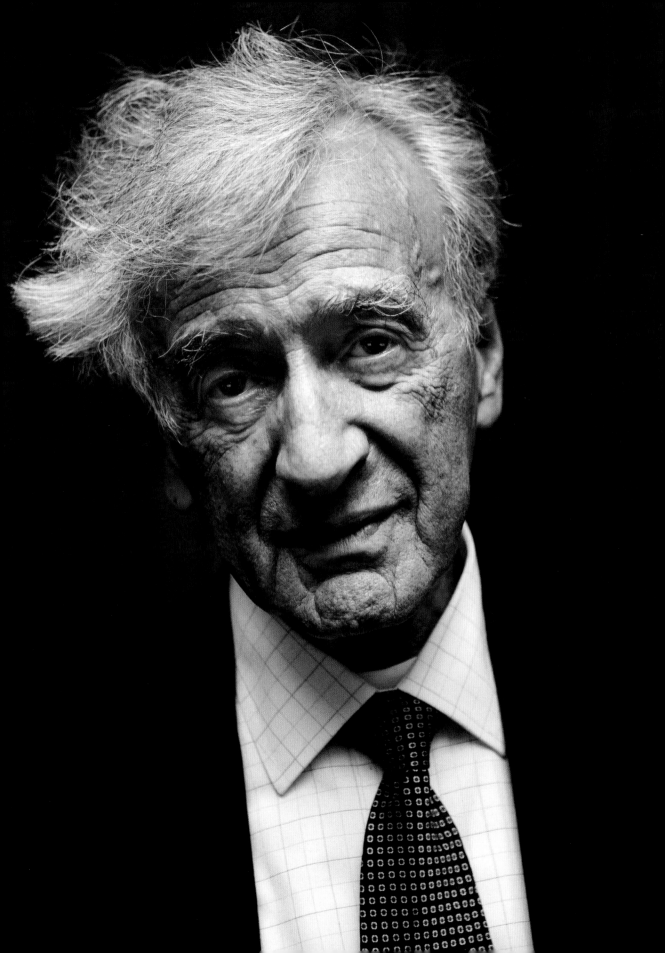

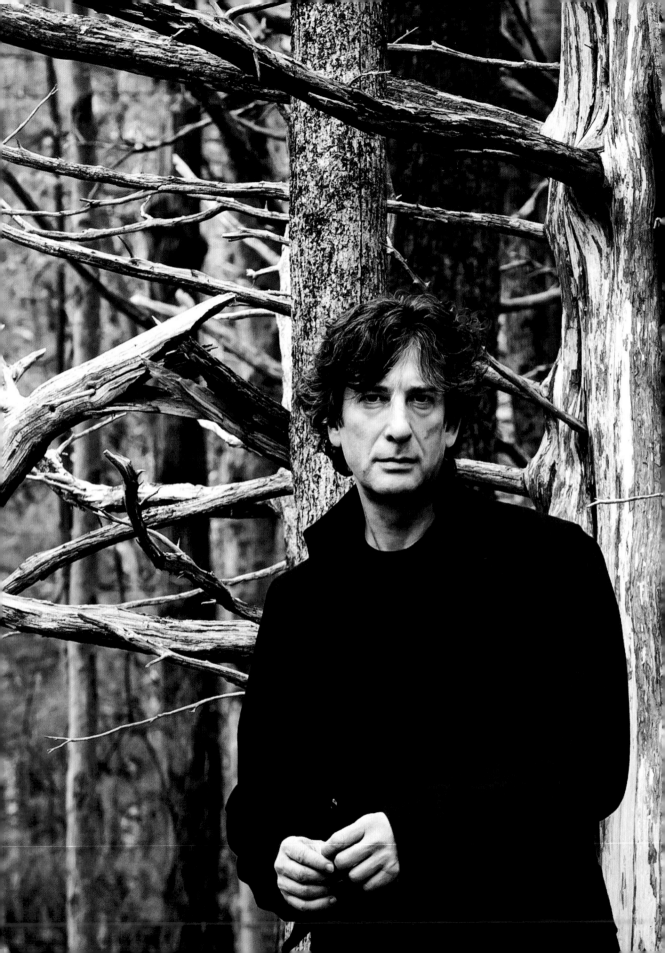

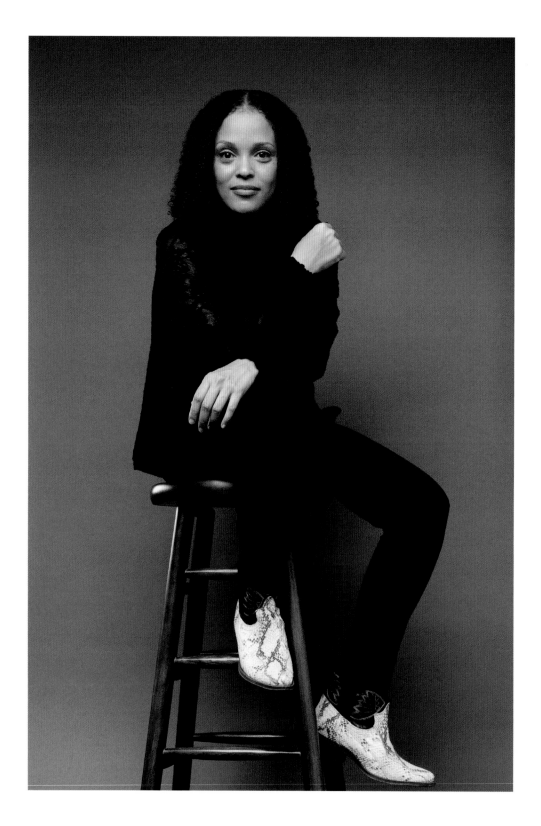

JESMYN WARD
PREVIOUS: NEIL GAIMAN

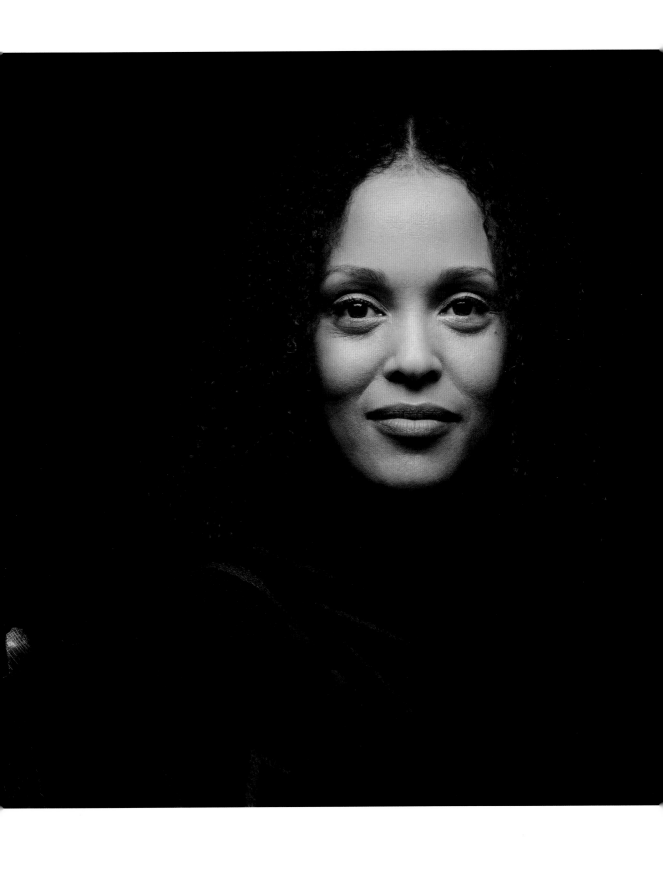

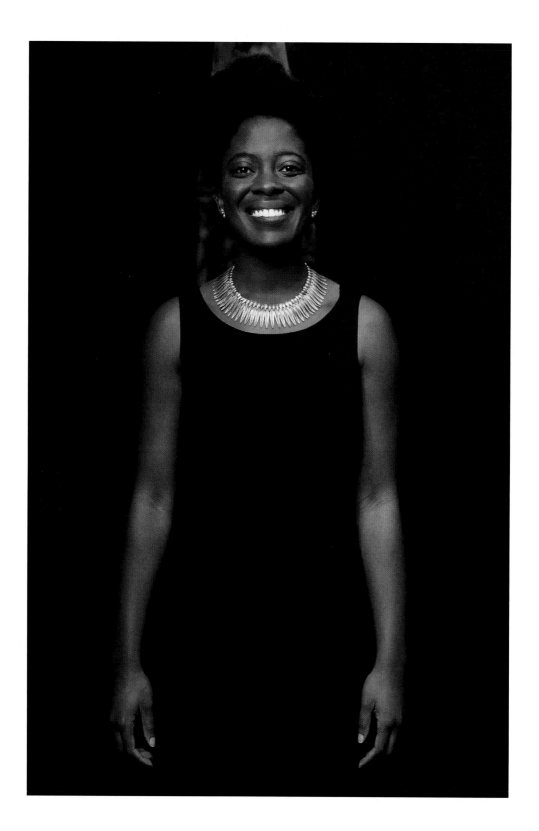

YAA GYASI · MALCOLM GLADWELL

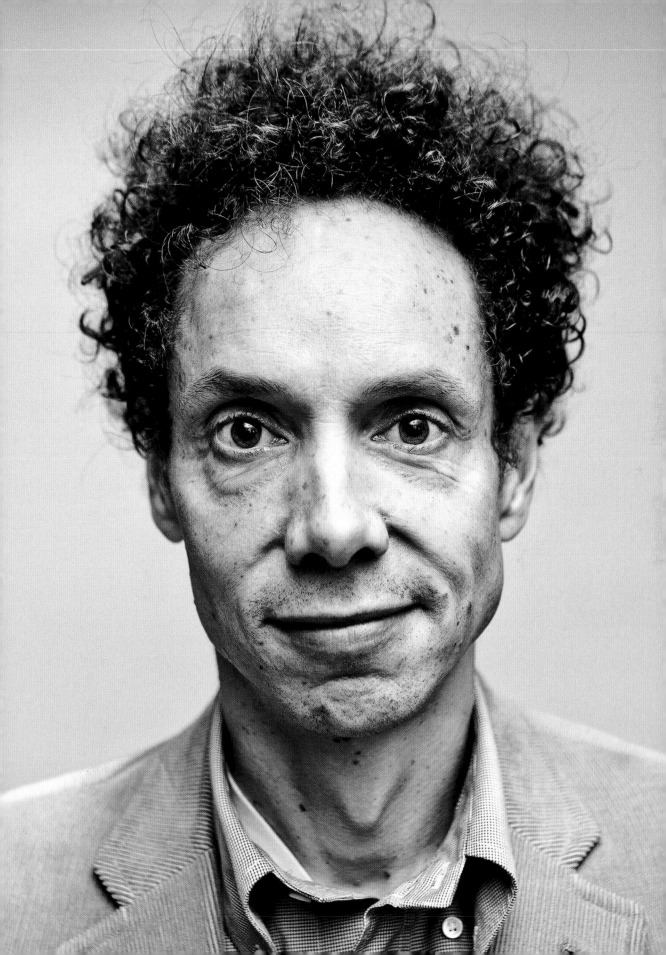

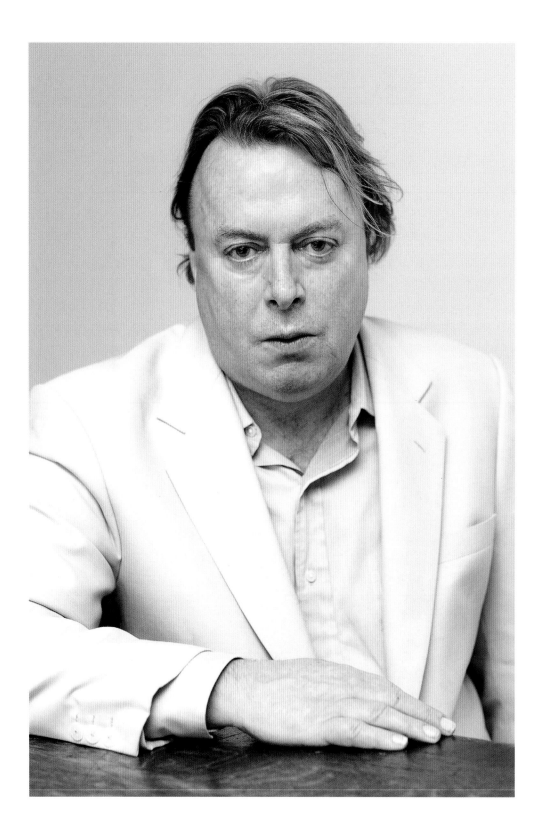

CHRISTOPHER HITCHENS

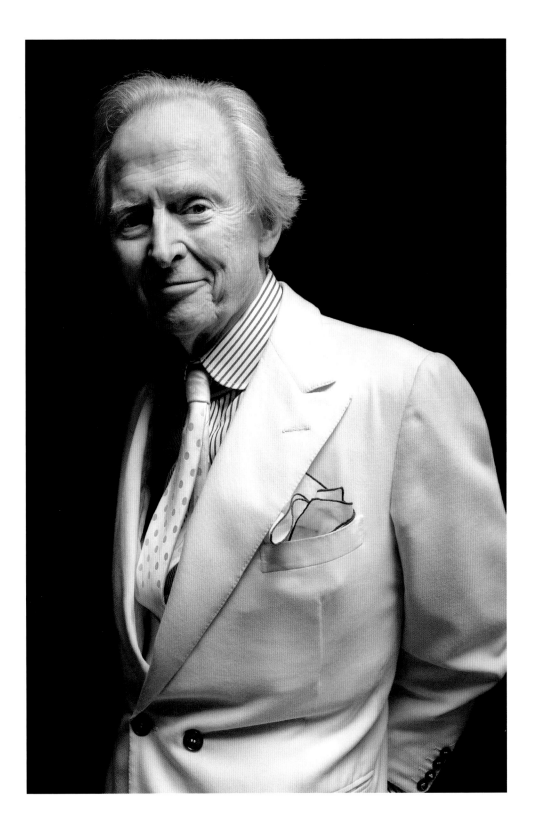

TOM WOLFE

ZADIE SMITH

SUNIL YAPA · MARLON JAMES

HARLAN COBEN

JOSEPH O'NEILL

JONATHAN AMES · SEBASTIAN JUNGER

BRANDEN JACOBS-JENKINS · EDWARD ALBEE

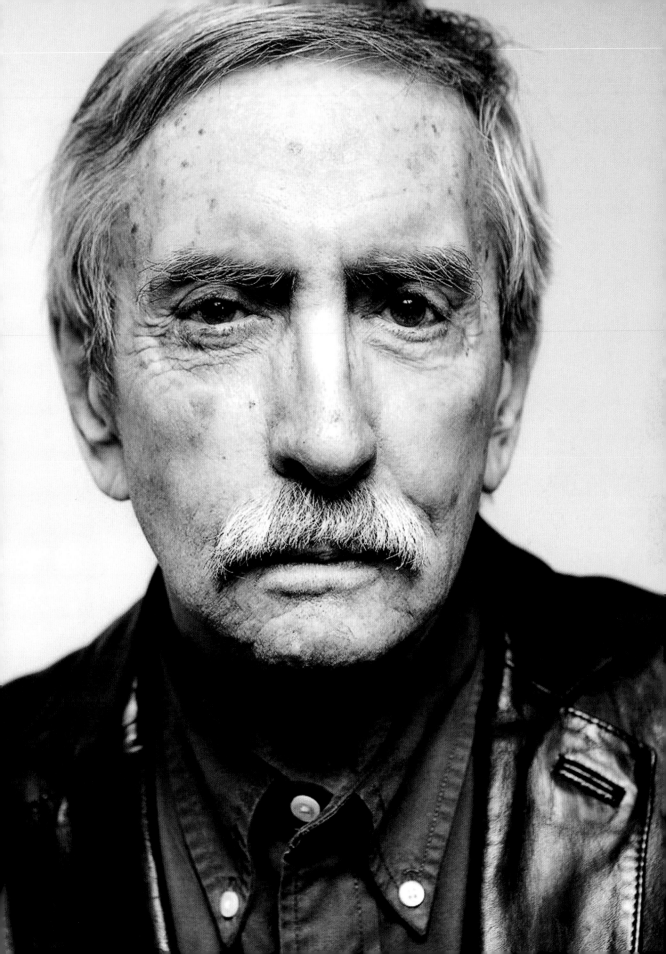

TARELL ALVIN McCRANEY

CLARE BARRON

WAYNE KOESTENBAUM

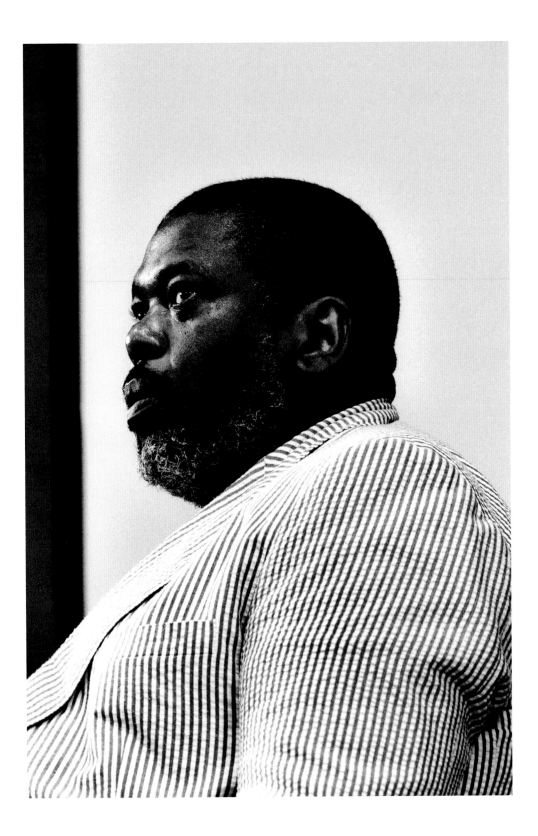

HILTON ALS

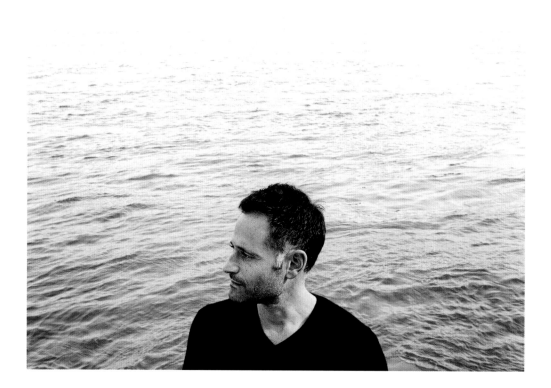

ALEXANDER MAKSIK · JOANNE C. HILLHOUSE

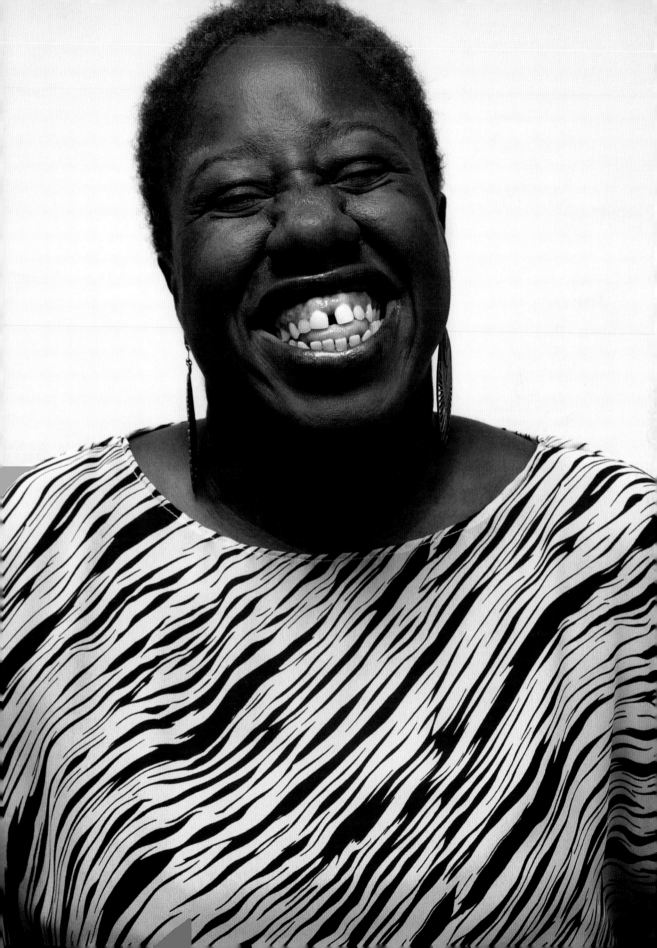

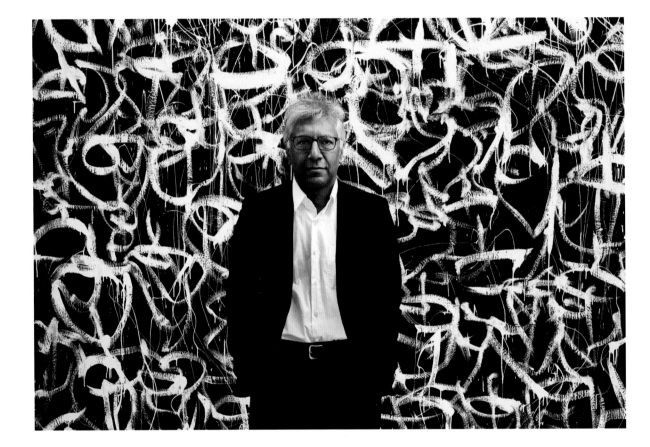

VIJAY SESHADRI

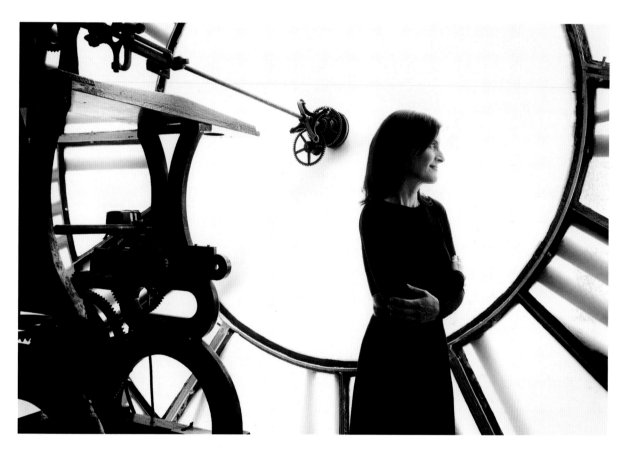

LAURA J. SNYDER

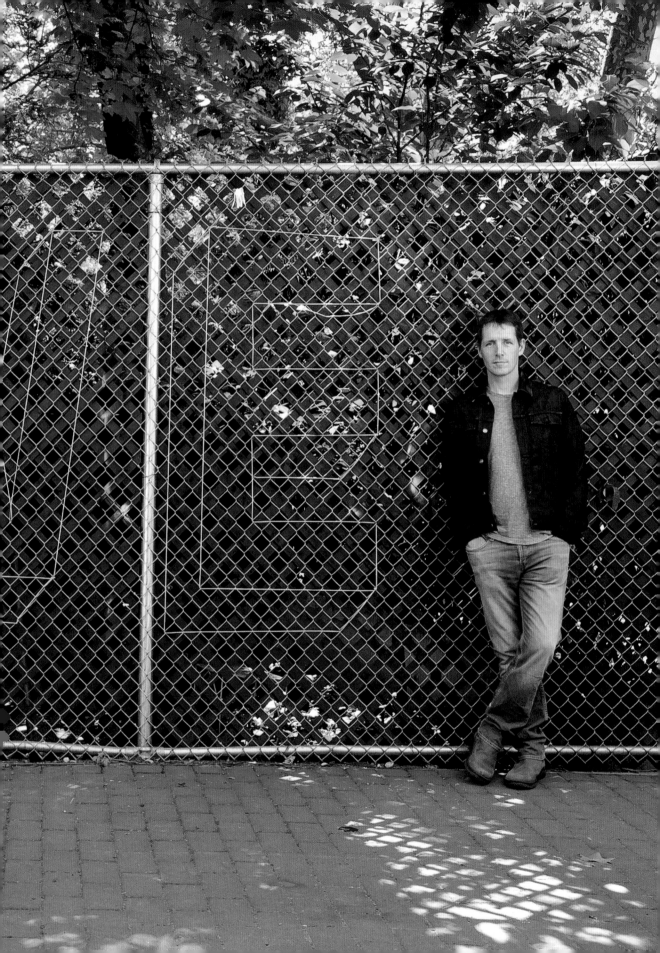

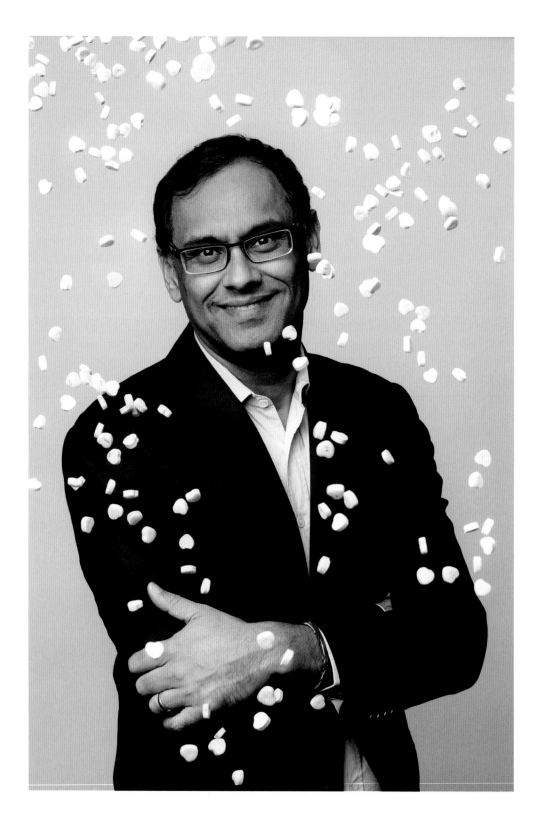

SANDEEP JAUHAR · KAITLYN GREENIDGE
PREVIOUS: JOE McGINNISS JR.

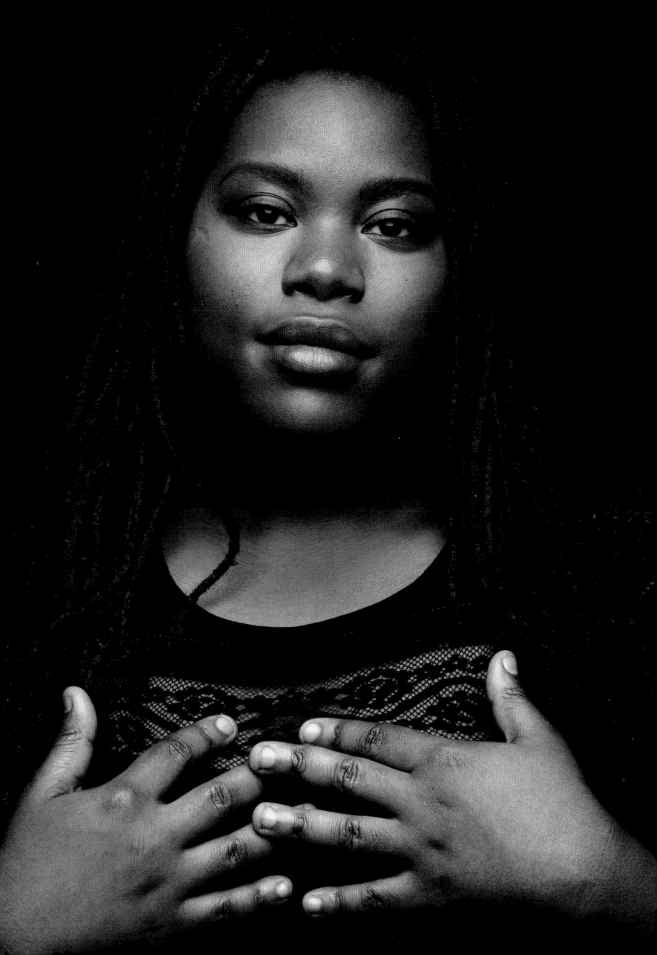

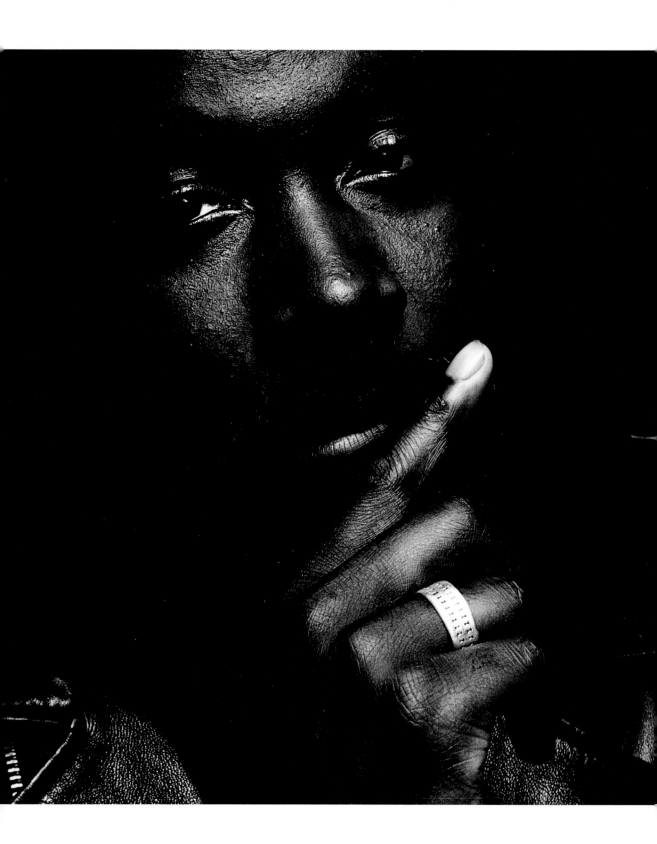

JASON REYNOLDS

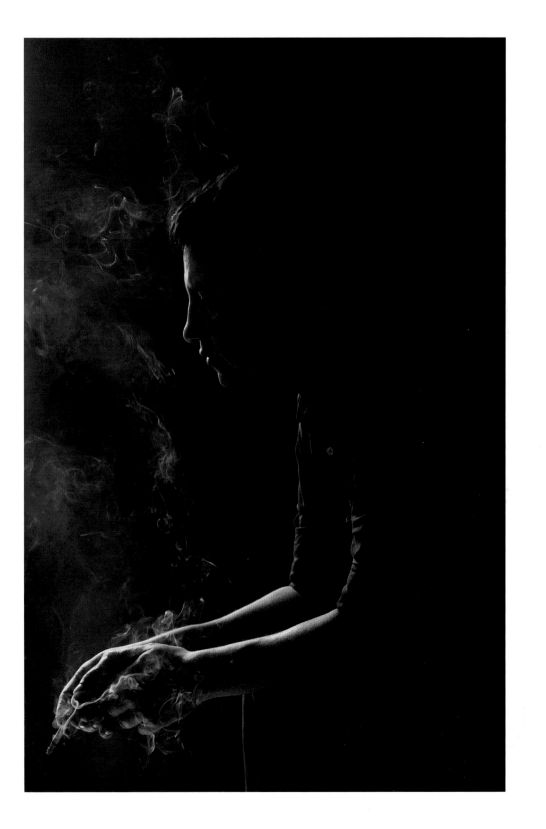

ALEJANDRO ZAMBRA

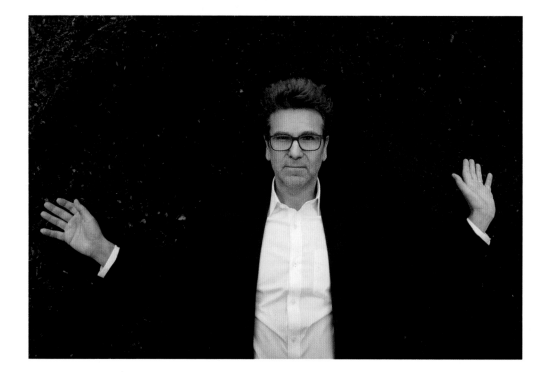

DAVID MEANS · ETGAR KERET

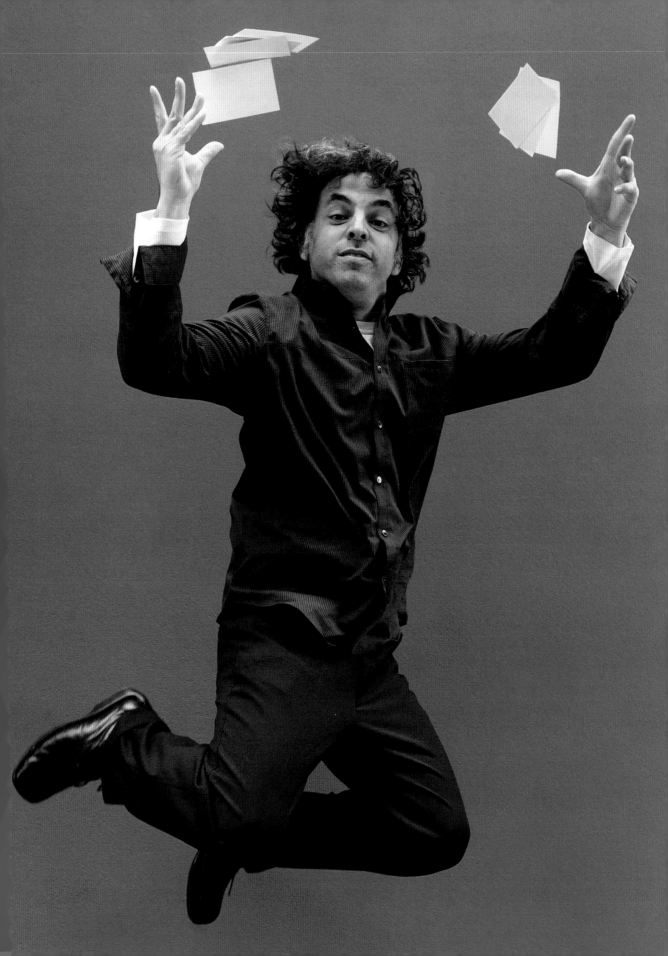

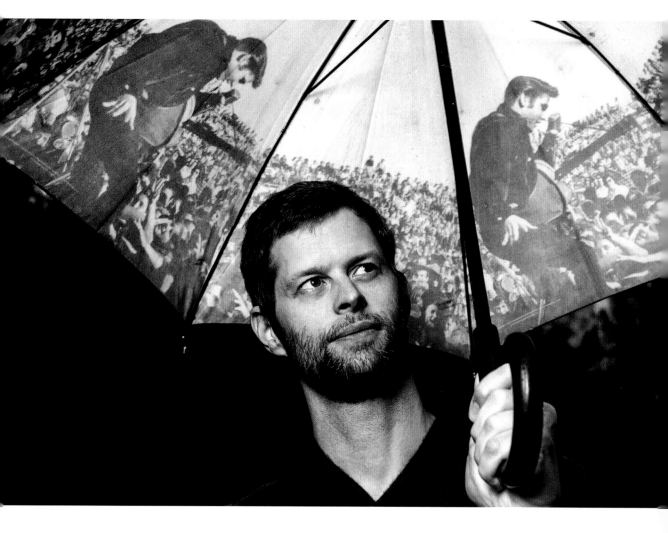

JOHN WRAY

EIMEAR McBRIDE

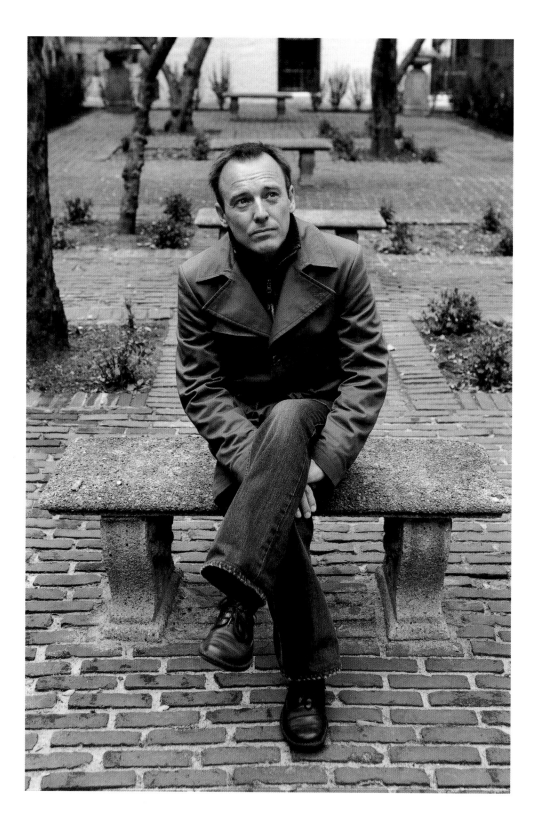

MIRKO BONNÉ

BRET EASTON ELLIS

EILEEN MYLES · MIN JIN LEE

VICTOR LaVALLE · GREGORY PARDLO

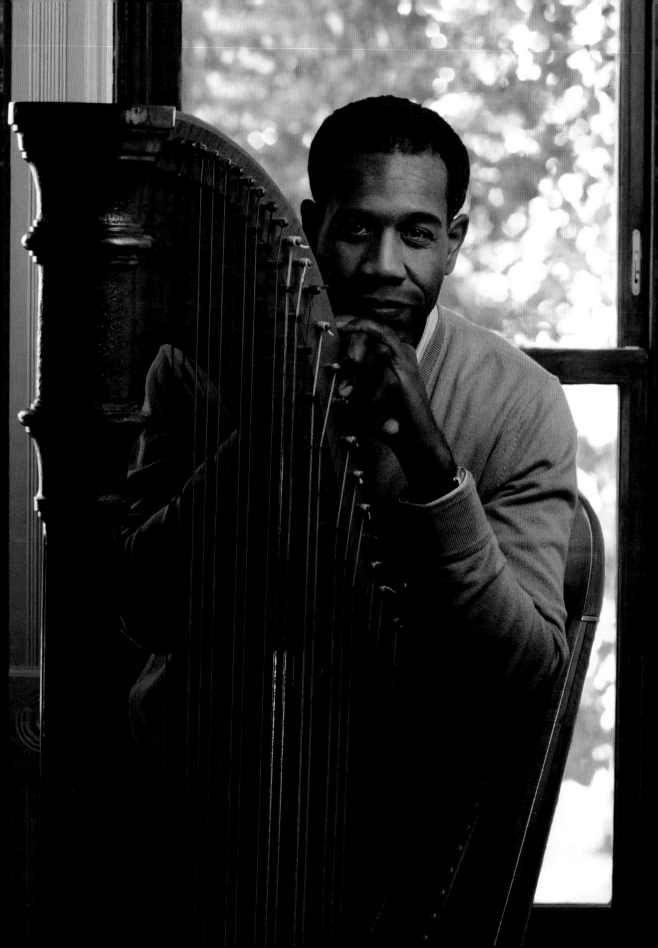

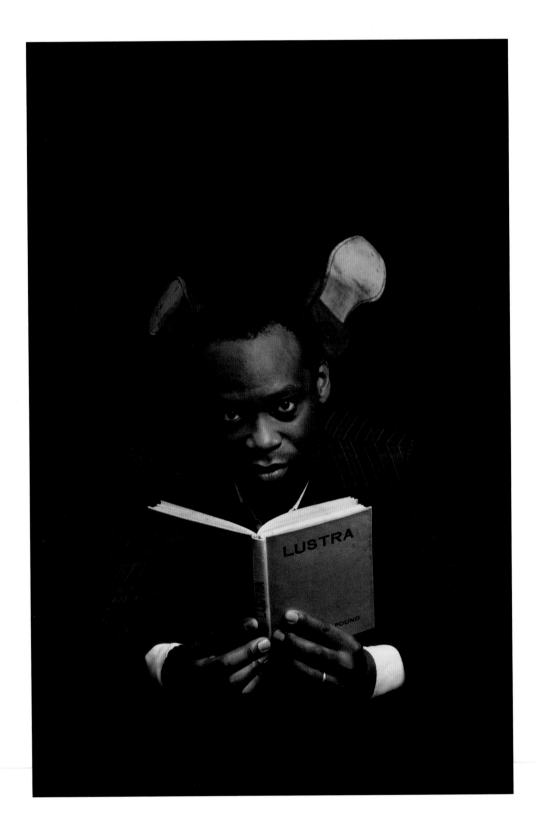

ROWAN RICARDO PHILLIPS

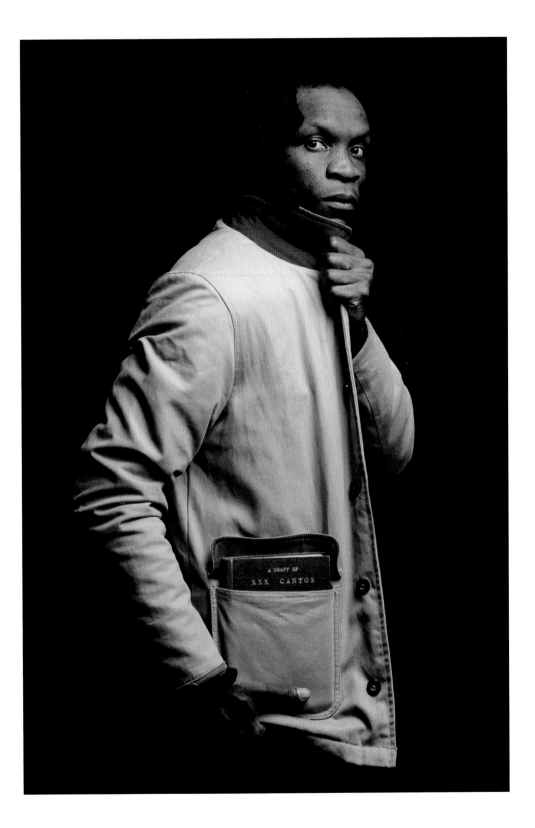

ISHION HUTCHINSON

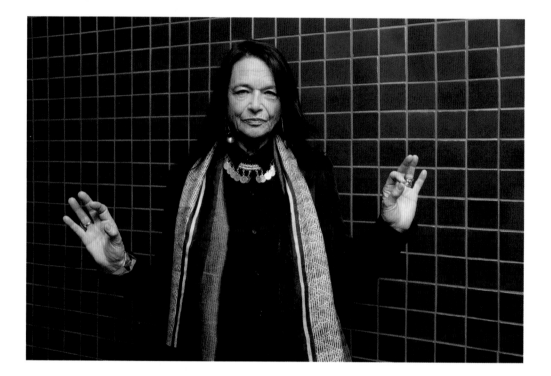

ANNE WALDMAN

GLORIA STEINEM

LOUISE ERDRICH

LYDIA DAVIS

KHET MAR

LIAO YIWU

ALAIN DE BOTTON · GEORGE SAUNDERS
PREVIOUS: NORA BOSSONG · PHILLIP B. WILLIAMS

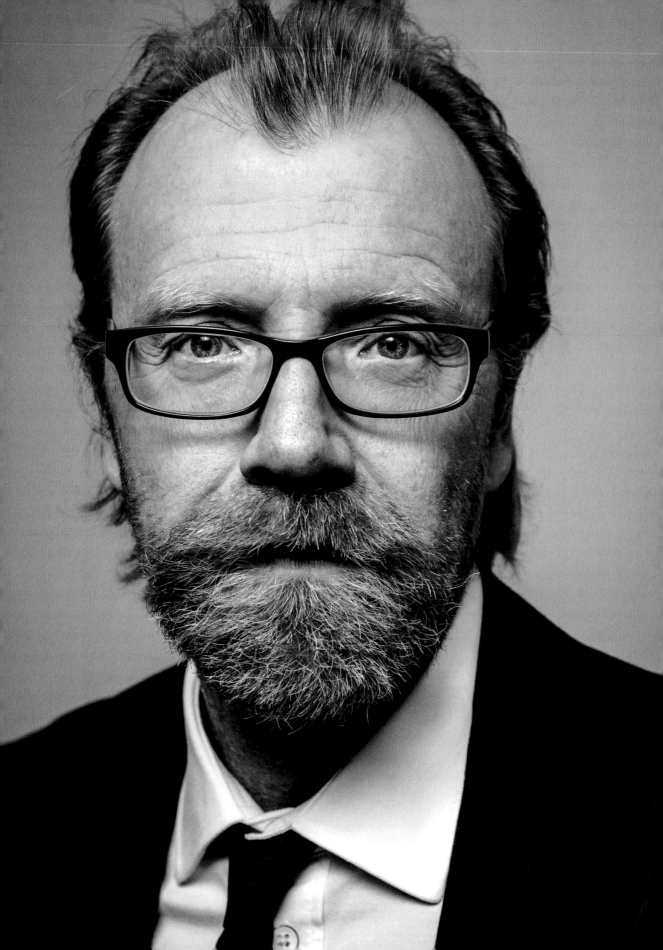

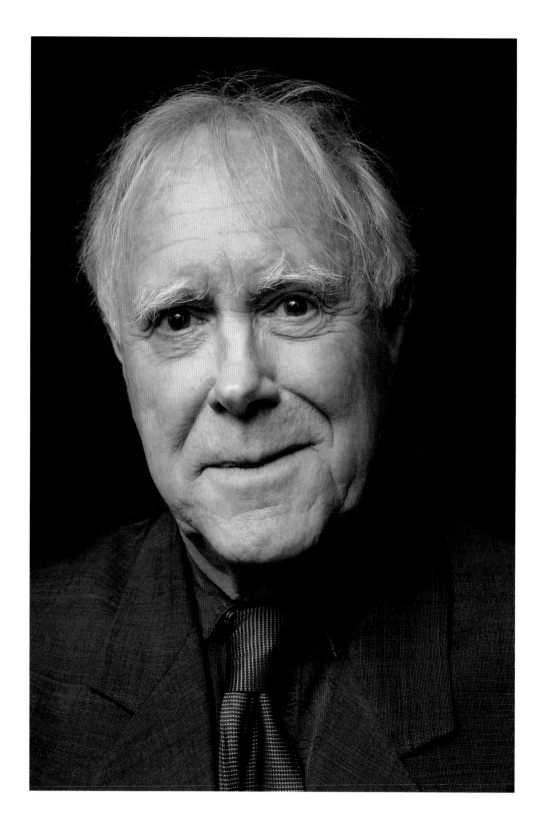

ROBERT HASS · GARTH GREENWELL

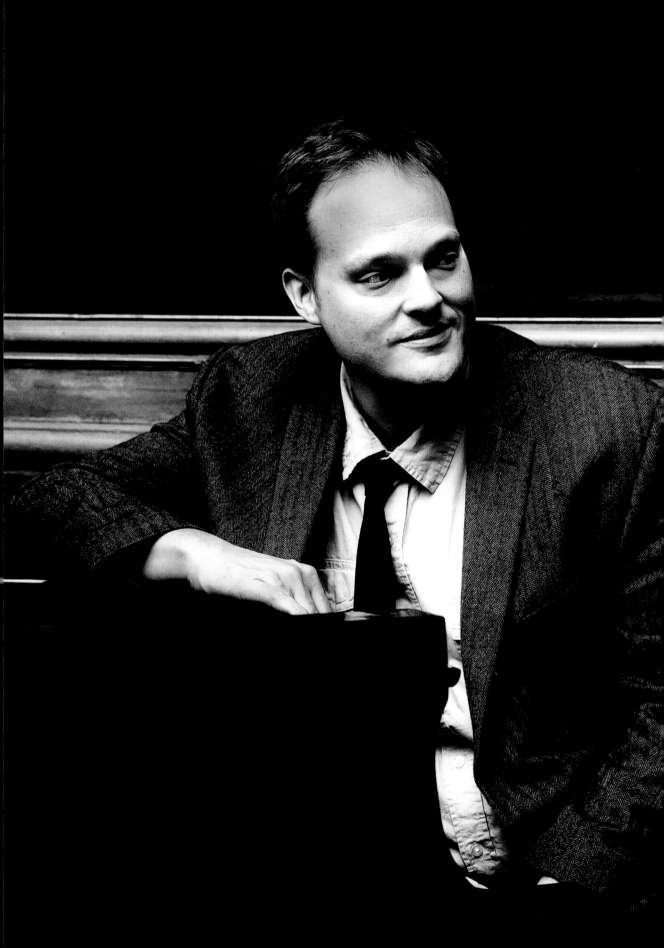

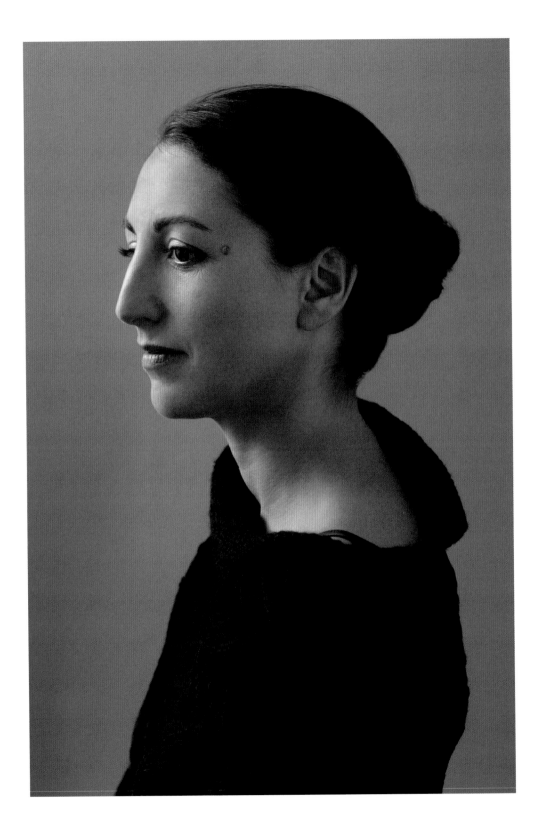

VIOLAINE HUISMAN

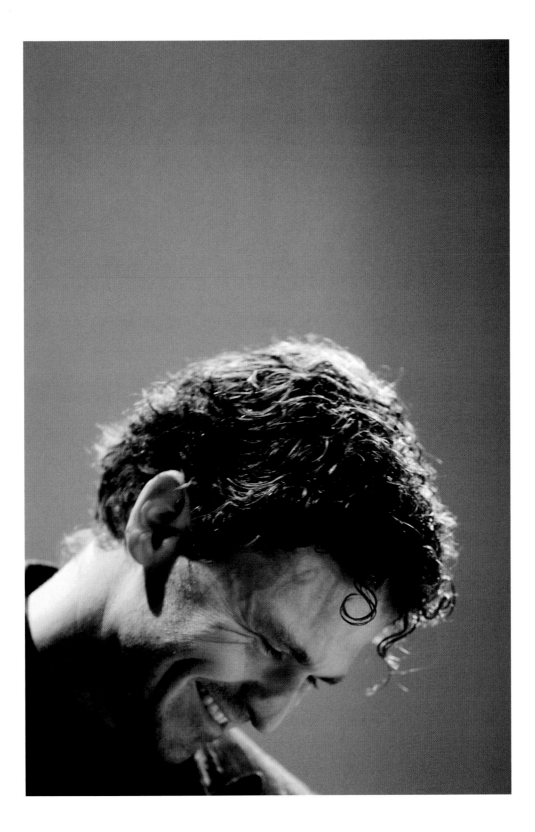

DAVE EGGERS

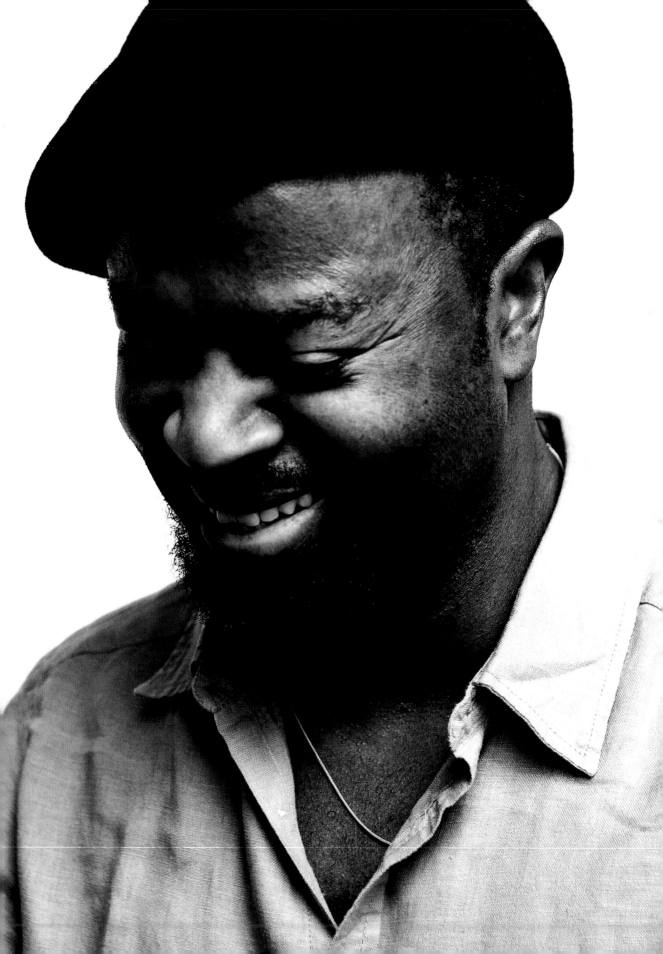

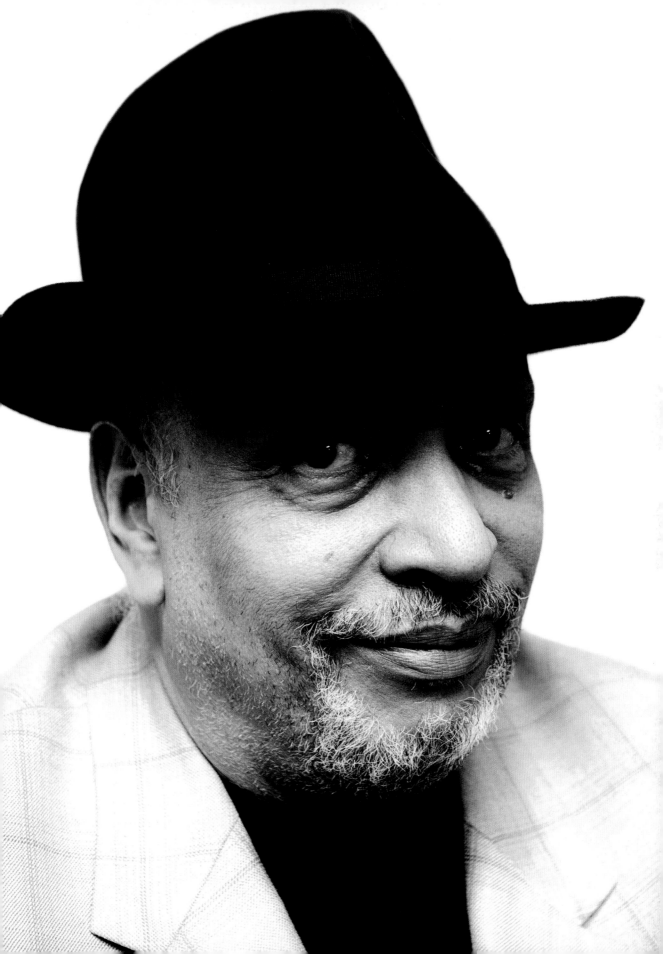

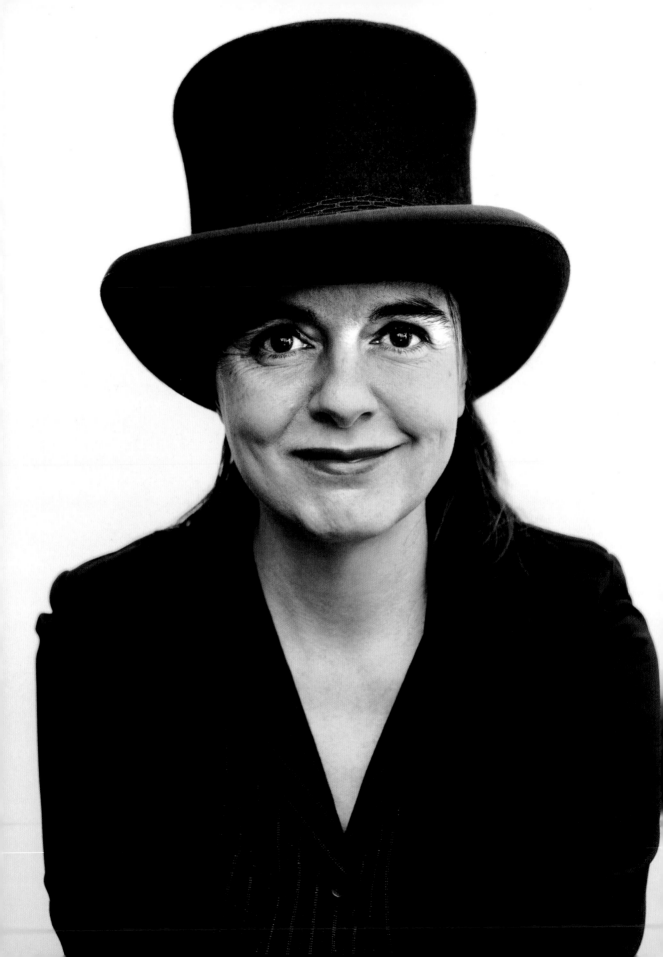

AMÉLIE NOTHOMB · JAMES MᴄBRIDE
PREVIOUS SPREAD: BEN OKRI · WALTER MOSLEY

ANNE CARSON · MAUREEN CHIQUET

CHARLES M. BLOW · JOSHUA COHEN

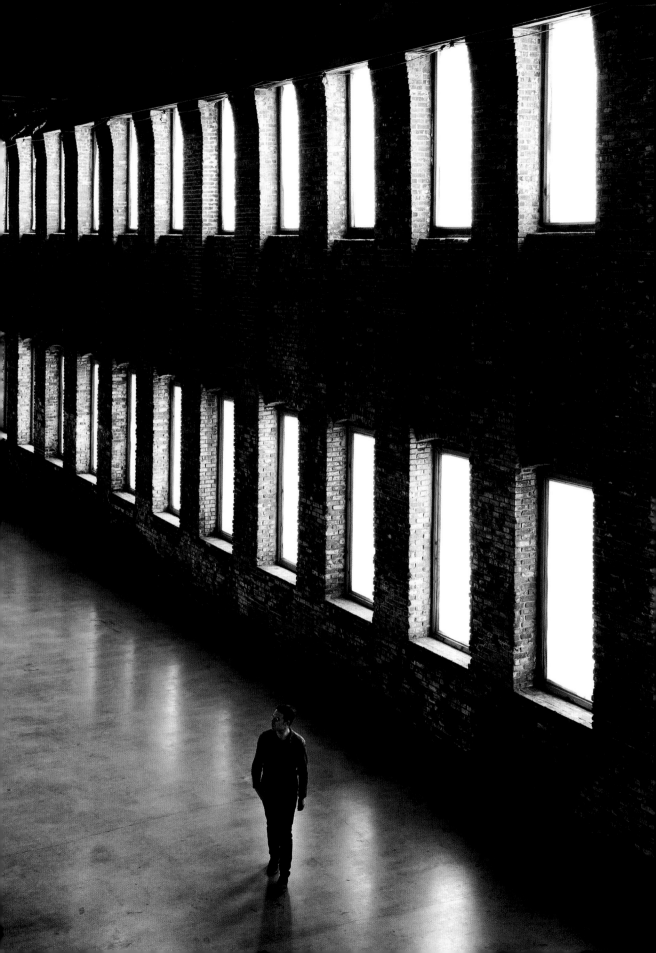

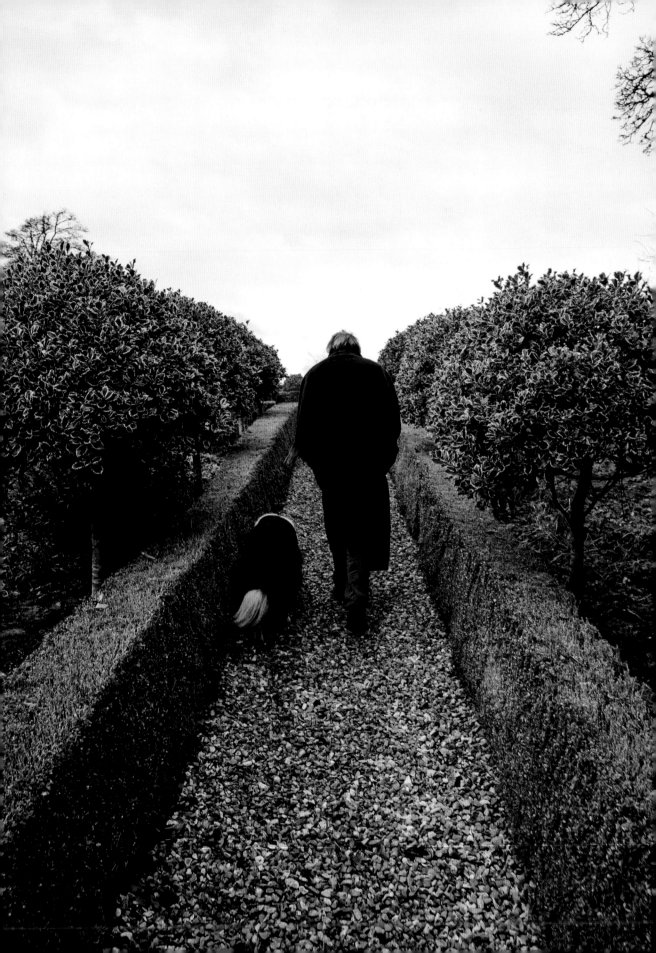

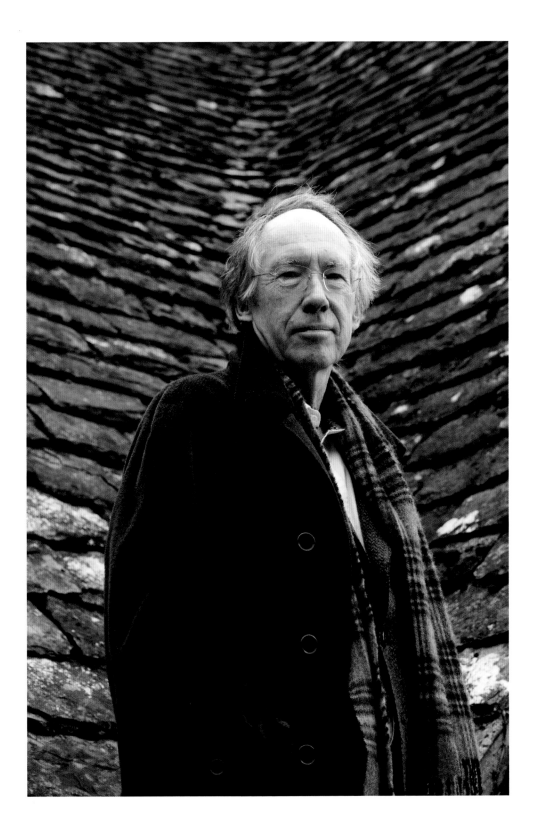

IAN McEWAN

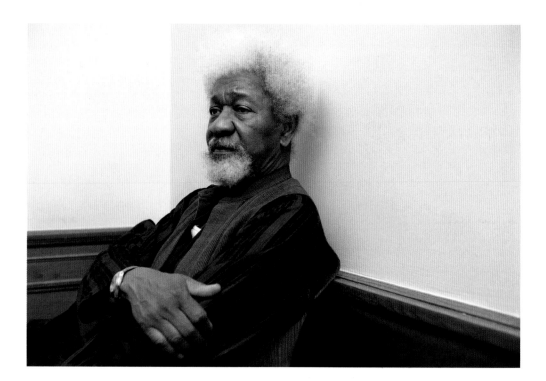

WOLE SOYINKA · TAIYE SELASI

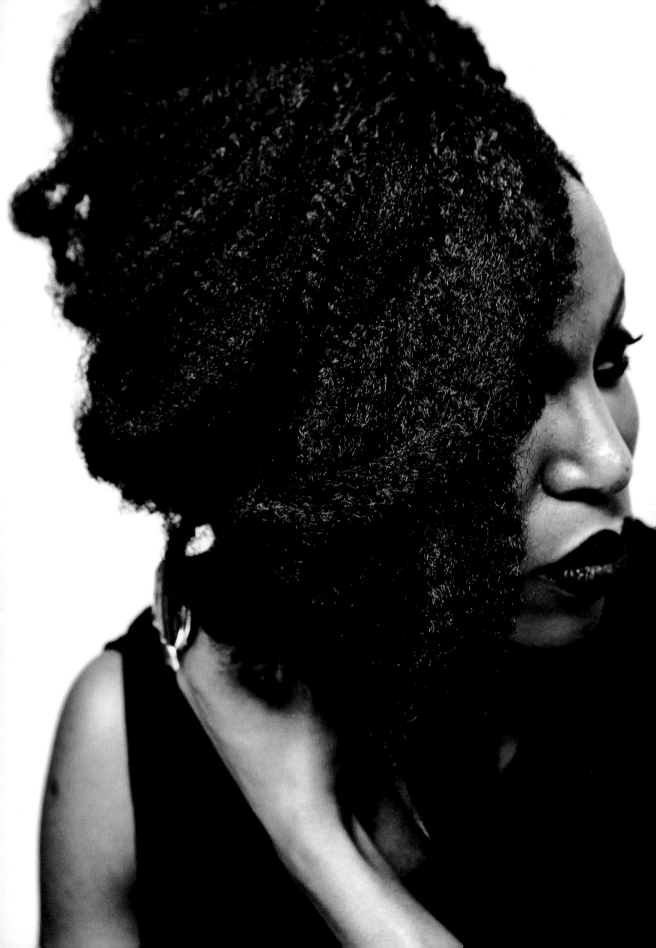

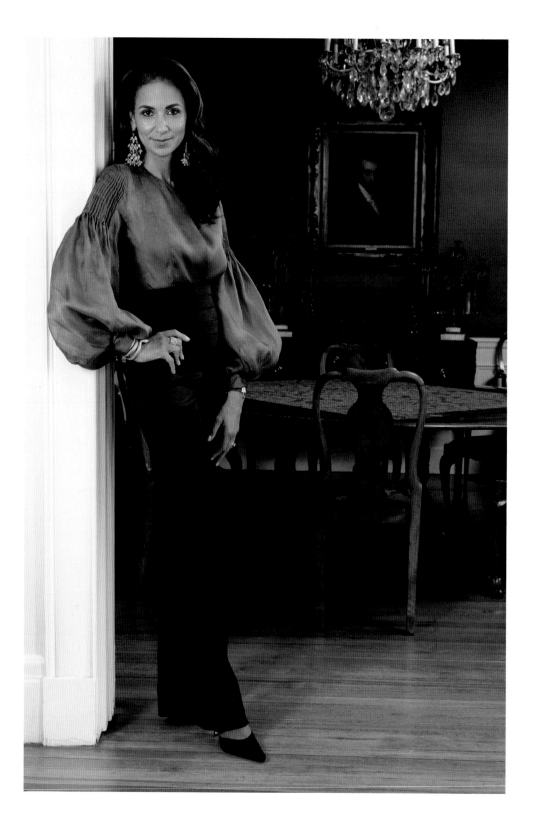

SUSAN FALES-HILL

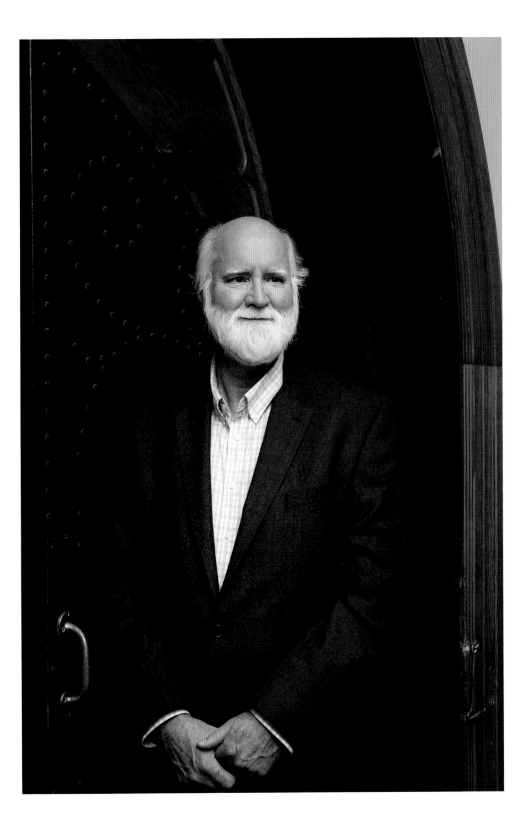

NICHOLSON BAKER

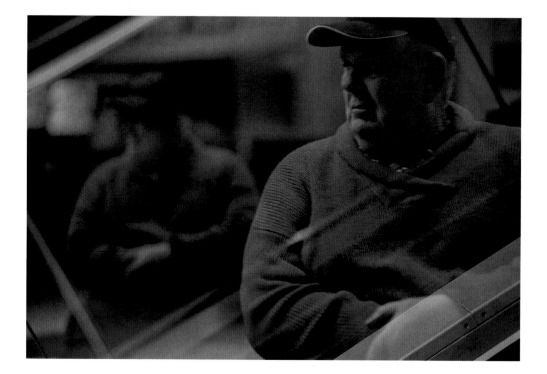

LES MURRAY

TEJU COLE

STEWART O'NAN · CHAD HARBACH

ARIEL DORFMAN

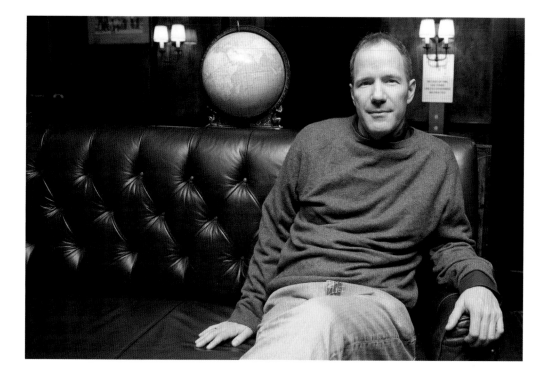

RICK MOODY

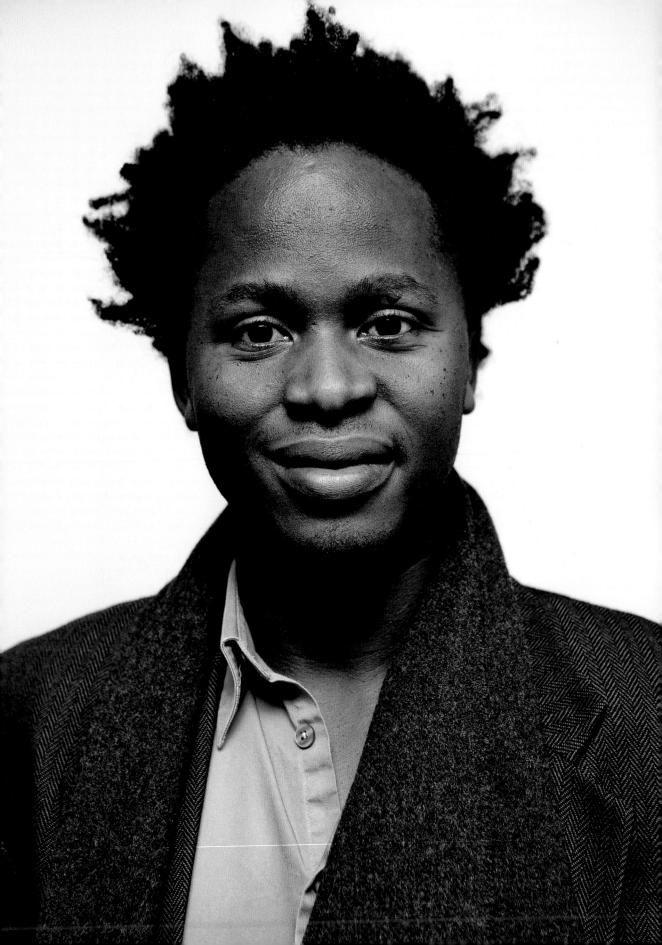

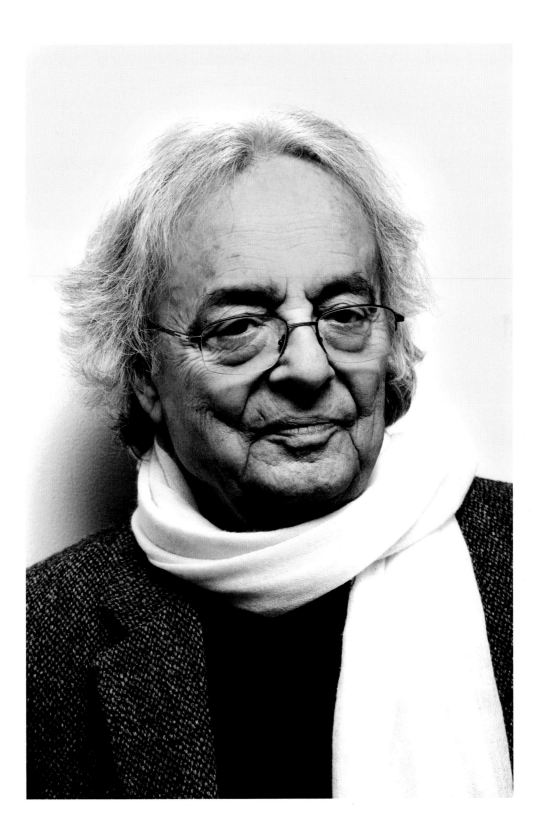

ISHMAEL BEAH · ADONIS

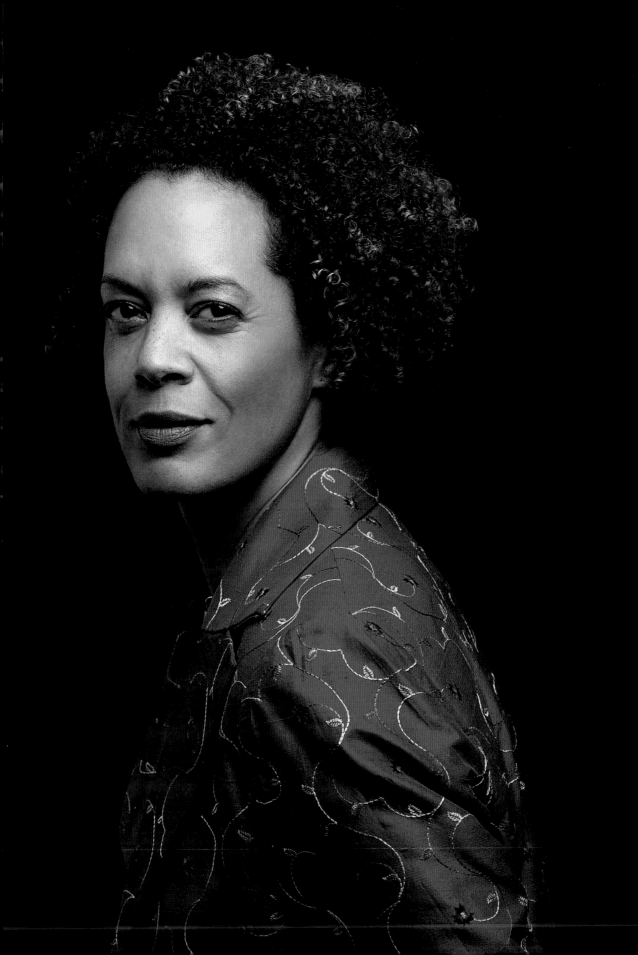

AMINATTA FORNA · MONA ELTAHAWY

RICHARD RUSSO · ANDRÉ ACIMAN

JACQUELINE WOODSON · LUCAS HNATH

JOHN IRVING

DANIELLE TRUSSONI · JAMAICA KINCAID

SHEILA HETI

SARAH THORNTON

LINDSAY HATTON · MICHELLE ALEXANDER

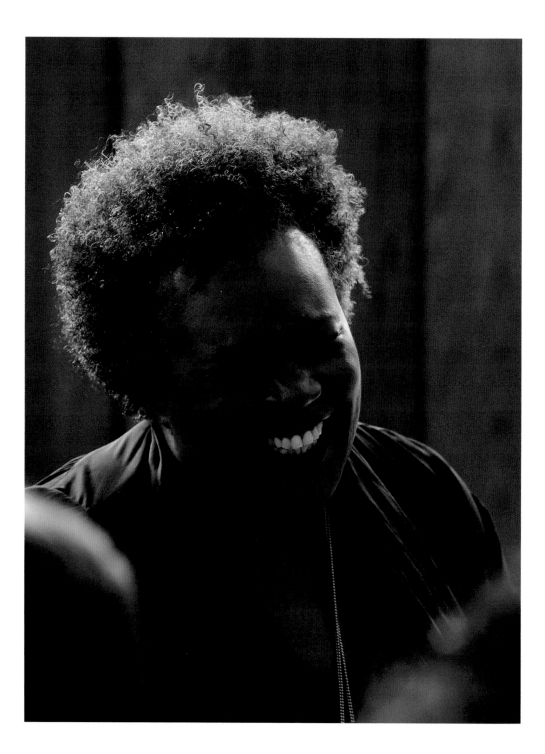

CLAUDIA RANKINE

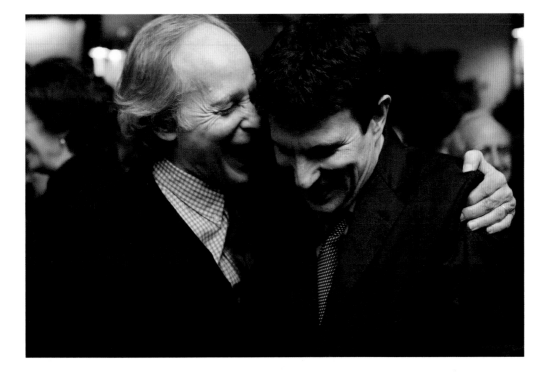

RICHARD FORD AND DAVID REMNICK

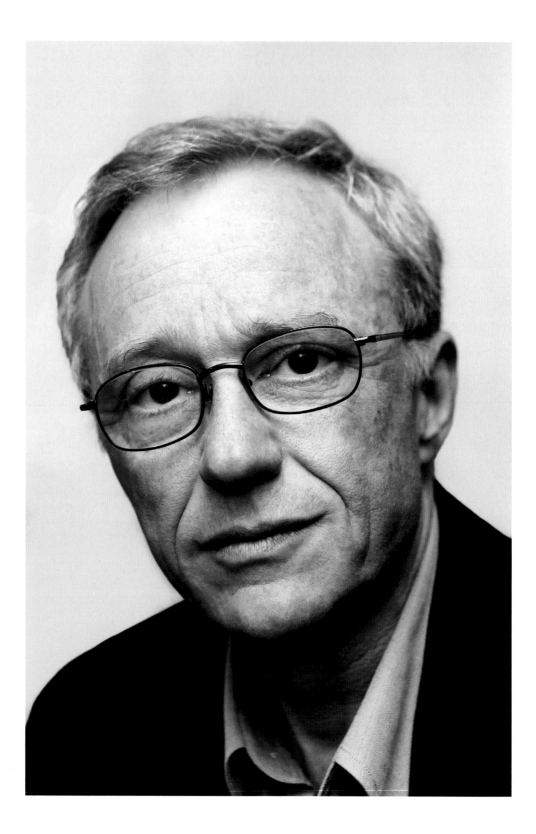

DAVID GROSSMAN

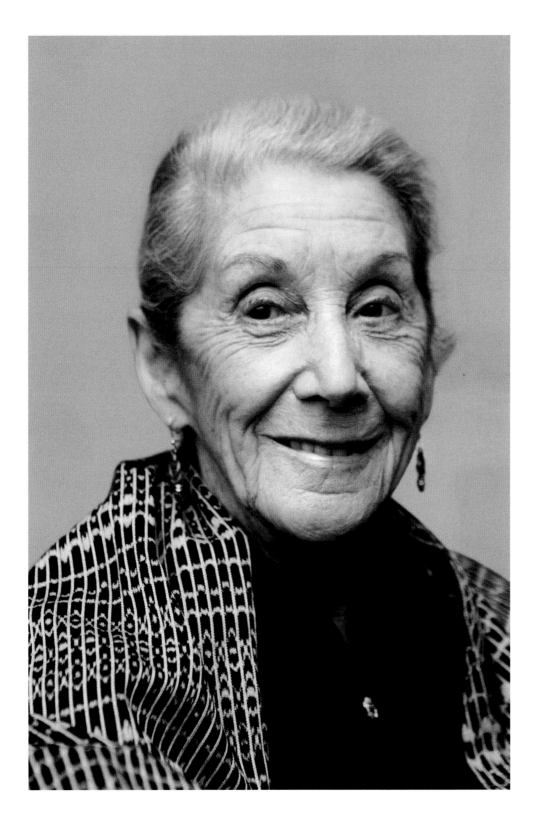

NADINE GORDIMER

CLAIRE MESSUD

REBECCA SKLOOT

GIANNINA BRASCHI

JOHN FREEMAN GILL AND JOHN FREEMAN

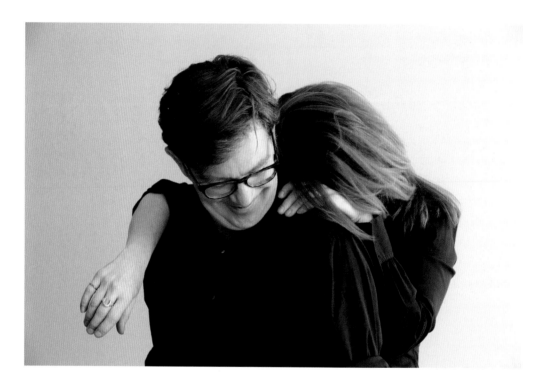

ELISSA SCHAPPELL AND ROB SPILLMAN

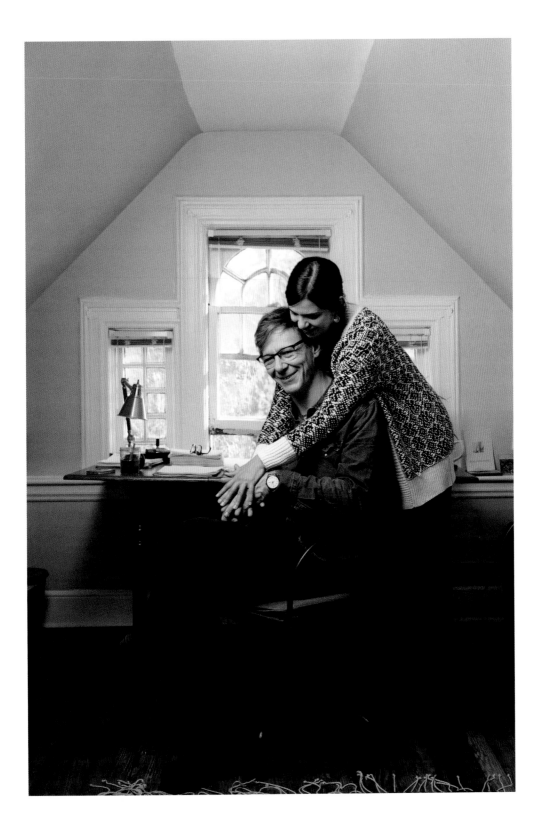

VALERIA LUISELLI AND ÁLVARO ENRIGUE

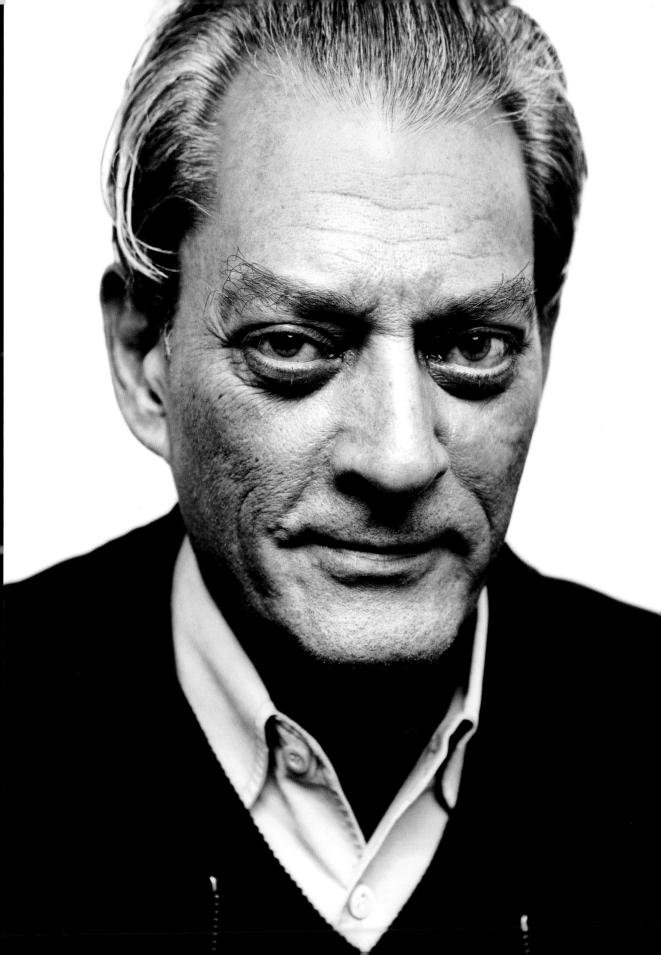

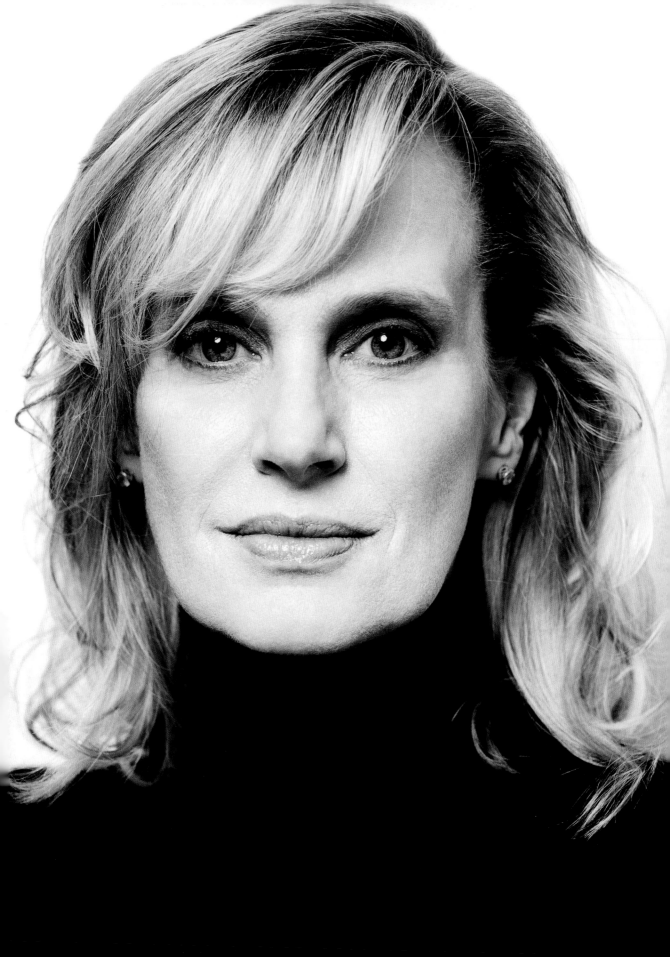

ALEXANDRA KLEEMAN
PREVIOUS: PAUL AUSTER · SIRI HUSTVEDT
CHARLES BOCK · LESLIE JAMISON

ALEX GILVARRY

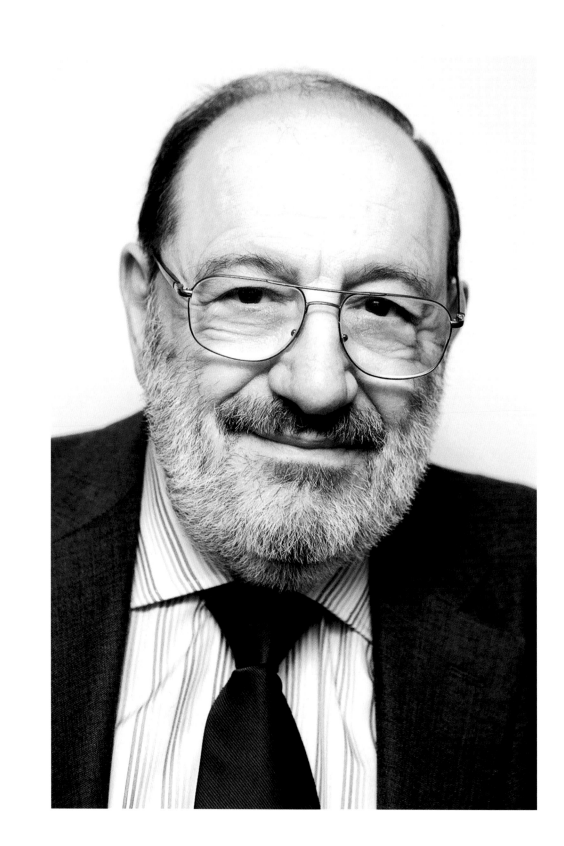

UMBERTO ECO
PREVIOUS: CHINA MIÉVILLE · ARACELIS GIRMAY

ROBERTO SAVIANO

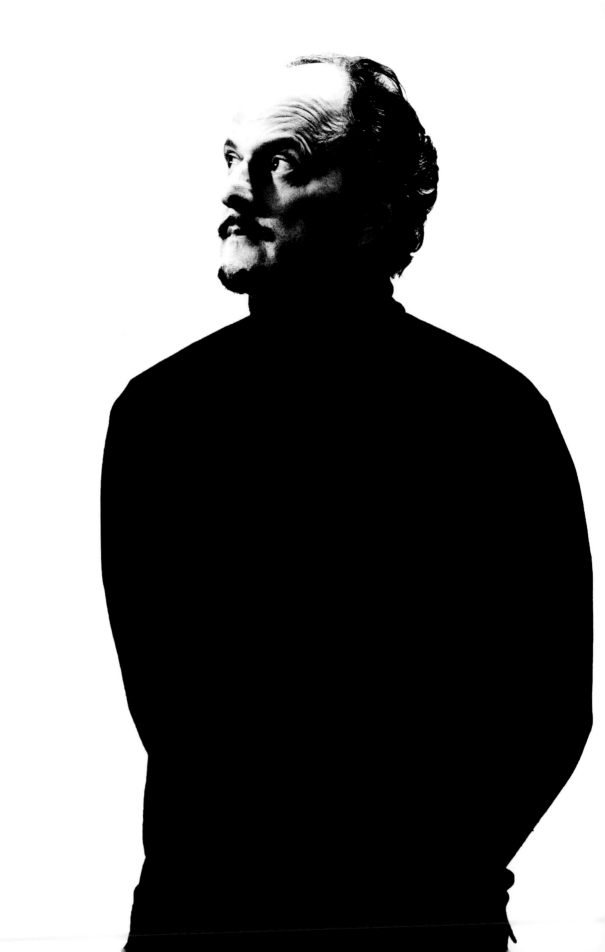

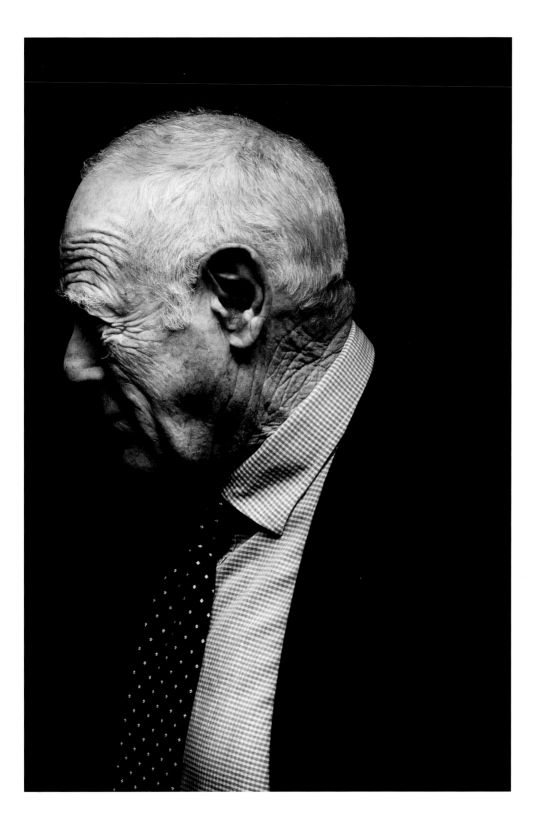

JEFFREY EUGENIDES · JAMES SALTER

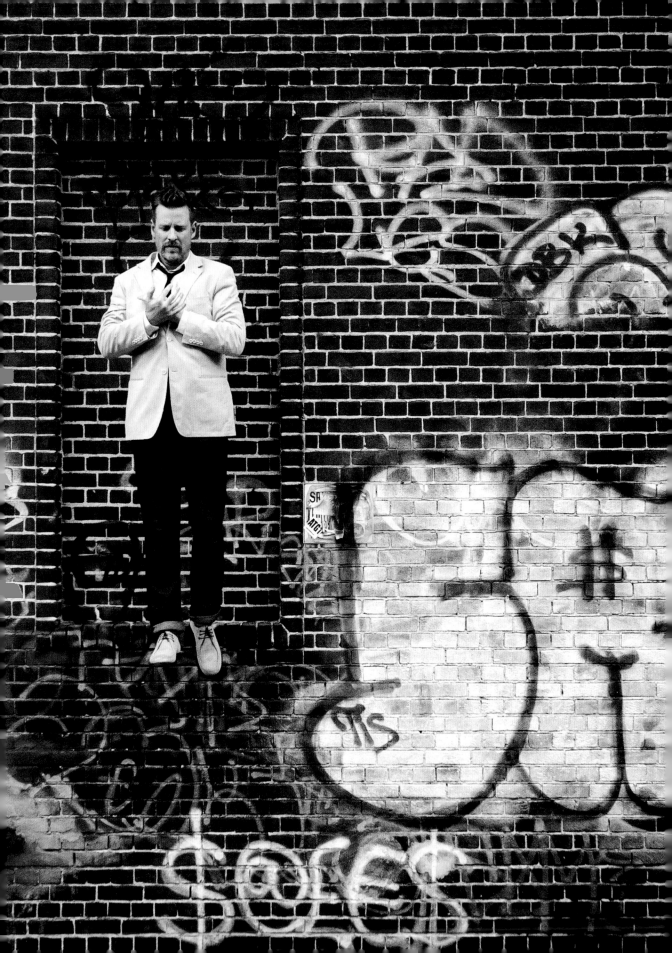

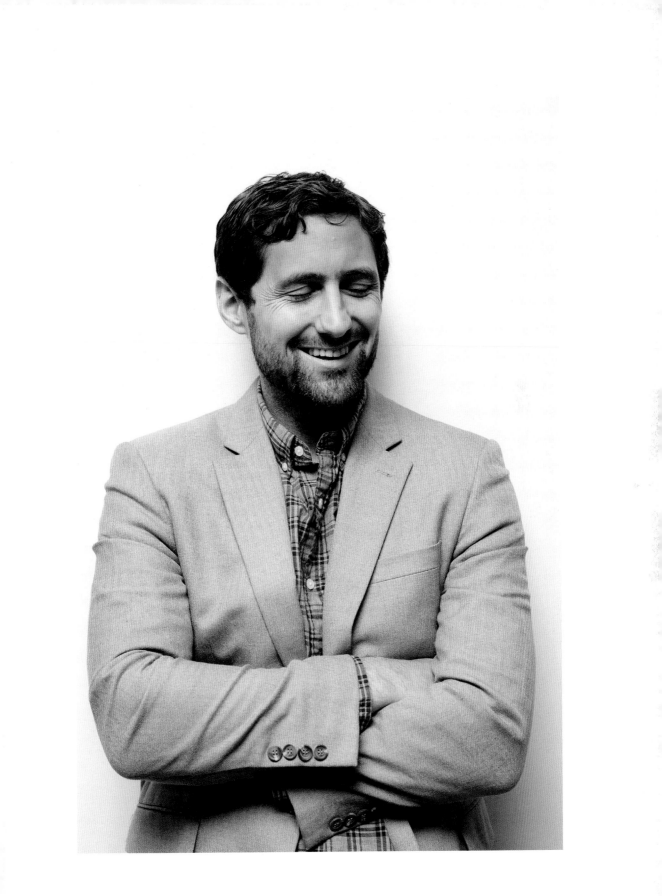

SCOTT CHESHIRE · PHIL KLAY

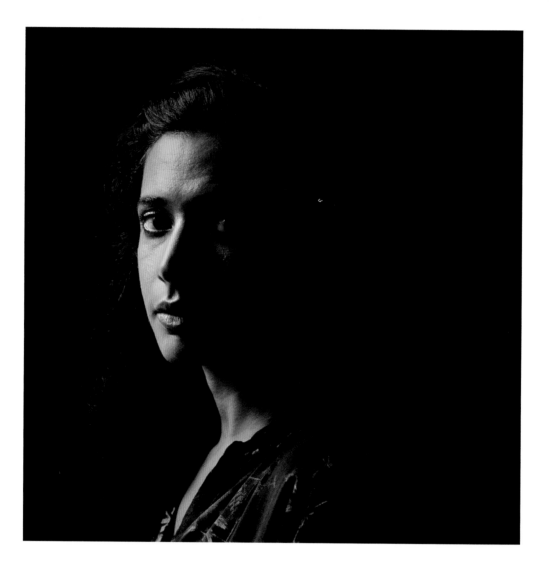

HALA ALYAN

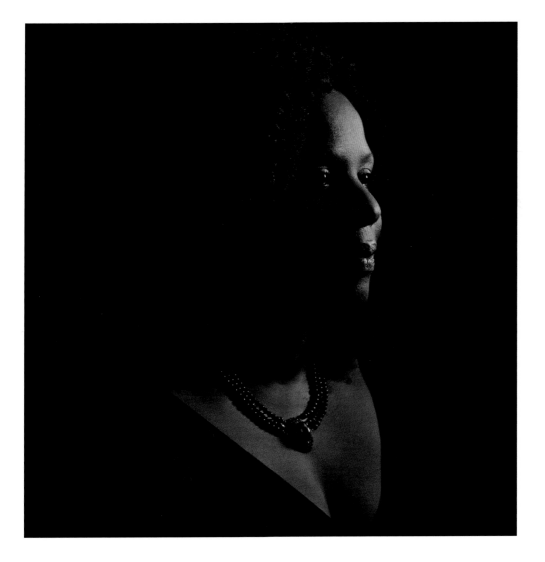

TAYARI JONES

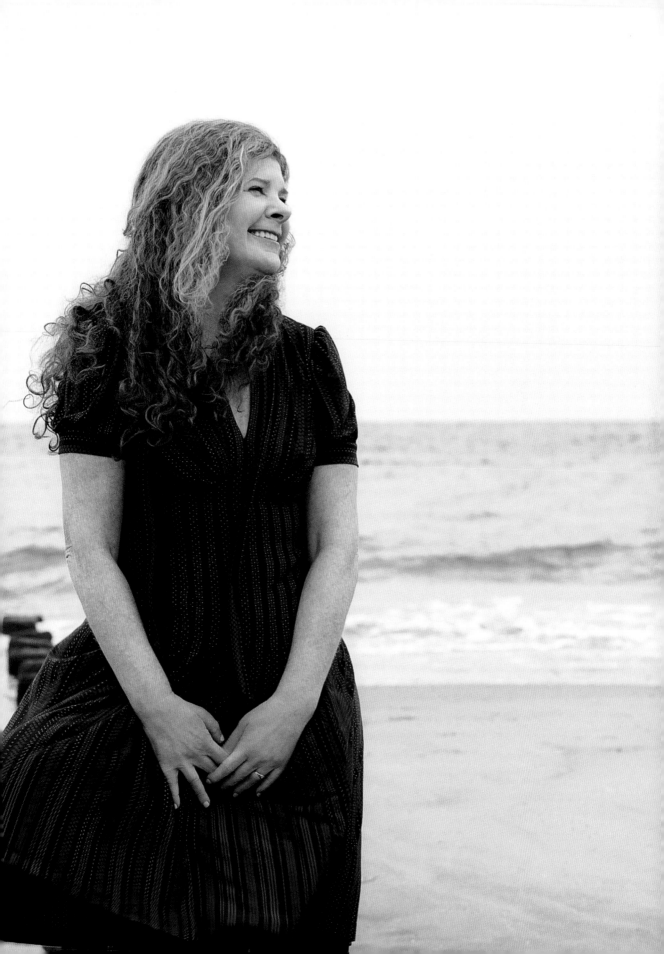

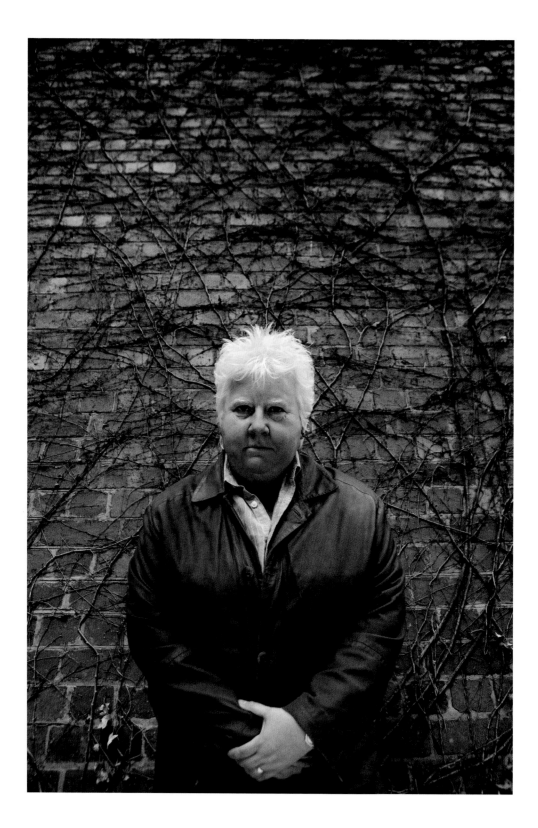

VAL McDERMID · AUGUST KLEINZAHLER
PREVIOUS: JILL EISENSTADT

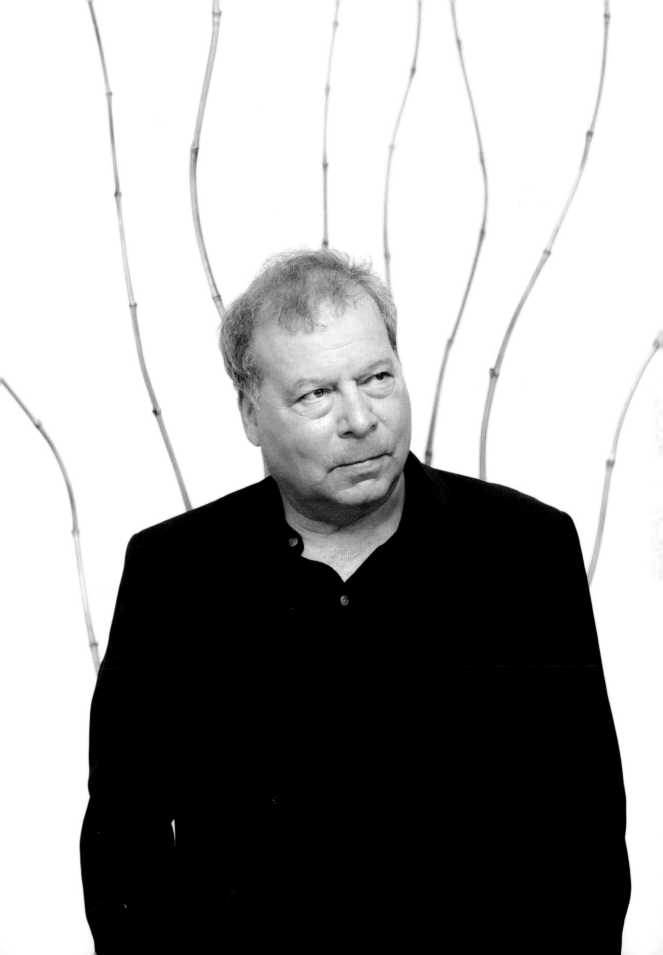

MASHA GESSEN

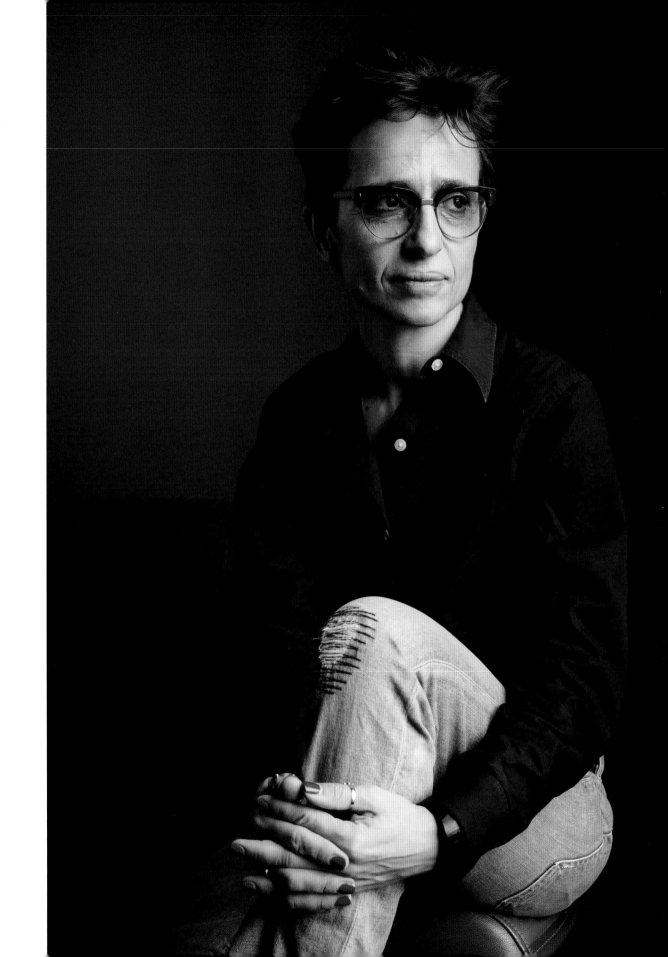

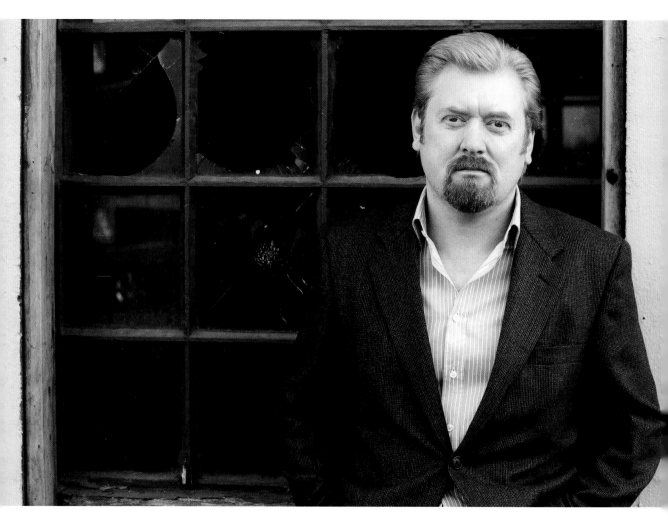

R.J. ELLORY

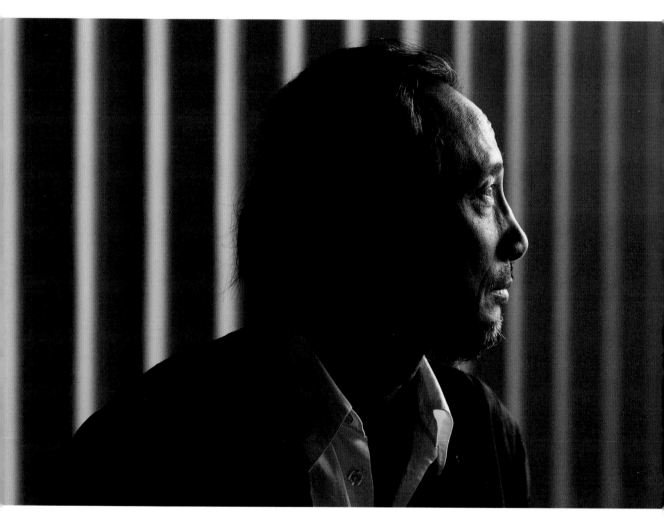

MA JIAN

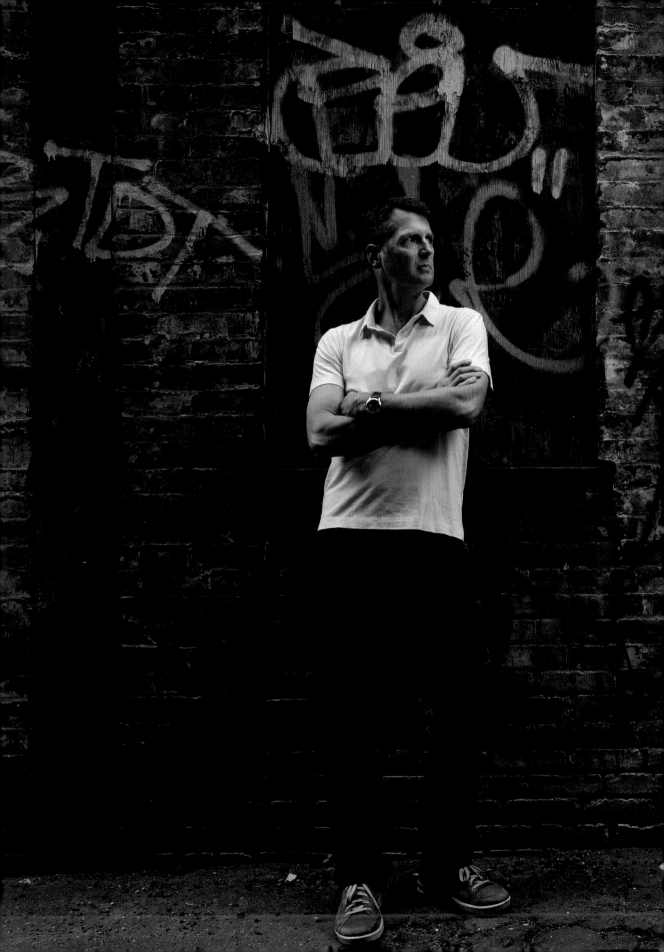

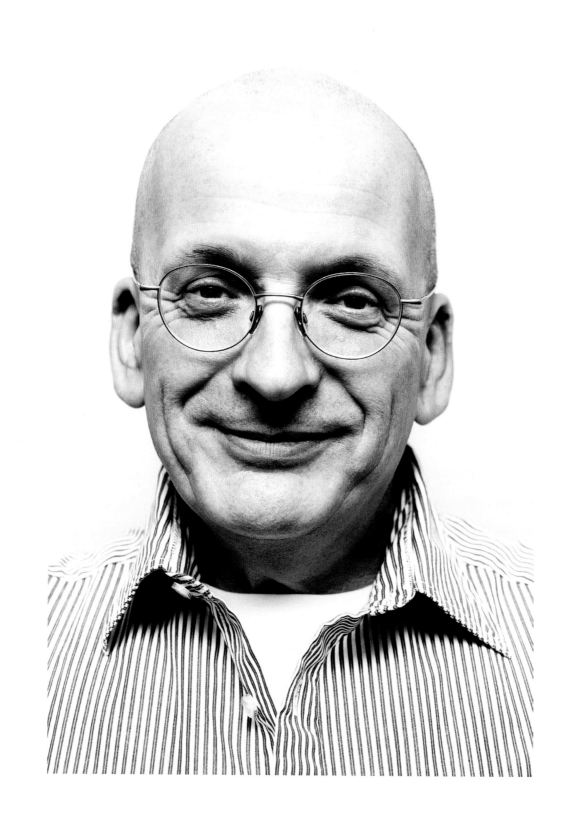

RODDY DOYLE
PREVIOUS: NEAL THOMPSON

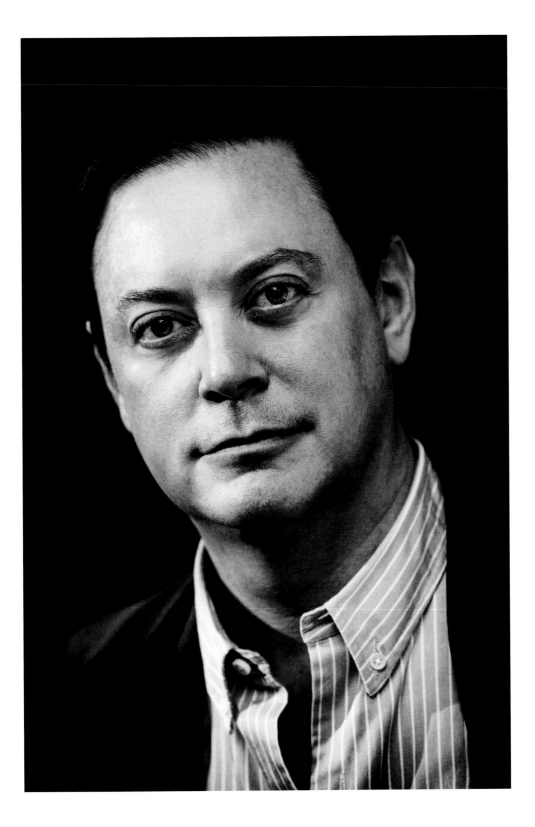

ANDREW SOLOMON

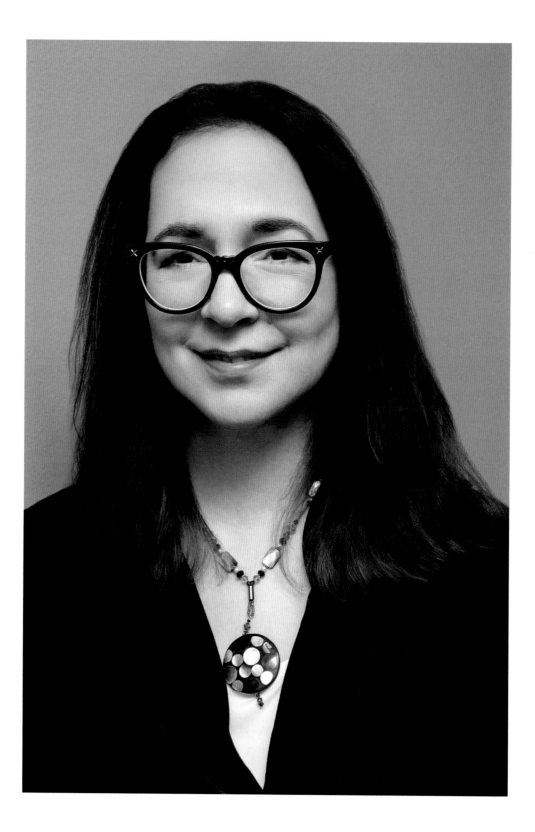

LORRIE MOORE

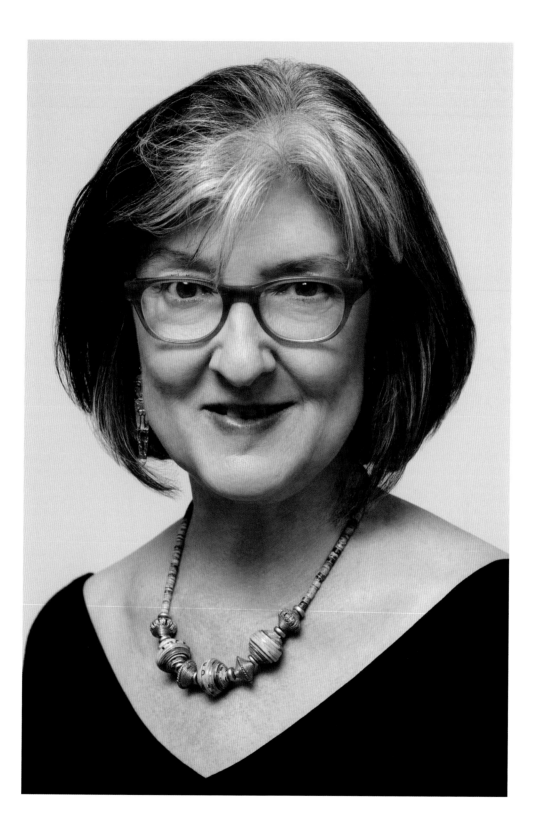

BARBARA KINGSOLVER

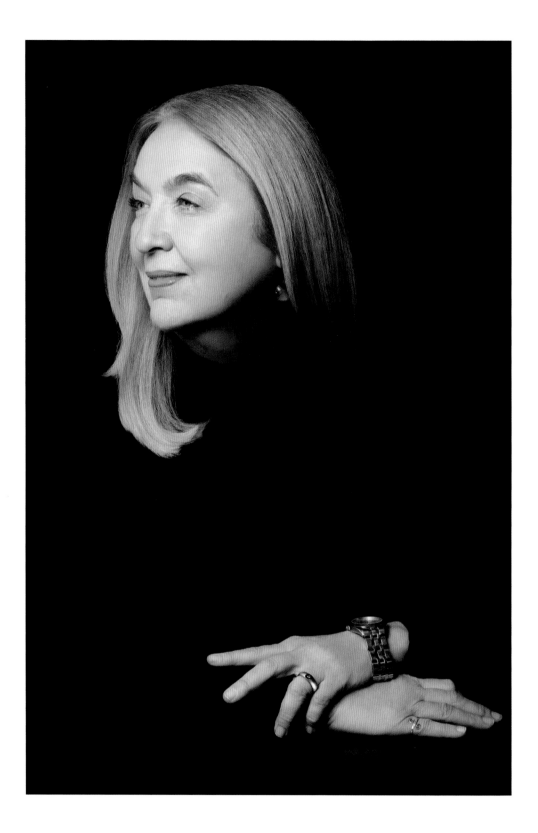

ANN HOOD

TÉA OBREHT

DAVID TOMAS MARTINEZ

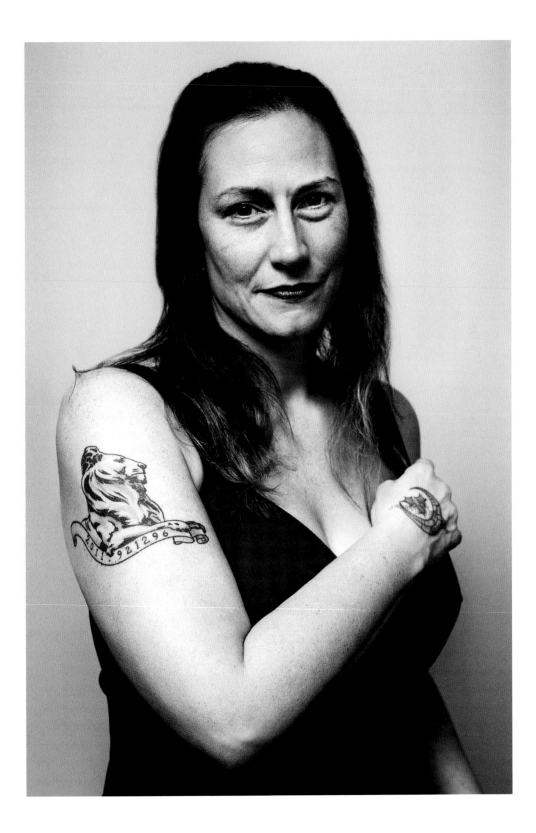

VANESSA VESELKA

BINYAVANGA WAINAINA

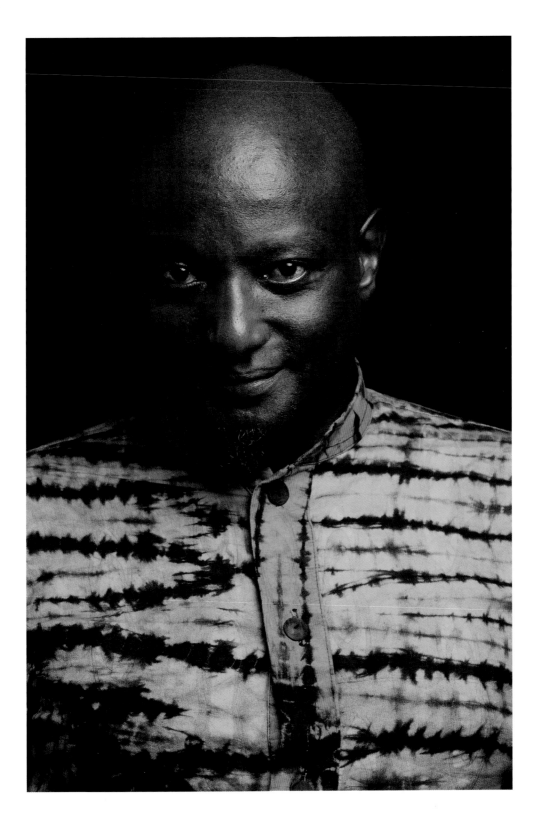

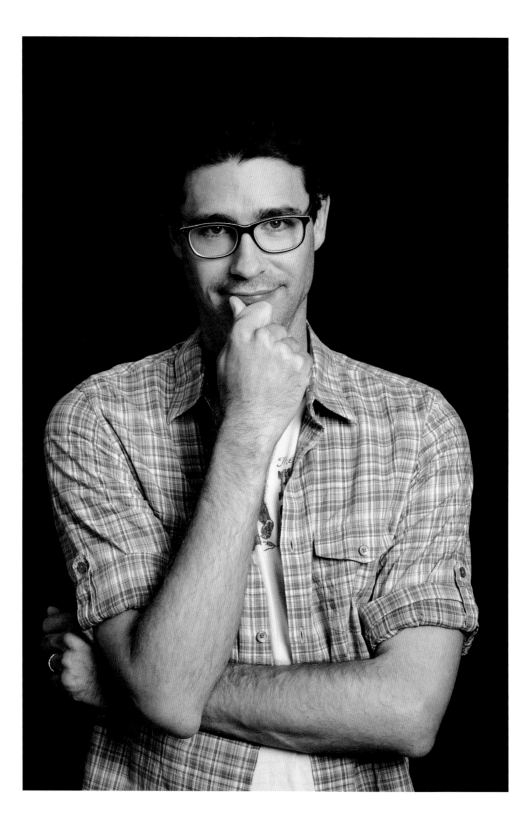

JOSHUA FERRIS

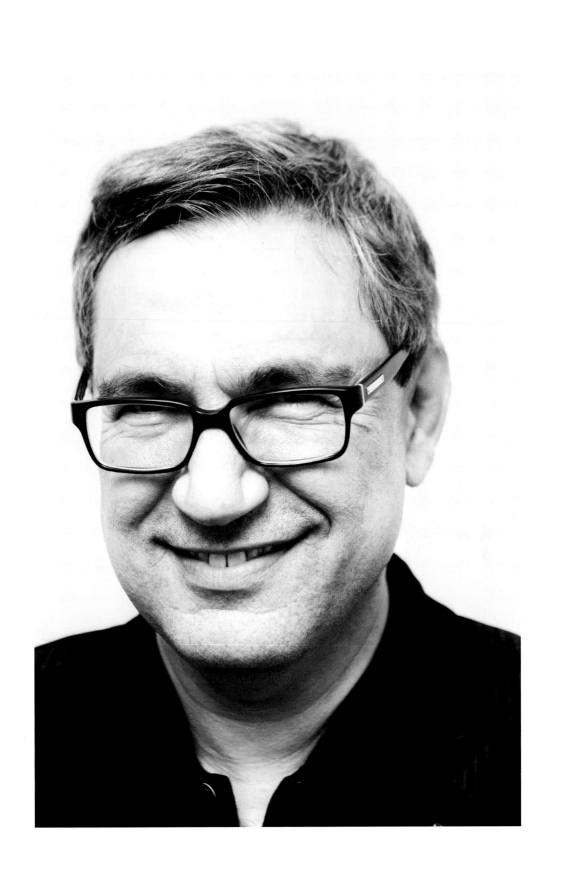

ORHAN PAMUK

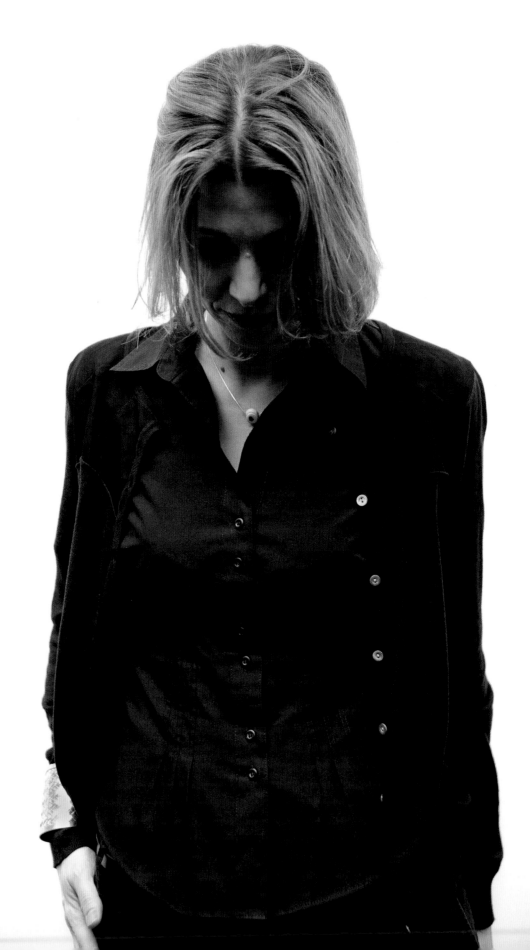

ELIF SHAFAK · ELIF BATUMAN

GARTH RISK HALLBERG

RICHARD FLANAGAN

DBC PIERRE · NICOLE SEALEY

HERTA MÜLLER · FRANCINE PROSE

FRANCISCO CANTÚ

RICH BENJAMIN

IRVINE WELSH
PREVIOUS: RUBY NAMDAR · JELANI COBB

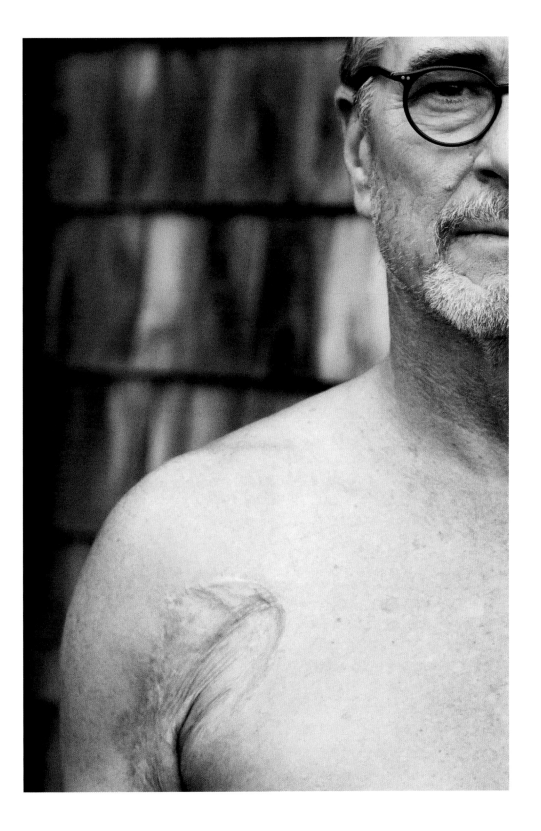

TOM BODETT

COLSON WHITEHEAD

ENRIQUE VILA-MATAS · ADAM HASLETT

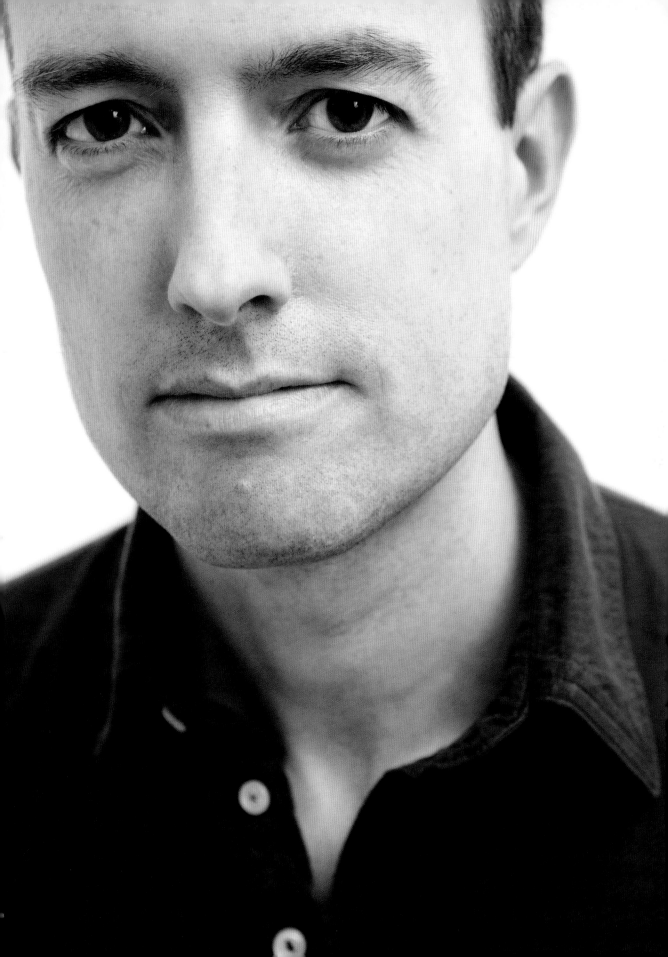

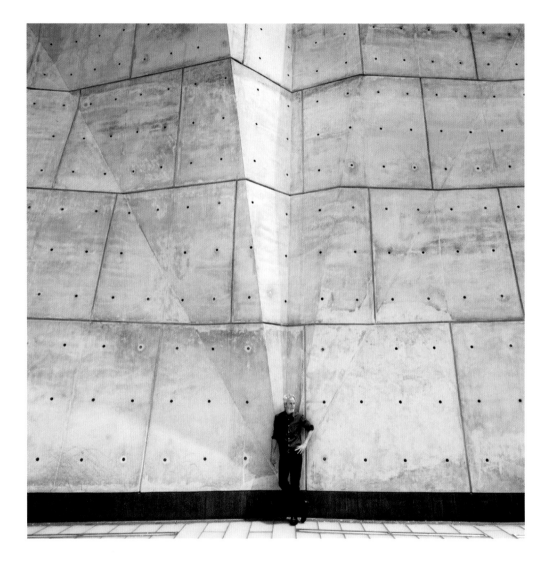

MICHAEL COFFEY · TISHANI DOSHI

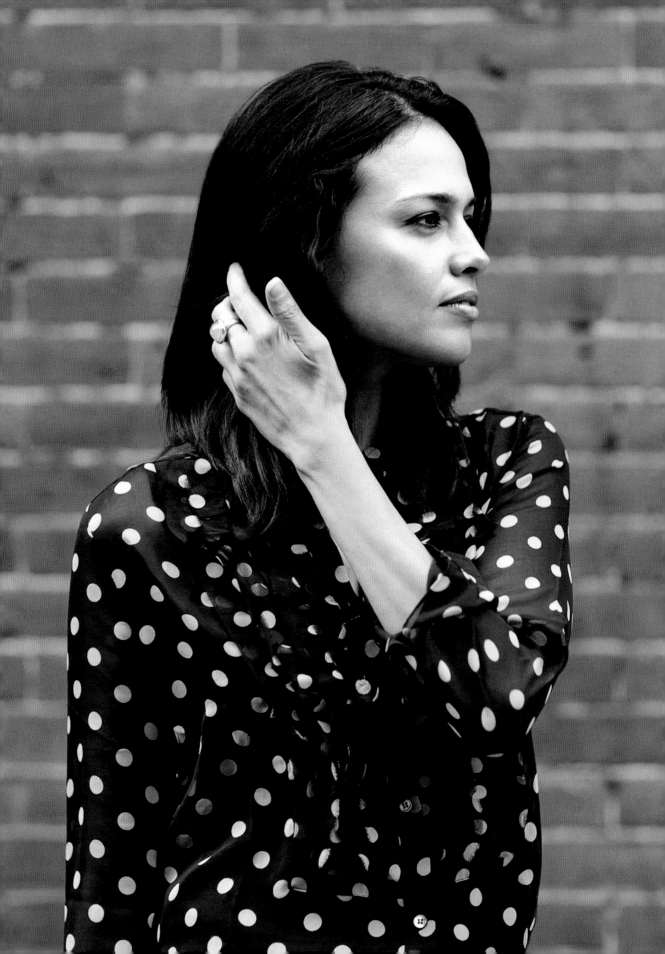

DANIEL KEHLMANN

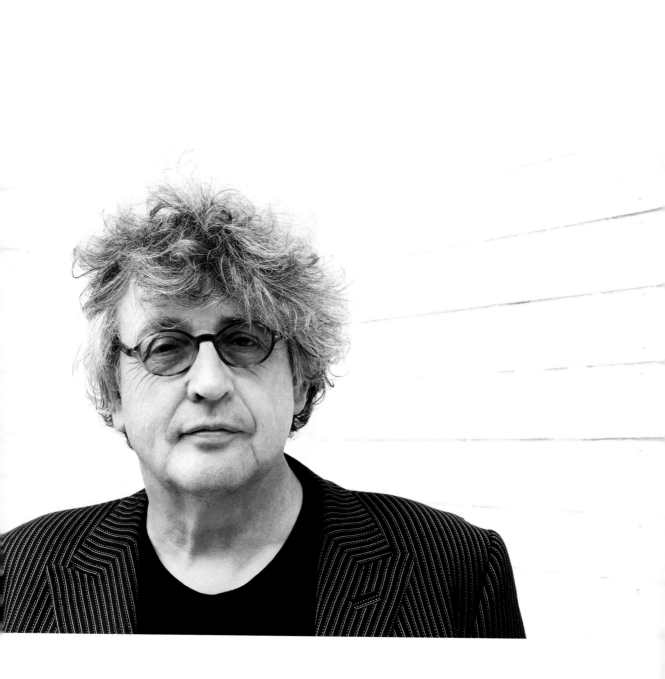

PAUL MULDOON · YUSEF KOMUNYAKAA

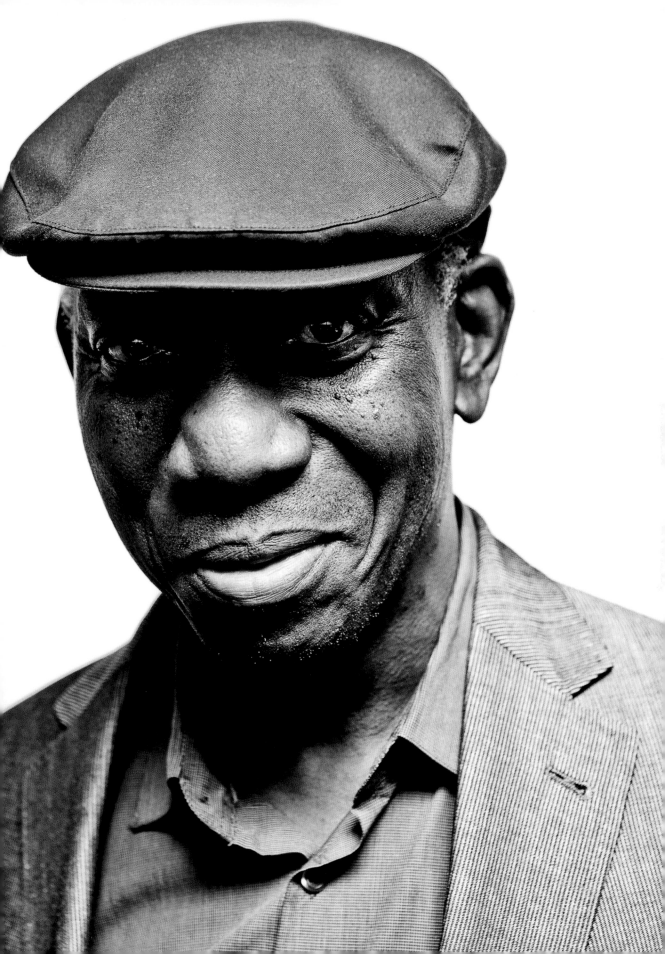

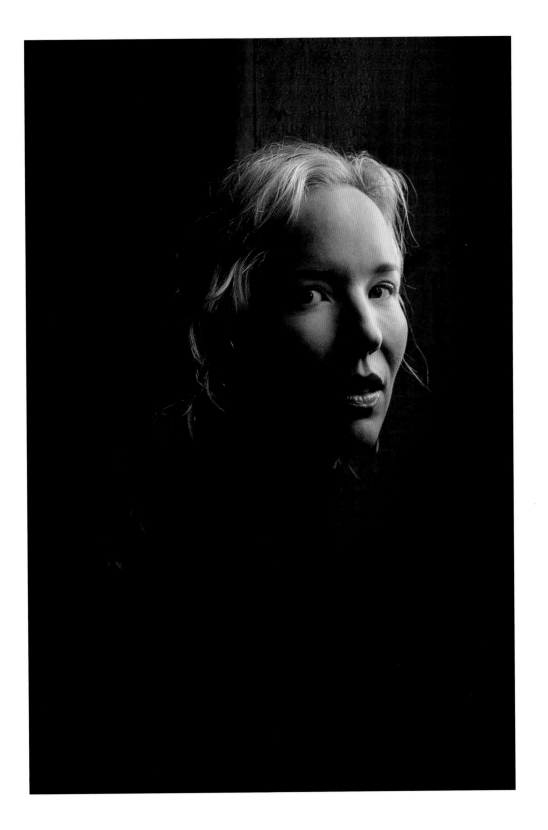

ALEX MAR · REBECCA DONNER

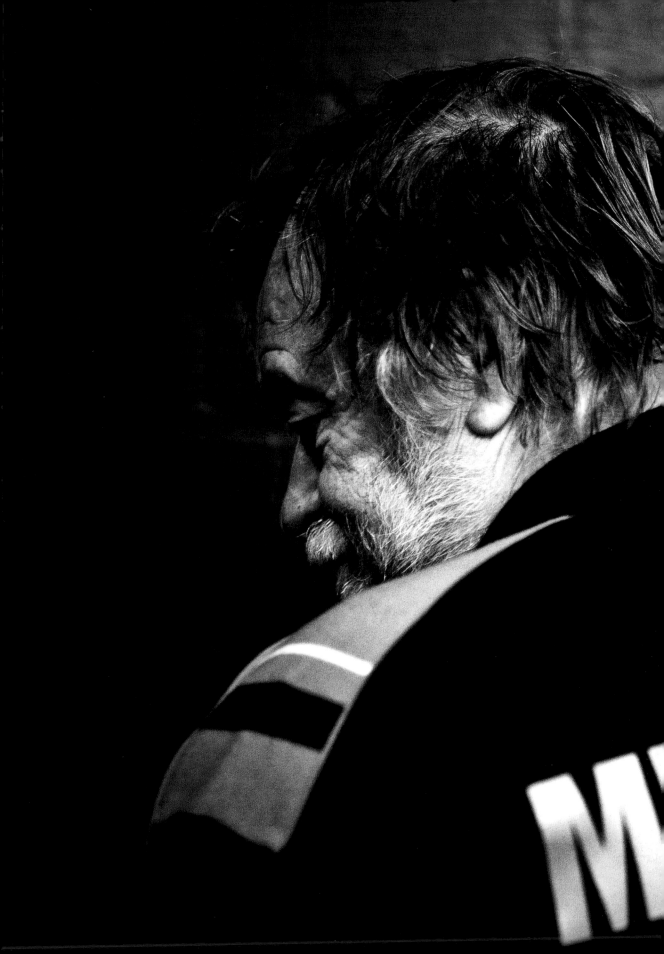

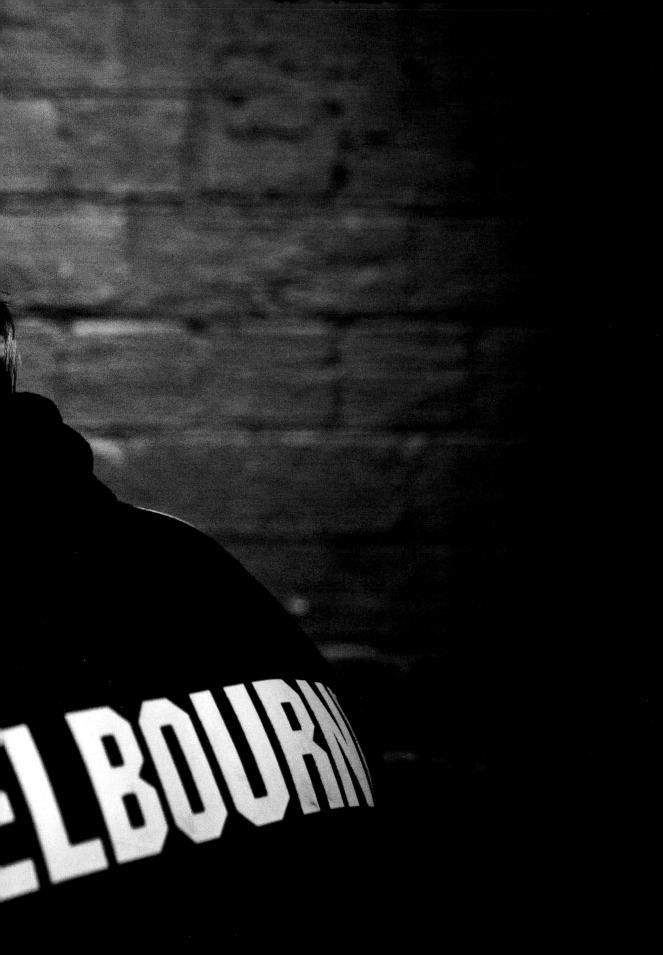

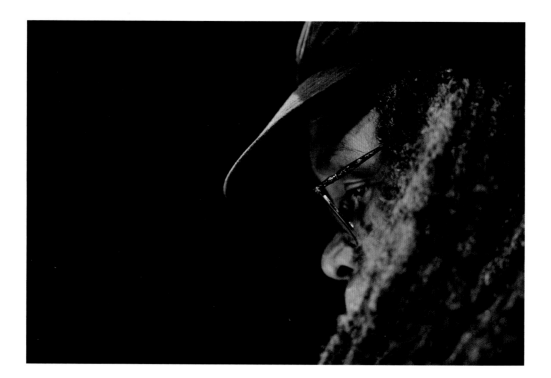

SONIA SANCHEZ · AMIRI BARAKA
PREVIOUS: BARRY DICKINS

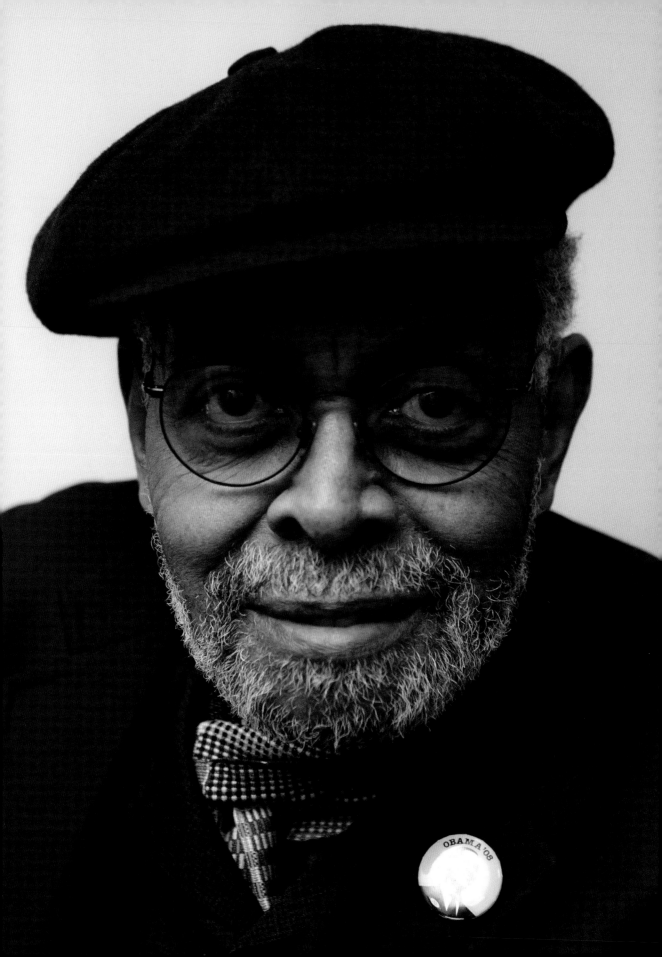

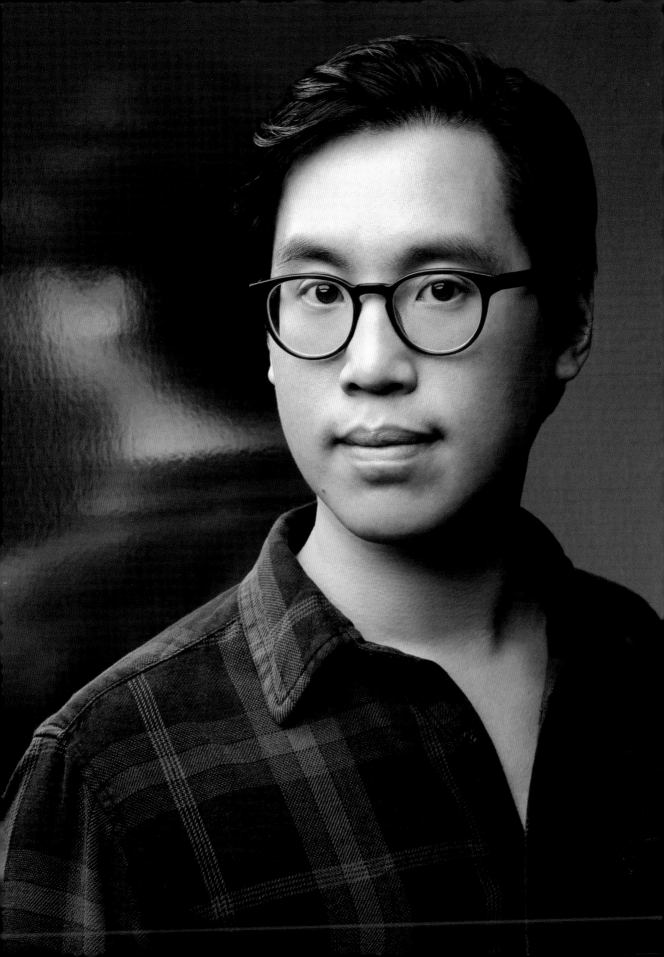

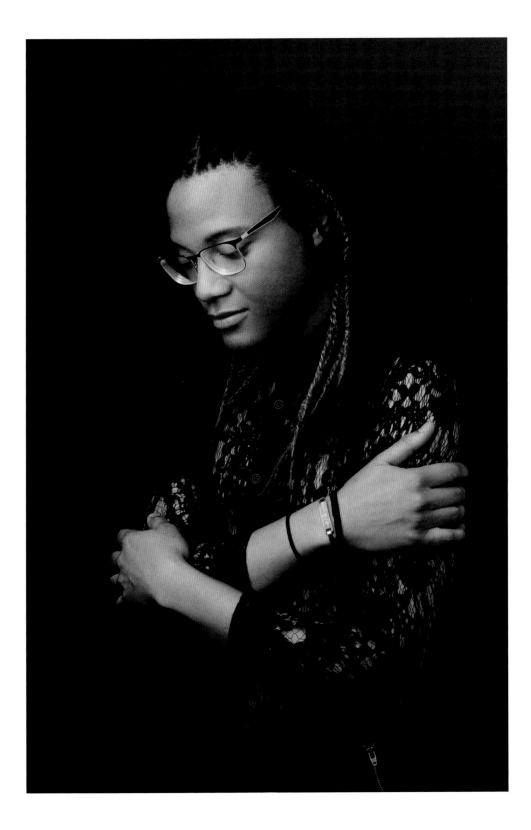

TONY TULATHIMUTTE · RICKEY LAURENTIIS

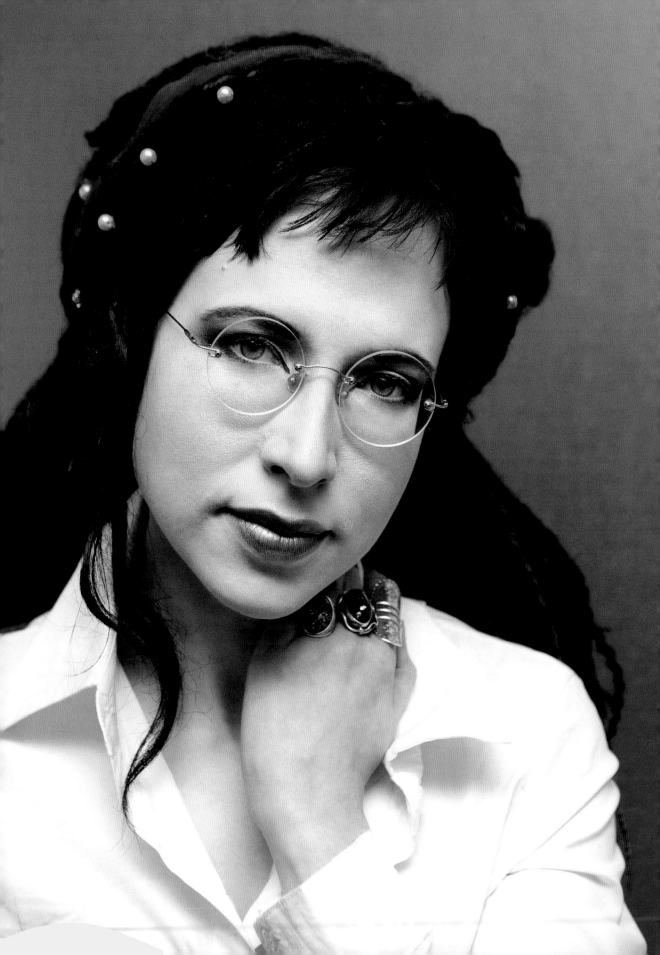

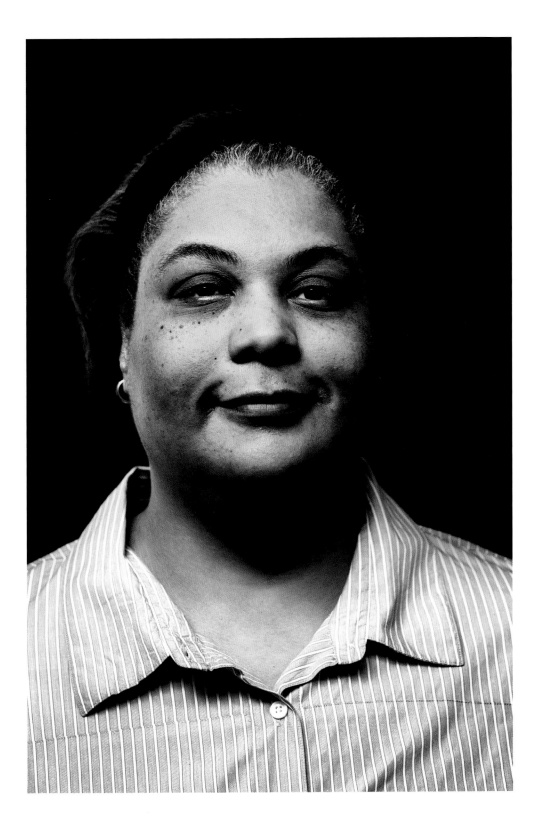

SOFI OKSANEN · ROXANE GAY

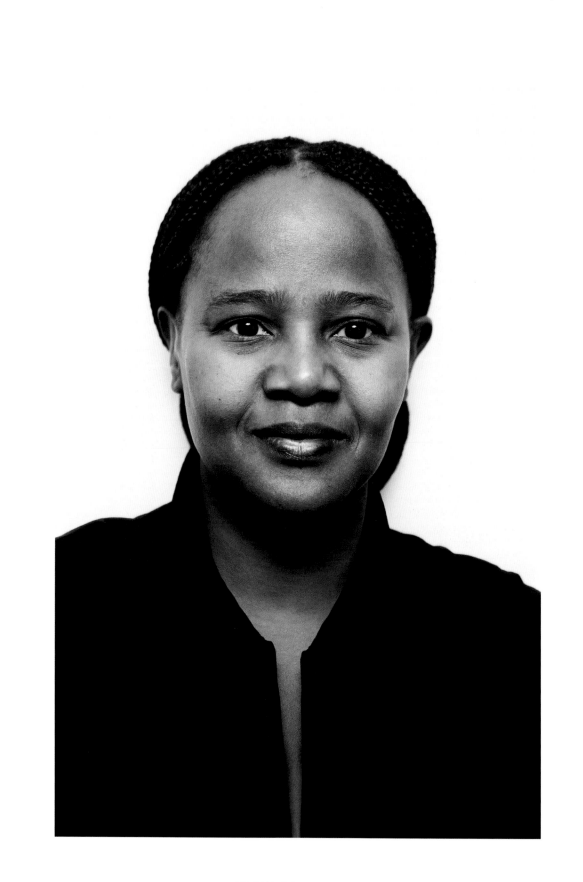

EDWIDGE DANTICAT

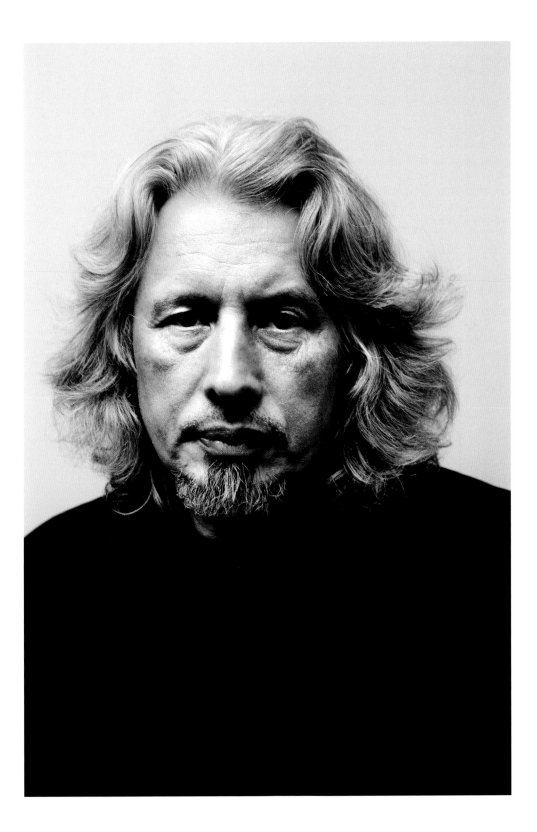

VLADIMIR SOROKIN

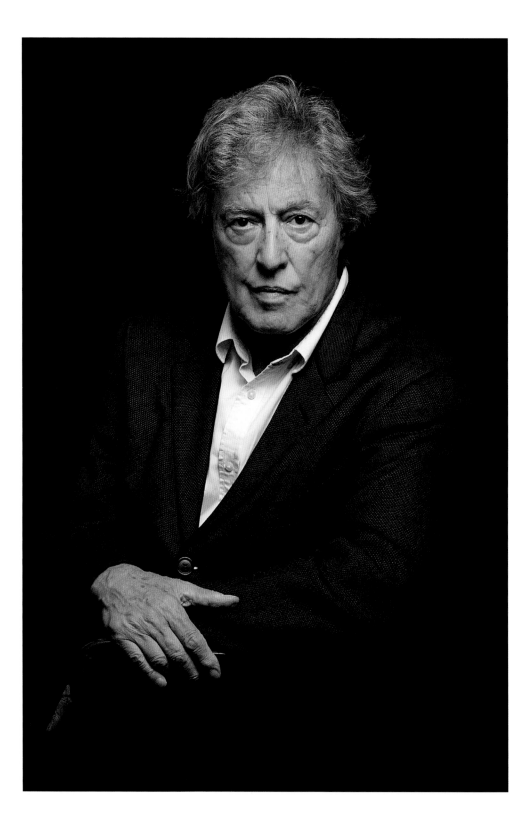

TOM STOPPARD · JENNIFER EGAN

TIM FEDERLE · MARIA DAHVANA HEADLEY

BEN LERNER · KEVIN YOUNG

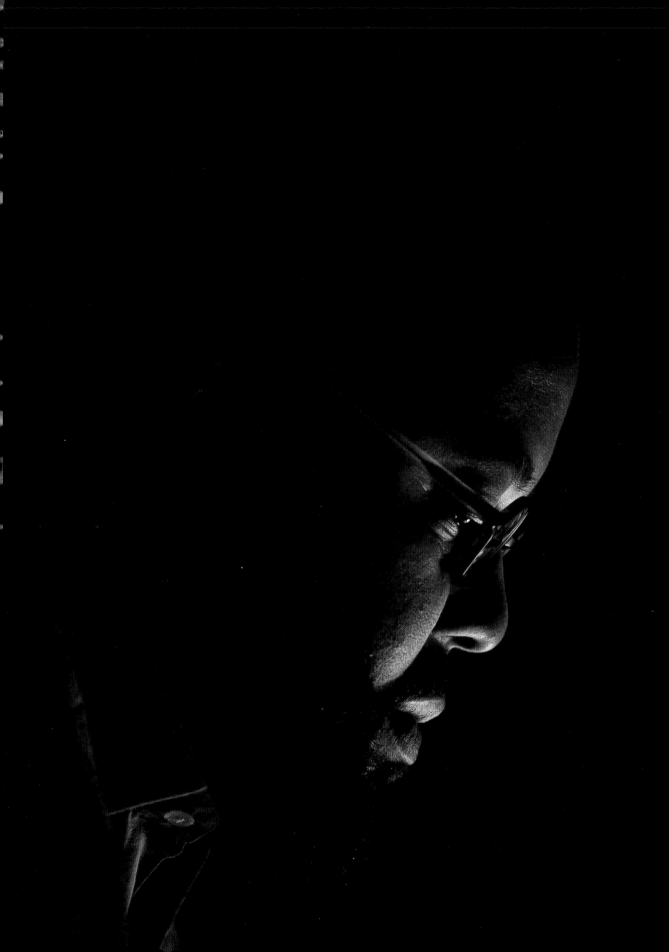

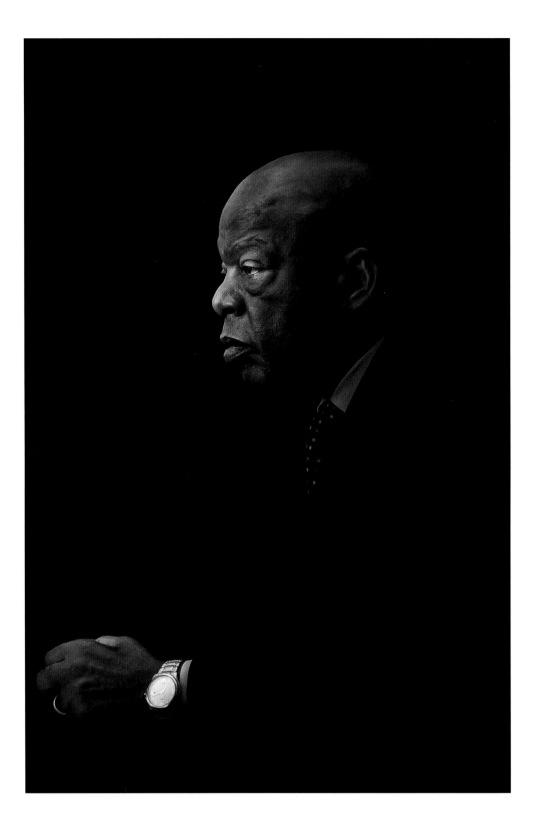

JOHN LEWIS · JOE BIDEN

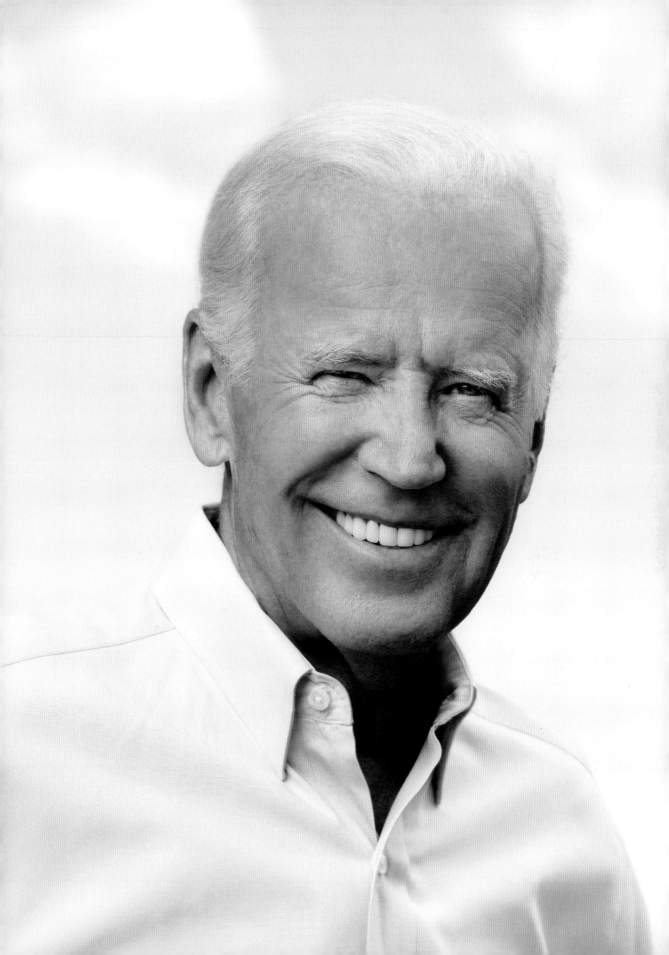

EMMA STRAUB

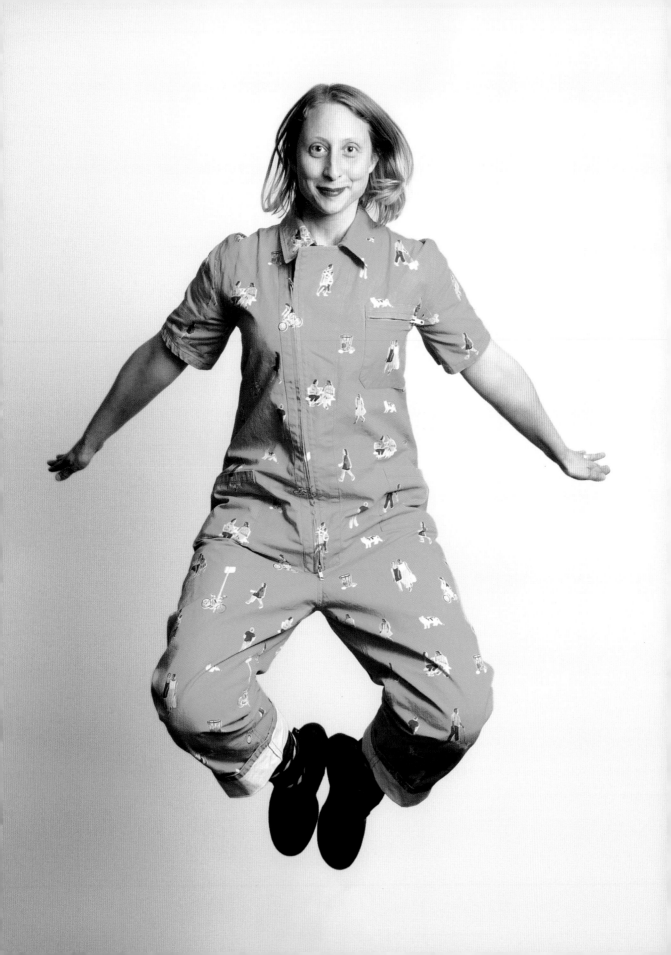

BIBLIOGRAPHY

Chinua Achebe
Marriage Is a Private Affair; Dead Men's Path; The Sacrificial Egg and Other Stories; Things Fall Apart; No Longer at Ease; Arrow of God; The Novelist as Teacher; The Voter; A Man of the People; Chike and the River; How the Leopard Got His Claws; Christmas in Biafra, and Other Poems; Morning Yet on Creation Day; Girls at War and Other Stories; The Flute; An Image of Africa: Racism in Conrad's "Heart of Darkness"; The Drum; The Trouble with Nigeria; Anthills of the Savannah; Hopes and Impediments: Selected Essays; Another Africa; Home and Exile; Collected Poems; The Education of a British-Protected Child; Refugee Mother and Child; Vultures; There Was a Country: A Personal History of Biafra

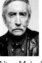

André Aciman
Out of Egypt; False Papers: Essays on Exile and Memory; The Proust Project; Call Me by Your Name; Eight White Nights; Alibis: Essays on Elsewhere; Harvard Square; Enigma Variations

Chimamanda Ngozi Adichie
Purple Hibiscus; Half of a Yellow Sun; The Thing Around Your Neck; Americanah; We Should All Be Feminist; Dear Ijeawele, or a Feminist Manifesto in Fifteen Suggestions

Adonis
The Blood of Adonis: Transpositions of Selected Poems of Adonis; Transformations of the Lover; An Introduction to Arab Poetics; The Pages of Day and Night; If Only the Sea Could Sleep; A Time Between Ashes and Roses; Sufism and Surrealism; Mihyar of Damascus: His Songs; Victims of a Map: A Bilingual Anthology of Arabic Poetry; Adonis: Selected Poems; Violence and Islam: Conversations with Houria Abdelouahed

Edward Albee
The Zoo Story; The Death of Bessie Smith; The Sandbox; Fam and Yam; The American Dream; Bartleby; Who's Afraid of Virginia Woolf?; The Ballad of the Sad Café; Tiny Alice; Malcolm; A Delicate Balance; Breakfast at Tiffany's; Everything in the Garden; Box; Quotations from Chairman Mao Tse-Tung; All Over; Seascape; Listening; Counting the Ways; The Lady of Dubuque; Lolita; The Man Who Had Three Arms; Finding the Sun; Walking; Envy; Marriage Play; Three Tall Women; The Lorca Play; Fragments; The Play about the Baby; The Goat, or Who Is Sylvia?; Occupant; Knock! Knock! Who's There?; Stretching My Mind: Essays 1960–2005; At Home at the Zoo; Me Myself and I

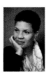

Michelle Alexander
The New Jim Crow: Mass Incarceration in the Age of Colorblindness

Hilton Als
The Women; Our Town: Images and Stories from the Museum of the City of New York; David Salle: Bears/Interiors; Peter Doig: No Foreign Land; Kara Walker: Dust Jackets for the Niggerati; White Girls; Robert Gober: The Heart Is Not a Metaphor; Forces in Nature; 700 Nimes Road; Julian Schnabel: New Plate Paintings; Alice Neel: Colored People; The Group

Hala Alyan
Atrium; Four Cities; Hijra; Salt Houses; The Twenty-Ninth Year

Jonathan Ames
I Pass Like Night; The Extra Man; Wake Up Sir!; What's Not to Love; My Less Than Secret Life; I Love You More Than You Know; The Double Life Is Twice as Good: Essays and Fiction; Bored to Death: A Noir-otic Story; You Were Never Really Here; The Alcoholic

Margaret Atwood
Double Persephone; Kaleidoscopes Baroque: a poem; Talismans for Children; The Circle Game; Expeditions; Speeches for Doctor Frankenstein; The Edible Woman; The Animals in That Country; The Journals of Susanna Moodie; Procedures for Underground; Power Politics; Surfacing; Survival: A Thematic Guide to Canadian Literature; You are Happy; Lady Oracle Selected Poems; Days of the Rebels 1815–1840; Marsh, Hawk; Dancing Girls; Up in the Tree; Two-Headed Poems; Life Before Man; Anna's Pet; True Stories; Bodily Harm; Notes Towards a Poem that Can Never Be Written; Second Words: Selected Critical Prose; Encounters with the Element Man; Murder in the Dark; Unearthing Suite; Snake Poems; Love Songs of a Terminator; Bluebeard's Egg; Interlunar; The Handmaid's Tale; Selected Poems II: Poems Selected and New, 1976–1986; Cat's Eye; For the Birds; Selected Poems 1966–1984; Wilderness Tips; Margaret Atwood Poems 1976–1986; Good Bones; The Robber Bride; Princess Prunella and the Purple Peanut; Strange Things: The Malevolent North in Canadian Literature; Morning in the Burned House; Alias Grace; Eating Fire, Selected Poetry 1965–1995; The Blind Assassin; Negotiating with the Dead: A Writer on Writing; Rude Ramsay and the Roaring Radishes; Oryx and Crake; Moving Targets: Writing with Intent 1982–2004; Bottle; The Penelopiad; Bashful Bob and Doleful Dorinda; Curious Pursuits: Occasional Writing; Writing with Intent: Essays, Reviews, Personal Prose 1983–2005; The Tent; Moral Disorder; The Door; Payback: Debt and the Shadow Side of Wealth; The Year of the Flood; Wandering Wenda and Widow Wallop's Wunderground Washery; In Other Worlds: SF and Human Imagination; I Dream of Zenia with the Bright Red Teeth; MaddAddam; Stone Mattress: Nine Tales; The Heart Goes Last; Hag-Seed; Angel Catbird

Paul Auster
Unearth; Wall Writing; Fragments from the Cold; Facing the Music; White Spaces; The Invention of Solitude; Squeeze Play; The New York Trilogy; In the Country of Last Things; Disappearances; Selected Poems; Moon Palace; The Music of Chance; Auggie

Wren's Christmas Story; Ground Work: Selected Poems and Essays 1970-1979; Leviathan; The Red Notebook; Why Write?; The Art of Hunger; Mr. Vertigo; Hand to Mouth; Timbuktu; The Book of Illusions; The Story of My Typewriter; Oracle Night; The Brooklyn Follies; Collected Prose; Travels in the Scriptorium; Collected Poems; Man in the Dark; Invisible; Sunset Park; Winter Journal; Day/Night; Here and Now: Letters, 2008–2011; Report from the Interior; A Life from the Interior; A Life in Words: In Conversation with I. B. Siegumfeldt; 4 3 2 1; It Don't Mean a Thing

Nicholson Baker

The Mezzanine: A Novel; Room Temperature; U and I: A True Story; Vox: A Novel; The Fermata; The Size of Thoughts: Essay and Other Lumber; The Everlasting Story of Nory; Double Fold: Libraries and the Assault on Paper; A Box of Matches; Checkpoint; The World on Sunday: Graphic Art in Joseph Pulitzer's Newspapers (1898-1911); Human Smoke: The Beginnings of World War II, the End of Civilization; The Anthologist; House of Holes: A Book of Raunch; The Way the World Works: Essays; Travelling Sprinkler; Substitute: Going to School with a Thousand Kids

David Baldacci

Absolute Power; Total Control; The Winner; The Simple Truth; Saving Faith; Wish You Well; Last Man Standing; The Christmas Train; Split Second; Hour Game; The Camel Club; The Collectors; Fries Alive; Stone Cold; Simple Genius; The Whole Truth; Divine Justice; The Mystery of Silas Finklebean; First Family; True Blue Deliver Us From Evil; Hell's Corner; The Sixth Man; Zero Day; One Summer; No Time Left; The Forgotten; The Innocent; The Hit; King and Maxwell; Day of Doom; The Escape; Bullseye; The Target; The Finisher; The Guilty; Memory Man; The Keeper; The Last Mile; No Man's Land; End Game; The Fix; The Width of the World; The Fallen

Amiri Baraka

Preface to a Twenty Volume Suicide Note; Blues People; The Dead Lecturer: Poems; Dutchman; The Slave; The System of Dante's Hell; Home: Social Essays; The Revolutionary Theatre; A Black Mass; The Baptism and The Toilet; Tales; Home on the Range and Police; Black Music; Four Black Revolutionary Plays; Black Magic; It's Nation Time; Slave Ship; Raise Race Rays Raze: Essays Since 1965; Kawaida Studies: The New Nationalism; Hard Facts, The Motion of History and Other Plays; Poetry for the Advanced; New Music, New Poetry; Reggae or Not!; Daggers and Javelins: Essays 1974–1979; The Autobiography of LeRoi Jones; The Music: Reflections on Jazz and Blues; Song; Transbluesency: The Selected Poems of Amiri Baraka/LeRoi Jones; Wise, Why's Y's; Funk Lore: New Poems 1984–1994; Jesse Jackson and Black People; Somebody Blew Up America & Other Poems; The Essence of Reparations; The Book of Monk; Tales of the Out & the Gone; Digging:

The Afro-American Soul of Classical Music; Most Dangerous Man in America (W.E.B. Du Bois); SOS: Poems, 1961-2003

Clare Barron

Solar Plexus; You Got Older; Dirty Crusty; Baby Screams Miracle; a boy put this girl in a cage with a dog and the dog killed the girl; I'll Never Love Again; Dance Nation

Elif Batuman

The Possessed: Adventures with Russian Books and the People Who Read Them; The Idiot

Ishmael Beah

A Long Way Gone: Memoirs of a Boy Soldier; Radiance of Tomorrow

Rich Benjamin

Faded Colors; Searching for Whitopia: An Improbable Journey to the Heart of White America

Joe Biden

Promises to Keep: On Life and Politics; Promise Me, Dad: A Year of Hope, Hardship, and Purpose

Charles M. Blow

Fire Shut Up in My Bones: A Memoir

Charles Bock

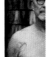

Beautiful Children; Alice & Oliver

Tom Bodett

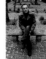

As Far as You Can Go Without a Passport; Small Comforts; The End of the Road; The Big Garage on Clearshot; The Free Fall of Webster Cummings; America's Historic Trails; Williwaw!; Norman Tuttle on the Last Frontier

Mirko Bonné

Langrenus; Gelenkiges Geschöpf; Der junge Fordt; Ein langsamer Sturz; Hibiskus Code; Der eiskalte Himmel; Die Republik der Silberfische; Wie wir verschwinden; Ausflug mit dem Zerberus; Der Eichelhäher

Nora Bossong

Gegend: Reglose Jagd: Gedichte; Webers Protokoll; Sommer vor den Mauern: Gedichte; Gesellschaft mit beschränkter Haftung: 36,9°: Rotlicht

Giannina Braschi

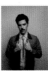

Empire of Dreams; Yo-Yo Boing!; United States of Banana

Francisco Cantú

The Line Becomes a River: Dispatches from the Border

Anne Carson

Eros the Bittersweet: An Essay; Short Talks; Glass, Irony and God; Plainwater: Essays and Poetry; Wild Workshop; Autobiography of Red: A Novel in Verse; Economy of the Unlost: Reading Simonides of Ceos with Paul Celan; Men in the Off Hours; The Beauty of the Husband: A Fictional Essay in 29 Tangos; If Not Winter: Fragments of Sappho, Wonderwater (Alice Offshore); Decreation: Poetry, Essays, Opera; NOX; Antigonick; Red Doc>; The Albertine Workout; Nay Rather; Float; Watchkeepers

Ron Chernow

The House of Morgan: An American Banking Dynasty and the Rise of Modern Finance; The Warburgs: The Twentieth-Century Odyssey of a Remarkable Jewish Family; The Death of the Banker: The Decline and Fall of the Great Financial Dynasties and the Triumph of the Small Investor; Titan: The Life of John D. Rockefeller, Sr.; Alexander Hamilton; Washington: A Life; Grant

Scott Cheshire

High as the Horses' Bridles

Maureen Chiquet

Beyond the Label: Women, Leadership, and Success on Our Own Terms

Noam Chomsky

Aspects of the Theory of Syntax; Cartesian Linguistics: A Chapter in the History of Rationalist Thought; American Power and the New Mandarins; At War with Asia; Problems of Knowledge and Freedom; Selected Readings; Studies on Semantics in Generative

Grammar; Language and Mind; For Reasons of State; Peace in the Middle East? Reflections on Justice and Nationhood; Questions of Form and Interpretation; Reflections on Language; The Logical Structure of Linguistic Theory; Essays on Form and Interpretation; Topics in the Theory of Generative Grammar; Syntactic Structures; Morphophonemics of Modern Hebrew; Language and Responsibility; Towards a New Cold War: Essays on the Current Crisis and How We Got There; Rules and Representations; Some Concepts and Consequences of the Theory of Government and Binding; Radical Priorities; Rules and Representations; The Fateful Triangle: The United States, Israel, and the Palestinians; Modular Approaches to the Study of the Mind; Knowledge and Language: Its Nature, Origin, and Use; Barriers; Turning the Tide: U.S. Intervention in Central America and the Struggle for Peace; Language and Problems of Knowledge; On Power and Ideology: The Managua Lectures; The Culture of Terrorism; Current Issues in Linguistic Theory; Manufacturing Consent: The Political Economy of the Mass Media; Language and Politics; The Sound Pattern of English; Necessary Illusions: Thought Control in Democratic Societies; Terrorizing the Neighborhood: American Foreign Policy in the Post–Cold War Era; Deterring Democracy; Review of Verbal Behavior by B. F. Skinner; What Uncle Sam Really Wants; Letters from Lexington: Reflections on Propaganda; Year 501: The Conquest Continues; Rethinking Camelot: JFK, the Vietnam War, and U.S. Political Culture; The Prosperous Few and the Restless Many; Secrets, Lies and Democracy; Keeping the Rabble in Line: Interviews with David Barsamian; Media Control: The Spectacular Achievements in Propaganda; World Orders, Old and New; Language and Thought; Pirates and Emperors: International Terrorism in the Real World; The Minimalist Program; The Cold War and the University: Toward an Intellectual History of the Postwar Years; Powers and Prospects: Reflections on Human Nature and the Social Order; Objectivity and Liberal Scholarship; Perspectives on Power: Reflections on Human Nature and the Social Order; The Common Good; Profit over People: Neoliberalism and Global Order; The Umbrella of U. S. Power: The Universal Declaration of Human Rights and the Contradictions of U. S. Policy; The New Military Humanism: Lessons from Kosovo; Latin America: From Colonization to Globalization; New Horizons in the Study of Language and Mind; Rogue States: The Rule of Force in World Affairs; Chomsky on MisEducation; The Architecture of Language; A New Generation Draws the Line: Kosovo, East Timor and the Standards of the West; Propaganda and the Public Mind: Conversations with Noam Chomsky and David Barsamian; 9-11; Understanding Power; Class Warfare: Interviews with David Barsamian; On Nature and Language; Middle East Illusions; Hegemony or Survival: America's Quest for Global Dominance; Government in the Future; Chomsky on Anarchism; Failed States: The Abuse of Power and the Assault on Democracy; Perilous Power: The Middle East and U. S. Foreign Policy Dialogues on Terror, Democracy, War, and Justice; The Chomsky-Foucault Debate: On Human Nature; Interventions;

Chomsky Notebook; Power and Terror: Conflict, Hegemony, and the Rule of Force; How the World Works; Making the Future: Occupations, Interventions, Empire and Resistance; The Science of Language: Interviews with James McGilvray; Occupy: Reflections on Class War, Rebellion and Solidarity; Masters of Mankind: Essays and Lectures, 1969–2013; What Kind of Creatures Are We?; Because We Say So; Who Rules the World?; On Western Terrorism: From Hiroshima to Drone Warfare; Requiem for the American Dream: The Principles of Concentrated Wealth and Power; Why Only Us? Language and Evolution; The Responsibility of Intellectuals; Yugoslavia: Peace, War, and Dissolution

Jelani Cobb

Antidote to Revolution: African American Anticommunism and the Struggle for Civil Rights 1931-1957; The Essential Harold Cruse; The Devil & Dave Chappelle and Other Essays; To the Break of Dawn: A Freestyle on the Hip Hop Aesthetic; The Substance of Hope: Barack Obama and the Paradox of Progress

Harlan Coben

Play Dead; Miracle Cure; Deal Breaker; Drop Shot; Fade Away; Back Spin; One False Move; The Final Detail; Darkest Fear; Tell No One; Gone for Good; No Second Chance; Just One Look; The Innocent; Promise Me; The Woods; Hold Tight; Long Lost; Caught; Live Wire; Shelter; Stay Close; Seconds Away; Six Years; Missing You; Found; The Stranger; The Magical Fantastical Fridge; Fool Me Once; Home; Don't Let Go

Michael Coffey

27 Men Out: Baseball's Perfect Games; CMYK; 87 North; Elemenopy; The Business of Naming Things; Samuel Beckett Is Closed

Joshua Cohen

The Quorum; Aleph-Bet: An Alphabet for the Perplexed; Cadenza for the Schneidermann Violin Concerto; A Heaven of Others; Bridge & Tunnel; Witz; Four New Messages; Book of Numbers; PCKWCK; Moving Kings; Attention: Dispatches from a Land of Distraction

Teju Cole

Open City; Every Day Is for the Thief; Known and Strange Things; Blind Spot

Edwidge Danticat

Breath, Eyes, Memory; Krik? Krak!; The Farming of Bones; Behind the Mountains; After the Dance: A Walk through Carnival in Jacmel, Haiti; The Dew Breaker; First Person Fiction: Behind the Mountains; Anacaona: Golden Flower, Haiti, 1490; Brother, I'm Dying;

Create Dangerously: The Immigrant Artist at Work; Tent Life: Haiti; Claire of the Sea Light; The Last Mapou; Mama's Nightingale; Untwine; The Art of Death: Writing the Final Story

Lydia Davis

The Thirteenth Woman and Other Stories; Sketches for a Life of Wassilly; Story and Other Stories; Break It Down; The End of the Story; Almost No Memory; Samuel Johnson Is Indignant; Varieties of Disturbance; Proust, Blanchot, and a Woman in Red; The Collected Stories of Lydia Davis; The Cows; Can't and Won't: Stories; The Stripper, the Drug Dealer and the Bishop

Alain de Botton

Essays in Love; On Love; The Romantic Movement; Kiss and Tell; How Proust Can Change Your Life: Not a Novel; The Consolations of Philosophy; The Art of Travel; Status Anxiety; The Architecture of Happiness; A Week at the Airport; The Pleasures and Sorrows of Work; Religion for Atheists: A Non-Believer's Guide to the Uses of Religion; How to Think More About Sex; Art as Therapy; The News: A User's Manual; The Course of Love

Junot Díaz

Drown; The Brief Wondrous Life of Oscar Wao; This Is How You Lose Her; Islandborn

Barry Dickins

Ghosts; A Season of Five Plays; Only an Old Kitbag; The Great Oscar Wilde Trial; The Interview; The Rotten Teeth Show; The Bloody Horror of Dentistry; In Light: Poems; The Ken Wright Show; Doing His Thing; The Banana Bender and The Death of Minnie; Interrogation of an Angel; The Ability to Eat Crow; The Gift of the Gab: Stories from the Life of Barry Dickins; Lennie Lower; A Couple of Broken Hearts; God and Geoff; A Kingly Crown; Graeme King Lear; One Woman Shoe; The Crookes of Epping; The Bridal Suite and Mag and Bag: Two plays; Beautland; Green Room; The Horror of Suburban Nature Strip; Reservoir by Night; The Gummy Man in Search of Love; What the Dickins! A Symposium of Pieces from the Low Life; The Golden Goldenbergs; More Greenroom; Eat Your Greens; The Fool's Shoe Hotel; Royboys; Bedlam Autos; Between Engagements; Ron Truffle: His Life & Bump Out; My Grandmother; Perfect English; Golden Braid; Hymie; A Woman's Tale; You'll Only Go In for Your Mates; I Love To Live: The Fabulous Life of Barry Dickins; A Dickins Christmas; The Foibles; Funny Fiction at La Mama; Post Office Restaurant and Other Stories; Dear Suburbia; Touch Me; My Grandfather: Years of Hope and Vigour; Remember Ronald Ryan; Dame Joan Green; The Australasian Post Great Aussie Beer Guide; Joey: A Dog for All Seasons; Guts and Pity: The Hanging that Ended Capital

Punishment in Australia; La Mama 30th Birthday Celebrations; The House of the Lord; Ordinary Heroes: Personal Recollections of Australians at War; Believe Me Oscar Wilde; Articles of Light: Reflections on Lowlifes, Ratbags and Angels; Go in Tight; Insouciance; Black and Whiteley: Barry Dickins in Search of Brett; Claustrophobia; All of Which Are American Dreams; Tyranny; Myer Emp; The Real Thring; Flashpoint; Unparalleled Sorrow: Finding my Way Back from Depression; See What I'm Talking About; Squizzy; Charles Blackman; Miniatures: Famous and Anonymous Souls I Collided With; Whiteley's Incredible Blue … an hallucination; The Way Out: A Masterpiece by a Dead Goblin; Barry and the Fairies of Miller Street; A Kind of Fabulous Hatred; Lost in Ringwood; Lessons in Humility: 40 Years of Teaching; Footy Works: Australian Football; A Line Drawing of My Father; Ryan; The Mouthless Murderer; Speechless; Last Words: The Hanging of Ronald Ryan; La Mama

Joan Didion

Run, River; Slouching Towards Bethlehem; Play It as It Lays; A Book of Common Prayer; The White Album; Salvador; Joan Didion: Essays & Conversations; Democracy; Miami; After Henry; The Last Thing He Wanted; Political Fictions; Fixed Ideas: America Since 9.11; Where I Was From; Vintage Didion; The Year of Magical Thinking; We Tell Ourselves Stories in Order to Live: Collected Nonfiction; Blue Nights; South and West: From a Notebook

E. L. Doctorow

Welcome to Hard Times; Big as Life; The Book of Daniel; Ragtime; Drinks Before Dinner; Loon Lake; American Anthem; E. L. Doctorow: Essays and Conversations; Lives of the Poets: A Novella and Six Stories; World's Fair; Billy Bathgate; Jack London, Hemingway and the Constitution: Selected Essays 1977-1992; The Waterworks; Conversations with E. L. Doctorow; City of God; Lamentation: 9/11; Reporting the Universe; Sweet Land Stories; The March; Creationists: Selected Essays 1993-2006; Abraham Lincoln; Homer & Langley; Andrew's Brain; All the Time in the World: New and Selected Stories

Rebecca Donner

On the Rocks; Sunset Terrace; Burnout

Ariel Dorfman

How to Read Donald Duck; Hard Rain; The Empire's Old Clothes: What the Lone Ranger, Babar, and Other Innocent Heroes Do to Our Minds; Widows; The Last Song of Manuel Sendero; Last Waltz in Santiago: And Other Poems of Exile and Disappearance; Mascara; My House is On Fire; Some Write to the Future: Essays on Contemporary Latin American Fiction; Death and the Maiden; Konfidenz; Heading

South, Looking North: A Bilingual Journey; The Nanny and the Iceberg; Blake's Therapy; In Case of a Fire in a Foreign Land: New and Collected Poems from Two Languages; Exorcising Terror: The Incredible Unending Trial of Augusto Pinochet; Manifesto for Another World: Voices from Beyond the Dark; Desert Memories: Journeys through the Chilean North; Other Septembers, Many Americas: Selected Provocations, 1980-2004; The Burning City; Feeding on Dreams: Confessions of an Unrepentant Exile; Homeland Security Ate My Speech: Messages from the End of the World; Darwin's Ghosts

Tishani Doshi

Countries of the Body; Conflict and Instability; The Pleasure Seekers; Everything Begins Elsewhere; Madras Then Chennai Now; Fountainville; The Adulterous Citizen: Poems Stories Essays; Girls Are Coming Out of the Woods

Roddy Doyle

Brownbread, War; The Commitments; The Snapper; War; The Van; Paddy Clarke Ha Ha Ha; The Woman Who Walked into Doors; A Star Called Henry; Not Just for Christmas; The Giggler Treatment; Rover Saves Christmas; Rory and Ita; The Meanwhile Adventures; Oh, Play That Thing; Mad Weekend; Paula Spencer; The Deportees and Other Stories; The Playboy of the Western World; Wilderness; Her Mother's Face; The Dead Republic; Brilliant; Greyhound of a Girl; Bullfighting; Two Pints; The Guts; The Second Half; Two More Pints; Dead Man Talking; Smile

Umberto Eco

The Absent Structure; Looking for a Logic of Culture; A Theory of Semiotics; Il Superuomo di massa; Dalla periferia dell'impero; Lector in Fabula; The Role of the Reader: Explorations in the Semiotics of Texts; Sette anni di desiderio; The Name of the Rose; Postscript to the Name of the Rose; Semiotics and the Philosophy of Language; Art and Beauty in the Middle Ages; Faith in Fakes: Travels in Hyperreality; De Bibliotheca; The Aesthetics of Thomas Aquinas; The Open Work; Foucault's Pendulum; The Middle Ages of James Joyce; Lo strano caso della Hanau; The Bomb and the General; The Three Astronauts; The Limits of Interpretation; Interpretation and Overinterpretation; The Gnomes of Gnu; La ricerca della lingua perfetta nella cultura europea; Misreadings; Apocalypse Postponed; Six Walks in the Fictional Woods; The Island of the Day Before; The Search for the Perfect Language; Encounter; Serendipities: Language and Lunacy; How to Travel with a Salmon & Other Essays; La bustina di Minerva; Kant and the Platypus: Essays on Language and Cognition; Belief or Nonbelief?; Experiences in Translation; Baudolino; Five Moral Pieces; Mouse or Rat: Translation as Negotiation; On Literature; History of Beauty; The Mysterious Flame of Queen Loana; Turning Back the Clock: Hot Wars and Media Populism; On Ugliness; The

Infinity of Lists; The Prague Cemetery; Inventing the Enemy; The Book of Legendary Lands; How to Write a Thesis; Numero Zero; Chronicles of a Liquid Society; The Story of the Betrothed

Jennifer Egan

Emerald City and Other Stories; The Invisible Circus; Look at Me; The Keep; A Visit from the Goon Squad; Black Box; Manhattan Beach

Dave Eggers

A Heartbreaking Work of Staggering Genius; You Shall Know Our Velocity!; Giraffes? Giraffes!; Sacrament; Your Disgusting Head; The Unforbidden Is Compulsory, or Optimism; How We Are Hungry; Short Short Stories; Teachers Have it Easy: The Big Sacrifices and Small Salaries of America's Teachers; Surviving Justice: America's Wrongfully Convicted and Exonerated; Animals of the Ocean, In Particular the Giant Squid; What Is the What: The Autobiography of Valentino Achak Deng; How the Water Feels to the Fishes; Cold Fusion; The Wild Things; Zeitoun; Promised Land; A Hologram for the King; Your Fathers, Where Are They? And the Prophets, Do They Live Forever; The Bridge Will Not Be Gray; Stories Upon Stories; Heroes of the Frontier; Her Right Foot; Ungrateful Mammals; The Story of Captain Nemo; The Monk of Mokah; Lifters; What Can a Citizen Do?

Jill Eisenstadt

From Rockaway; Kiss Out; Swell: A Novel

Bret Easton Ellis

Less Than Zero; The Rules of Attraction; American Psycho; The Informers; Glamorama; Lunar Park; Imperial Bedrooms

R. J. Ellory

Candlemoth; Ghostheart; A Quiet Vendetta; City of Lies; A Quiet Belief in Angels; A Simple Act of Violence; The Sister; The Anniversary Man; Saints of New York; Bad Signs; A Dark and Broken Heart; The Cop; The Killer; The Devil and the River; Carnival of Shadows; Mockingbird Songs; Kings of America

Mona Eltahawy

Headscarves and Hymens: Why the Middle East Needs a Sexual Revolution

Álvaro Enrigue

La muerte de un instalador; Virtudes capitals; El cementerio de sillas; Hipotermia; Vidas perpendiculares; Decencia; El amigo del héroe; Sudden Death

Louise Erdrich
Love Medicine; Jacklight; The Beet Queen; Tracks; Baptism of Desire; Route Two; The Crown of Columbus; The Bingo Palace; The Blue Jay's Dance: A Memoir of Early Motherhood; Grandmother's Pigeon; Tales of Burning Love; The Antelope Wife; The Birchbark House; Two Languages in Mind, But Just One in the Heart; The Last Report on the Miracles at Little No Horse; The Range Eternal; The Master Butchers Singing Club; Books and Islands in Ojibwe County: Traveling Through the Land of My Ancestors; Original Fire: Selected and New Poems; Four Souls; The Painted Drum; The Game of Silence; The Plague of Doves; The Porcupine Year; The Red Convertible: Collected and New Stories 1978–2008; Shadow Tag; Chickadee; The Round House; Makoons; LaRose; Future Home of the Living God

Jeffrey Eugenides
The Virgin Suicides; Middlesex; The Marriage Plot; Fresh Complaint

Susan Fales-Hill
Always Wear Joy: My Mother Bold and Beautiful; One Flight Up; Imperfect Bliss

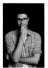

Tim Federle
Better Nate Than Ever; Tequila Mockingbird: Cocktails with a Literary Twist; Five, Six, Seven, Nate!; Hickory Daiquiri Dock: Cocktails with a Nursery Rhyme Twist; Tommy Can't Stop!; Gone with the Gin: Cocktails with a Hollywood Twist; Summer Days and Summer Nights; The Great American Whatever; Life Is Like a Musical: How to Live, Love, and Lead Like a Star; How I Resist: Activism and Hope for a New Generation; Nate Expectations; Are you There God? It's Me, Margarita: More Cocktails with a Literary Twist

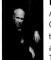

Joshua Ferris
Then We Came to the End; The Unnamed; To Rise Again at a Decent Hour; The Dinner Party and Other Stories

Richard Flanagan
A Terrible Beauty: History of the Gordon River Country; The Rest of the World is Watching—Tasmania and the Greens; Codename Iago: The Story of John Friedrich; Parish-Fed Bastards: A History of the Politics of the Unemployed in Britain; Death of a River Guide; The Sound of One Hand Clapping; Gould's Book of Fish: A Novel in Twelve Fish; The Unknown Terrorist; Wanting; And What Do you Do, Mr. Gable?; The Narrow Road to the Deep North; Notes on an Exodus; First Person

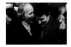

Richard Ford
A Piece of My Heart; The Ultimate Good Luck; The Sportswriter; Rock Springs; Wildlife; Independence Day; Women with Men: Three Stories; A Multitude of Sins; Vintage Ford; The Lay of the Land; Canada; Let me Be Frank with You; Between Them: Remembering My Parents

Aminatta Forna
Mother of All Myths: How Society Molds and Constrains Mothers; The Devil that Danced on the Water; Ancestor Stones; The Memory of Love; The Hired Man; The Angels of Mexico City; Happiness

Jonathan Franzen
The Twenty-Seventh City; Strong Motion; The Corrections; How to Be Alone; The Discomfort Zone; Freedom; Farther Away; Purity; The End of the End of the Earth: Essays

John Freeman
The Tyranny of E-mail: The Four-Thousand Year Journey to Your Inbox; How to Read a Novelist; Tales of Two Cities: The Best and Worst of Times in Today's New York; Tales of Two Americas: Stories of Inequality in a Divided Nation; Maps

Neil Gaiman
Don't Panic; Good Omens; Now We Are Sick; Angels & Visitations; Neverwhere; Smoke & Mirrors; Stardust; American Gods; Coraline; Adventures in the Dream Trade; A Walking Tour of the Shambles; The Wolves in the Walls; Anansi Boys; MirrorMask; Fragile Things; The Sandman: Book of Dreams; M is for Magic; Melinda; InterWorld; The Graveyard Book; Odd and the Frost Giants; The Dangerous Alphabet; The Ocean at the End of the Lane; Make Good Art; Chu's Day; The Day I Swapped My Dad for Two Goldfish; Blueberry Girl; Crazy Hair; Who Killed Amanda Palmer; Instructions; Fortunately, the Milk; Chu's First Day of School; Chu's Day at the Beach; Hansel & Gretel; The Sleeper and the Spindle; The Truth Is a Cave in the Black Mountains; Trigger Warning: Short Fictions and Disturbances; The View from the Cheap Seats: Selected Nonfiction; Norse Mythology

Roxane Gay
Ayiti; An Untamed State; Bad Feminist: Essays; Black Panther World of Wakanda; Difficult Women; Hunger: A Memoir of (My) Body; Not That Bad: Dispatches from Rape Culture

Masha Gessen
Dead Again: The Russian Intelligentsia After Communism; Ester and Ruzya: How My Grandmothers Survived Hitler's War and Stalin's Peace; Blood Matters: From Inherited Illness to Designer Babies, How the World and I Found Ourselves in the Future of the Gene; Perfect Rigor: A Genius and the Mathematical Breakthrough of the Century; The Man Without a Face: The Unlikely Rise of Vladimir Putin; Words Will Break Cement: The Passion of Pussy Riot; Brothers: The Road to An American Tragedy; Where the Jews Aren't: The Sad and Absurd Story of Birobidzhan, Russia's Autonomous Region; The Future Is History: How Totalitarianism Reclaimed Russia; Never Remember: Searching for Stalin's Gulags in Putin's Russia

John Freeman Gill
The Gargoyle Hunters

Alex Gilvarry
From the Memoirs of a Non-Enemy Combatant; Eastman Was Here

Aracelis Girmay
Changing, Changing: Stories and Collages; Teeth; Kingdom Animalia: Poems; The Black Maria

Malcolm Gladwell
The Tipping Point: How Little Things Can Make a Big Difference; Blink: The Power of Thinking Without Thinking; Outliers: The Story of Success; What the Dog Saw: And Other Adventures; David and Goliath: Underdogs, Misfits, and the Art of Battling Giants

Nadine Gordimer
Face to Face; The First Circle; The Soft Voice of the Serpent; Six Feet of the Country; Which New Era Would that Be?; A World of Strangers; Friday's Footprint and Other Stories; Occasion for Loving; Not For Publication; The Late Bourgeois World; A Guest of Honour; Livingstone's Companions; Sounds of a Cowhide Drum; The Black Interpreters; The Conservationist; No Place Like This: Selected Stories; Selected Stories; Burger's Daughter; A Soldier's Embrace; What Happened to Burger's Daughter or How South African Censorship Works; July's People; Three in a Bed: Fiction, Morals, and Politics; Town and Country Lovers; Something Out There; Correspondence Course and Other Stories; Lifetimes Under Apartheid; A Sport of Nature; The Essential Gesture: Writing, Politics and Places; The Moment Before the Gun Went Off; Once Upon a Time; My Son's Story; Jump: And Other Stories; Crimes and Conscience: Selected Short Stories; Why Haven't You Written: Selected Stories 1950-1972; Something for the Time Being 1950-1972; None to Accompany Me; The Lying Days; Writing and Being: The Charles Eliot Norton Lectures; The House Gun; Living in Hope and History: Notes from Our History; The Pickup; Loot and Other Stories; Pandemic: Facing AIDS;

Get a Life; Beethoven Was One-Sixteenth Black; Telling Times: Writing and Living, 1954–2008; Life Times: Stories; No Time Like the Present

Kaitlyn Greenidge
We Love You, Charlie Freeman

Garth Greenwell
Mitko; What Belongs to You

David Grossman
Duel; The Yellow Wind; See Under: Love; The Smile of the Lamb; The Book of Intimate Grammar; Sleeping on a Wire: Conversations with Palestinians in Israel; The Zigzag Kid; Be My Knife; Someone to Run With; Death as a Way of Life: Israel Ten Years after Oslo; Her Body Knows: Two Novellas; Lion's Honey: The Myth of Samson; Writing in the Dark: Essays on Literature and Politics; To the End of the Land; Falling Out of Time; A Horse Walks into a Bar: A Novel

Yaa Gyasi
Homegoing

Garth Risk Hallberg
A Field Guide to the North American Family; The Penny: A Little History of Luck; City on Fire

Chad Harbach
The Art of Fielding

Adam Haslett
You are Not a Stranger Here; Union Atlantic; Imagine Me Gone

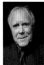

Robert Hass
Field Guide; Praise; Twentieth Century Pleasures: Prose on Poetry; Human Wishes; Sun Under Wood; Poet's Choice: Poems for Everyday Life; Now and Then: The Poet's Choice Columns; Time and Materials: Poems 1997–2005; The Apple Trees at Olema: New and Selected Poems; What Light Can Do: Essays on

Art, Imagination, and the Natural World; A Little Book on Form: An Exploration into the Formal Imagination of Poetry

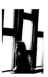

Lindsay Hatton
Monterey Bay: A Novel

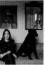

Maria Dahvana Headley
The Year of Yes; Queen of Kings; Magonia: A Novel; Aerie; The Mere Wife

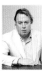

Sheila Heti
The Middle Stories; Ticknor: A Novel; How Should a Person Be?: A Novel from Life; The Chairs Are Where the People Go; We Need a Horse; All Our Happy Days Are Stupid; Motherhood

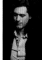

Joanne C. Hillhouse
The Boy from Willow Bend; Dancing Nude in the Moonlight; Oh Gad!; Musical Youth; With Grace; Lost! A Caribbean Sea Adventure

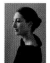

Christopher Hitchens
Karl Marx and The Paris Commune; Callaghan, The Road to Number Ten; Cyprus; Prepared for the Worst: Selected Essays and Minority Reports; Imperial Spoils: The Curious Case of the Elgin Marbles; Hostage to History: Cyprus from the Ottomans to Kissinger; Blood, Class, and Nostalgia: Anglo-American Ironies; The Monarchy: A Critique of Britain's Favourite Fetish; For the Sake of Argument: Essays and Minority Reports; The Missionary Position: Mother Teresa in Theory and Practice; No One Left to Lie To: The Triangulations of William Jefferson Clinton; Unacknowledged Legislation: Writers in the Public Sphere; Letters to a Young Contrarian; The Trial of Henry Kissinger; Why Orwell Matters; A Long Short War: The Postponed Liberation of Iraq; Love, Poverty, and War: Journeys and Essays; Thomas Jefferson: Author of America; Thomas Paine's "Rights of Man": A Biography; The Portable Atheist: Essential Readings for the Nonbeliever; God Is Not Great: How Religion Poisons Everything; Christopher Hitchens and His Critics; Terror, Iraq and the Left; Is Christianity Good for the World?; The Parthenon Marbles: The Case for Reunification; Hitch-22: A Memoir; Hitchens v. Blair: Be It Resolved Religion Is a Force for Good in the World; Arguably: Essays; Mortality; And Yet . . .: Essays

Lucas Hnath
Death Tax; A Public Reading of an Unproduced Screenplay About the Death of Walt Disney; Red Speedo; Isaac's Eye; The Christians; Hillary and Clinton; A Doll's House, Part 2

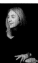

Ann Hood
Somewhere Off the Coast of Maine; Waiting to Vanish; Three-Legged Horse; Something Blue; Places to Stay the Night; The Properties of Water; Ruby; Creating Character Emotions; Do Not Go Gentle: My Search for Miracles in a Cynical Time; An Ornithologist's Guide to Life: Stories; The Knitting Circle; Comfort: A Journey Through Grief; How I Saved My Father's Life (And Ruined Everything Else); The Red Thread; The Obituary Writer; An Italian Wife; Knitting Yarns: Writers Writing About Knitting; The Book That Matters Most; Morningstar; She Loves You (Yeah, Yeah, Yeah); Kitchen Yarns

Violaine Huisman
Fugitive parce que reine

Siri Hustvedt
Reading to You; The Blindfold; The Enchantment of Lily Dahl; Yonder; What I Loved; Mysteries of the Rectangle: Essays on Painting; A Plea for Eros; The Sorrows of an American; Embodied Visions: What Does It Mean to Look at Art?; The Shaking Woman or a History of My Nerves; The Eight Voyages of Sinbad; The Summer Without Men; Living, Thinking, Looking; Almodor's Gaze: Robert Mapplethorpe; The Blazing World; A Woman Looking at Men Looking at Women

Ishion Hutchinson
Far District: Poems; House of Lords and Commons

John Irving
Setting Free the Bears; The Water-Method Man; The 158-Pound Marriage; The World According to Garp; The Hotel New Hampshire; The Cider House Rules; A Prayer for Owen Meany; A Son of the Circus; The Imaginary Girlfriend; Trying to Save Piggy Sneed; A Widow for One Year; My Movie Business; The Fourth Hand; A Sound Like Someone Trying Not to Make a Sound; Until I Find You; Last Night in Twisted River; In One Person; Avenue of Mysteries; Darkness As a Bride

Walter Isaacson
Pro and Con; The Wise Men: Six Friends and the World They Made; Kissinger: A Biography; Benjamin Franklin: An American Life; Einstein: His Life and Universe; American Sketches: Great Leaders, Creative Thinkers, and Heroes of a Hurricane; Steve Jobs; The Innovators: How a Group of Inventors, Hackers, Geniuses, and Geeks Created the Digital Revolution; Leonardo Da Vinci

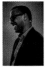

Branden Jacobs-Jenkins
Neighbors; War; Appropriate; An Octoroon; Gloria; Everybody

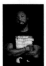

Marlon James
John Crow's Devil; The Book of Night Women; A Brief History of Seven Killings

Leslie Jamison
The Gin Closet; The Empathy Exams; The Recovering: Intoxication and the Aftermath

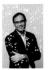

Sandeep Jauhar
Intern: A Doctor's Initiation; Doctored: The Disillusionment of an American Physician; Heart: A History

Ma Jian
Ma Jian's Road; Stick Out Your Tongue: Stories; A Dog's Life; Bardo; The Noodle Maker; The Nine Crossroads; The Lament; Life Companion; Intimately Related; Red Dust: A Path Through China, Beijing Coma; The Dark Road

Tayari Jones
Leaving Atlanta; The Untelling; Silver Sparrow; An American Marriage

Sebastian Junger
The Perfect Storm: A True Story of Men Against the Sea; Fire; A Death in Belmont; War; A World Made of Blood; Tribe: On Homecoming and Belonging

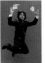

Daniel Kehlmann
Me and Kaminski; Measuring the World; Fame: A Novel in Nine Episodes; F: A Novel; You Should Have Left; The Mentor; Christmas Eve; Tyll

Etgar Keret
Jetlag; The Bus Driver Who Wanted to Be God and Other Stories; Dad Runs Away with the Circus; Gaza Blues; Pizzeria Kamikaze; The Nimrod Flipout; Missing Kissinger; The Girl on the Fridge; Four Stories; A Moonless Night; Suddenly, a Knock on the Door; Seven Good Years: A Memoir

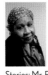

Jamaica Kincaid
At the Bottom of the River; Annie John; Annie, Gwen, Lilly, Pam, and Tulip; A Small Place; Lucy; The Autobiography of My Mother; My Brother; My Garden Book; Talk Stories; Mr. Potter; Among Flowers: A Walk in the Himalayas; See Now Then

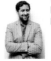

Barbara Kingsolver
The Bean Trees; Homeland and Other Stories; Holding the Line: Women in the Great Arizona Mine Strike of 1983; Animal Dreams; Another America/Otra América; Pigs in Heaven; High Tide in Tucson: Essays from Now or Never; The Poisonwood Bible; Prodigal Summer; Small Wonder; Last Stand: America's Virgin Lands; Animal, Vegetable, Miracle: A Year of Food Life; The Lacuna; Flight Behavior: A Novel; Unsheltered: A Novel

Phil Klay
Redeployment; The Citizen-Soldier: Moral Risk and the Modern Military

Alexandra Kleeman
You Too Can Have a Body Like Mine; Intimations

August Kleinzahler
A Calendar of Airs; The Sausage Master of Minsk: Poems; A Calendar of Airs; Storm over Hackensack; Earthquake Weather; Like Cities, Like Storms; Red Sauce, Whiskey and Snow; Green Sees Things in Waves; Live from the Hong Kong Nile Club: Poems, 1975–1990; The Strange Hours Travelers Keep; Cutty, One Rock: Low Characters and Strange Places, Gently Explained; Music: I–LXXIV; Sleeping It Off in Rapid City; The Hotel Oneira: Poems; Sallies, Romps, Portraits, and Send-Offs: Selected Prose 2000–2016; Before Dawn on Bluff Road/Hollyhocks in the Fog: Selected New Jersey Poems/Selected San Francisco Poems

Karl Ove Knausgaard
Out of the World; A Time for Everything; My Struggle Book 1; My Struggle Book 2; Boyhood Island: My Struggle Book 3; Dancing in the Dark: My Struggle Book 4; Some Rain Must Fall: My Struggle Book 5; The End: My Struggle Book 6; Autumn; Winter; Spring; Summer

Yusef Komunyakaa
Dedications and Other Dark-horses; Lost in the Bone Wheel Factory; Copacetic; I Apologize for the Eyes in My Head; Toys in a Field; Dien Cai Dau; Magic City; Neon Vernacular; Thieves of Paradise; Pleasure Dome; Talking Dirty to the Gods; Taboo;

Gilgamesh: A Verse Play; Warhorses; The Chameleon Couch; Testimony, a Tribute to Charlie Parker: With New and Selected Jazz Poems; The Emperor of Water Clocks

Wayne Koestenbaum
Double Talk: The Erotics of Male Literary Collaboration; Ode to Anna Moffo and Other Poems; The Queen's Throat: Opera, Homosexuality, and the Mystery of Desire; Rhapsodies of a Repeat Offender; Jackie Under My Skin: Interpreting An Icon; The Milk of Inquiry; Cleavage: Essays on Sex, Stars, and Aesthetics; Andy Warhol; Model Homes; Moira Orfei in Aigues-Mortes; Best-Selling Jewish Porn Films; Hotel Theory; Humiliation; The Anatomy of Harpo Marx; Blue Stranger with Mosaic Background; My 1980s and Other Essays; The Pink Terrace Notebooks; Notes on Glaze: 18 Photographic Investigations; Camp Marmalade

Rickey Laurentiis
Whipped; Prime; Boy with Thorn

Victor LaValle
Slapboxing with Jesus: Stories; The Ecstatic; Big Machine; The Devil in Silver; Lucretia and the Kroons; The Ballad of Black Tom; The Changeling; Victor LaValle's Destroyer

Min Jin Lee
Free Food for Millionaires; Pachinko

Ben Lerner
The Lichtenberg Figures; Angle of Yaw; Mean Free Path; Leaving the Atocha Station; 10:04; No Art; The Hatred of Poetry

John Lewis
Walking with the Wind: A Memoir of the Movement; Across That Bridge: A Vision for Change and the Future of America; March: Book One; March: Book Two

Valeria Luiselli
Papeles falsos; Los ingrávidos; Faces in the Crowd; Sidewalks; The Story of My Teeth; Tell Me How It Ends: An Essay in Forty Questions

Alexander Maksik
You Deserve Nothing; A Marker to Measure Drift; Shelter in Place

Alex Mar
Witches of America

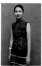

Khet Mar
Wild Snowy Night; The Souls of Fallen Flowers; Night Birds and Other Stories

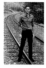

David Tomas Martinez
Hustle; Post Traumatic Hood Disorder

Eimear McBride
A Girl Is a Half-Formed Thing; The Lesser Bohemians

James McBride
The Color of Water: A Black Man's Tribute to His White Mother; Miracle at St. Anna; Song Yet Sung; The Good Lord Bird; Kill 'Em and Leave: Searching for James Brown and the American Soul; Five-Carat Soul

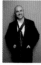

Colum McCann
Fishing the Sole-Black River; Songdogs; This Side of Brightness; Everything in this Country Must; Dancer; Zoli; Let the Great World Spin; TransAtlantic; Thirteen Ways of Looking; Letters to a Young Writer

Cormac McCarthy
The Orchard Keeper; Outer Dark; Child of God; Suttree; Blood Meridian, Or the Evening Redness in the West; All The Pretty Horses; The Crossing; The Stonemason: A Play In Five Acts; Cities of the Plain; No Country for Old Men; The Road; The Sunset Limited: A Novel in Dramatic Form; The Gardner's Son

Tarell Alvin McCraney
In Moonlight Black Boys Look Blue; The Brothers Size; In the Red and Brown Water; Marcus, or the Secret of Sweet; Wig Out!; American Trade; Choir Boy; Head of Passes; Without/Sin; Run, Mourner, Run

Val McDermid
Report for Murder; Common Murder; Final Edition; Dead Beat; Union Jack; Kick Back; Crack Down; A Suitable Job for a Woman; Clean Break; The Mermaids Singing; The Blue Genes; Booked for Murder; Wire in the Blood; The Writing on the Wall and Other

Stories; Star Struck; A Place of Execution; Killing the Shadows; The Last Temptation; The Distant Echo; Hostage to Murder; The Torment of Others; Stranded; The Grave Tattoo; Beneath the Bleeding; A Darker Domain; Fever of the Bone; Trick of the Dark; Retribution; The Vanishing Point; Cross and Burn; Northanger Abbey; The Skeleton Road; Forensics; Splinter the Silence; Out of Bounds; Insidious Intent

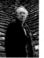

Ian McEwan
Jack Flea's Birthday Celebration; First Love, Last Rites; In Between the Sheets; The Cement Garden; The Comfort of Strangers; The Imitation Game; Or Shall We Die?; The Ploughman's Lunch; Rose Blanche; The Child in Time; Soursweet; The Innocent; Black Dogs; The Daydreamer; The Short Stories; Enduring Love; Amsterdam; Atonement; Saturday; On Chesil Beach; For You (Libretto); Solar; Sweet Tooth; The Children Act; Nutshell

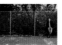

Joe McGinniss Jr.
The Delivery Man; Carousel Court

David Means
A Quick Kiss of Redemption and Other Stories; Assorted Fire Events; The Secret Goldfish; The Spot; Hystopia

Claire Messud
When the World Was Steady; The Last Life: A Novel; The Hunters; The Professor's History; The Emperor's Children; The Woman Upstairs; The Burning Girl

China Miéville
Hellblazer; King Rat; Perdido Street Station; The Scar; The Tain; Iron Council; Looking for Jake; Between Equal Rights: A Marxist Theory of International Law; Un Lun Dun; The City & the City; Red Planets: Marxism and Science Fiction; Kraken; Pathfinder Chronicles: Guide to the River Kingdoms; Justice League; London's Overthrow; Embassytown; Railsea; Dial H; The Apology Chapbook; Three Moments of an Explosion: Stories; Preface to a Book Not Yet Written or Disavowed; This Census-Taker; The Last Days of New Paris; The Worst Breakfast; October: The Story of the Russian Revolution

Rick Moody
Garden State; The Ice Storm; The Ring of Brightest Angels Around Heaven: A Novella and Stories; Purple America; Surplus Value Books: Catalog Number 13; Demonology; The Black Veil: A Memoir with Digressions; The Diviners; Right Livelihoods: Three Novellas; The Four Fingers of Death; On Celestial Music—And Other Adventures in Listening; Hotels of North America

Lorrie Moore
Self-Help; Anagrams; Like Life; The Forgotten Helper; Who Will Run the Frog Hospital?; Birds of America; The Collected Stories; A Gate at the Stairs; Bark: Stories; See What Can Be Done: Essays, Criticism, and Commentary

Toni Morrison
The Bluest Eye; Sula; The Black Book; Song of Solomon; Tar Baby; Dreaming Emmett; Beloved; Jazz; Playing in the Dark: Whiteness and the Literary Imagination; The Dancing Mind; Paradise; The Big Box; The Book of Mean People; Love; Who's Got Game?: The Ant or the Grasshopper? The Lion or the Mouse? Poppy or the Snake?; Remember: The Journey to School Integration; Margaret Garner; The Mirror or the Glass; What Moves at the Margin: Selected Nonfiction; A Mercy; Peeny Butter Fudge; Little Cloud and Lady Wind; The Tortoise or the Hare; Desdamona; Home; Please Louise; God Help the Child; The Origin of Others

Walter Mosley
Devil in a Blue Dress; A Red Death; White Butterfly; Black Betty; RL's Dream; A Little Yellow Dog; Gone Fishin'; Always Outnumbered, Always Outgunned; Blue Light; Walkin' the Dog; Workin' on the Chain Gang: Shaking off the Dead Hand of History; Fearless Jones; Futureland: Nine Stories of an Imminent World; Bad Boy Brawly Brown; Six Easy Pieces; Fear Itself; What Next: A Memoir Toward World Peace; Little Scarlet; The Man in My Basement; Cinnamon Kiss; The Wave; 47; Maximum Fantastic Four; Walking the Line; Fortunate Son; Killing Johnny Fry: A Sexistential Novel; Life Out of Context: Which Includes a Proposal for the Non-violent Takeover of the House of Representatives; Fear of the Dark; Blonde Faith; This Year You Write Your Novel; Diablerie; The Tempest Tales; The Right Mistake; The Long Fall; Known to Evil; The Last Days of Ptolemy Grey; When the Thrill Is Gone; The Fall of Heaven; Twelve Steps Toward Political Revelation; All I Did Was Shoot My Man; Parishioner; The Gift of Fire / On the Head of a Pin; Merge / Disciple; Stepping Stone / The Love Machine; Little Green; White Lilies; Rose Gold; Lift; Debbie Doesn't Do It Anymore; And Sometimes I Wonder About You; Inside a Silver Box; Leading from the Affair; Charcoal Joe; Folding the Red into the Black: Developing a Viable Utopia for Human Survival in the 21st Century; Down the River unto the Sea

Paul Muldoon
Knowing My Place; New Weather; Spirit of Dawn; Mules; Names and Addresses; Immram; Why Brownlee Left; The O-O's Party; Out of Siberia; Quoof; The Wishbone; Paul Muldoon: Selected Poems 1968-1983; Meeting the British; Madoc: A Mystery; The Annals of Chile; The Prince of the Quotidian; Incantata; Six Honest

Serving Men; The Last Thesaurus; Kerry Slides; New Selected Poems: 1968-1994; Hopewell Haiku; The Noctuary of Narcissus Batt; Hay; The Bangle (Slight Return); Bandana; To Ireland, I; Poems 1968-1998; Vera of Las Vegas; Moy Sand and Gravel; Unapproved Road; Medley for Morin Khur; Sixty Instant Messages to Tom Moore; Horse Latitudes; The End of the Poem: All Souls Night; General Admission; When the Pie Was Opened; Plan B; Wayside Shrines; Maggot; Songs and Sonnets; The Word on the Street; One Thousand Things Worth Knowing; Poems 1968-2014; Rising to the Rising; I Gave the Pope a Rhino; Superior Aloeswood

Herta Müller
Nadir; Oppressive Tango; Barefoot February; The Passport; Traveling on One Leg; How Perception Invents Itself; The Devil Is Sitting in the Mirror; The Fox Was Ever the Hunter; A Warm Potato Is a Warm Bed; The Guard Takes His Comb; Arrived As If Not There; The Land of Green Plums; Hunger and Silk; In a Trap; The Appointment; The Foreign View, or Life Is a Fart in a Lantern; Home Is What Is Spoken There; The Hunger Angel; The King Bows and Kills: Essays; Christina and Her Double: Selected Essays

Les Murray

The Ilex Tree; The Weatherboard Cathedral; Poems Against Economics; Lunch and Counter Lunch; Selected Poems: The Vernacular Republic; Creeper Habit; Ethnic Radio; The Peasant Mandarin; The Boys Who Stole the Funeral; The Vernacular Republic: Poems 1961-1981; Equanimities; Flowering Eucalypt in Autumn; The People's Otherworld; Persistence in Folly, Selected Prose Writing; The Australian Year: The Chronicle of Our Seasons and Celebrations; Selected Poems; The Daylight Moon; Collected Poems; The Idyll Wheel; Blocks and Tackles: Articles and Essays 1982 to 1990; Dog Fox Field; Collected Poems; Translations from the Natural World; The Paperback Tree; Late Summer Fires; Selected Poems; Subhuman Redneck Poems; Killing the Black Dog; New Selected Poems; Conscious & Verbal; Fredy Neptune: A Novel in Verse; The Quality of Sprawl: Thoughts about Australia; A Working Forest: Selected Prose; An Absolutely Ordinary Rainbow; Learning Human: New Selected Poems; Poems the Size of Photographs; New Collected Poems; The Full Dress: An Encounter with the National Gallery of Australia; The Biplane Houses; Taller When Prone; Killing the Black Dog: A Memoir of Depression; The Best 100 Poems of Les Murray; New Selected Poems; Waiting for the Past: Poems; On Bunyah

Eileen Myles

The Irony of the Leash; Polar Ode; A Fresh Young Voice from the Plains; Sappho's Boat; Bread and Water; 1969; Not Me; Chelsea Girls; On My Way; Maxfield Parrish: Early & New Poems; The New Fuck You; School of Fish; Cool for You; Skies; Sorry, Tree;

Tow; The Importance of Being Iceland; Inferno (a poet's novel); Different Streets; Snow-Flake; I Must Be Living Twice: New and Selected Poems 1975-2014; Afterglow: A Dog Memoir

Ruby Namdar

Haviv; The Ruined House

Amélie Nothomb

Hygiene and the Assassin; Loving Sabotage; Human Rites; The Stranger Next Door; Fear and Trembling; The Character of Rain; The Enemy's Cosmetique; The Book of Proper Names; Antichrista; The Life of Hunger; Sulphuric Acid; Tokyo Fiancée; The Prince's Act; The Winter Journey; Life Form; Pétronille; Strike Your Heart

Téa Obreht

The Tiger's Wife

Ben Okri

Flowers and Shadows; The Landscapes Within; Incidents at the Shrine; Stars of the New Curfew; The Famished Road; An African Elegy; Songs of Enchantment; Astonishing the Gods; Birds of Heaven; A Way of Being Free; Infinite Riches; Mental Fight; In Arcadia; Starbook; Tales of Freedom; A Time for New Dreams; Wild; The Age of Magic; The Magic Lamp: Dreams of Our Age

Sofi Oksanen

Stalin's Cows; Baby Jane; Purge; When the Doves Disappeared; Norma

Stewart O'Nan

Transmission; In the Walled City; Snow Angels; The Name of the Dead; The Speed Queen; A World Away; A Prayer for the Dying; The Circus Fire; Everyday People; Wish You Were Here; The Night Country; Faithful: Two Diehard Boston Red Sox Fans Chronicle the Historic 2004 Season; The Good Wife; Last Night at the Lobster; Songs for the Missing; Emily, Alone; The Odds; A Face in a Crowd; West of Sunset; City of Secret

Joseph O'Neill

This Is the Life; The Breezes; Blood-Dark Track: A Family History; Netherland; The Dog; Good Trouble: Collected Stories

Orhan Pamuk

The White Castle; The Black Book; The New Life; My Name Is Red; Snow; Istanbul: Memories and the City; Other Colors: Essays and a Story; The Museum of Innocence; The Naïve and Sentimental Novelist; Silent House; A Strangeness in My Mind; The Red-Haired Woman

Gregory Pardlo

Totem; Digest; Air Traffic: A Memoir of Ambition and Manhood in America

Rowan Ricardo Phillips

Ariadne in the Grotesque Labyrinth: Stories; When Blackness Rhymes with Blackness; The Ground; Heaven

DBC Pierre

Vernon God Little; Ludmila's Broken English; Suddenly Doctor Cox; Lights Out in Wonderland; Petit Mal; Breakfast with the Borgias; Release the Bats

Francine Prose
Stories from Our Living Past; Judah the Pious; The Glorious Ones; Marie Laveau; Animal Magnetism; Household Saints; Hungry Hearts; Bigfoot Dreams; Women and Children First; Primitive People; Hunters and Gatherers; Dybbuk: A Story Made in Heaven; Guided Tours of Hell; The Angel's Mistake; The Peaceable Kingdom; You Never Know: A Legend of the Lamed-vavniks; Blue Angel; Scent of a Woman's Ink: Essays; The Demons' Mistake; The Lives of the Muses: Nine Women & The Artists They Inspired; Gluttony: The Seven Deadly Sins; Sicilian Odyssey; After; Caravaggio: Painter of Miracles; A Changed Man; Leopold, The Liar of Leipzig; Reading Like A Writer; Bullyville; The Photographs of Marion Post Wolcott; Goldengrove; Touch; Anne Frank: The Book, The Life, The Afterlife; Rhino, Rhino, Sweet Potato; My New American Life; The Turning; Lovers at the Chameleon Club: Paris 1932; Peggy Guggenheim: The Shock of the Modern; Mister Monkey; What to Read and Why

Claudia Rankine
The End of the Alphabet; Nothing in Nature Is Private; Don't Let Me Be Lonely: An American Lyric; Plot; Provenance of Beauty; Existing Conditions; Citizen: An American Lyric

David Remnick
Lenin's Tomb: The Last Days of the Soviet Empire; The Devil Problem and Other True Stories; Resurrection: The Struggle for a New

Russia; King of the World: Muhammad Ali and the Rise of an American Hero; Reporting: Writings from The New Yorker; The Bridge: The Life and Rise of Barack Obama

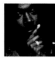

Jason Reynolds
My Name Is Jason. Mine Too.: Our Story. Our Way; When I Was the Greatest; The Boy in the Black Suit; All American Boys; As Brave As You; Ghost; Miles Morales: Spider-Man; Patina; Long Way Down; Sunny; For Everyone; Lu

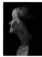

J. K. Rowling
Harry Potter and the Philosopher's Stone; Harry Potter and the Chamber of Secrets; Harry Potter and the Prisoner of Azkaban; Harry Potter and the Goblet of Fire; Fantastic Beasts and Where to Find Them; Quidditch Through the Ages; Harry Potter and the Order of the Phoenix; Harry Potter and the Half-Blood Prince; Harry Potter and the Deathly Hallows; Harry Potter: The Prequel; The Tales of Beedle the Bard; The Casual Vacancy; The Cuckoo's Calling; The Silkworm; Very Good Lives: The Fringe Benefits of Failure and the Importance of Imagination; Career of Evil; Harry Potter and the Cursed Child; Short Stories from Hogwarts of Power, Politics, and Pesky Poltergeists; Short Stories from Hogwarts of Heroism, Hardship, and Dangerous Hobbies; Hogwarts: An Incomplete and Unreliable Guide; Lethal White

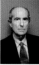

Philip Roth
Goodbye, Columbus; Letting Go; When She Was Good; Portnoy's Complaint; Our Gang; The Breast; The Great American Novel; My Life as a Man; Reading Myself and Others; The Professor of Desire; The Ghost Writer; Zuckerman Unbound; The Anatomy Lesson; The Prague Orgy; The Counterlife; The Facts: A Novelist's Autobiography; Deception; Patrimony: A True Story; Operation Shylock; Sabbath's Theater; American Pastoral; I Married a Communist; The Human Stain; Shop Talk; The Dying Animal; The Plot Against America; Everyman; Exit Ghost; Indignation; The Humbling; Nemesis

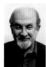

Salman Rushdie
Grimus; Midnight's Children; Shame; The Jaguar Smile: A Nicaraguan Journey; The Satanic Verses; Haroun and the Sea of Stories; In Good Faith; Is Nothing Sacred?; Imaginary Homelands: Essays and Criticism, 1981-1991; East, West; The Moor's Last Sigh; Mirrorwork: 50 Years of Indian Writing 1947-1997; The Ground Beneath Her Feet; Fury; Step Across This Line: Collected Nonfiction, 1992-2002; Shalimar the Clown; The Enchantress of Florence; Luka and the Fire of Life; Joseph Anton: A Memoir; The Wizard of Oz; Two Years Eight Months and Twenty-Eight Nights; The Golden House

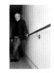

Richard Russo
Mohawk; The Risk Pool; Nobody's Fool; Straight Man; Empire Falls; The Whore's Child and Other Stories; Bridge of Sighs; That Old Cape Magic; Interventions; Elsewhere: A Memoir; Everybody's Fool; Trajectory: Stories; The Destiny Thief: Essays on Writing, Writers and Life

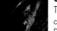

Sonia Sanchez
The Bronx Is Next; Homecoming; It's a New Day: Poems for Young Brothas and Sistuhs; Sista Son/Ji; We a Baddddd People; The Adventures of Fat Head, Small Head, and Square Head; Love Poems;A Blues Book for a Blue Black Magic Woman; Uh Huh; But How Do It Free Us?; Malcolm Man/Don't Live Here No More; I'm Black When I'm Singing, I'm Blue When I Ain't; Homegirls and Handgrenades; I've Been a Woman: New and Selected Poems; Under a Soprano Sky; Shake Down Memory: A Collection of Political Essays and Speeches; Autumn Blues; Continuous Fire: A Collection of Poetry; Wounded in the House of a Friend; A Sound Investment and Other Stories; Does Your House Have Lions; Like the Singing Coming Off of Drums; Shake Loose My Skin; Ash; Bum Rush the Page: A Def Poetry Jam; Morning Haiku

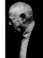

James Salter
The Hunters; The Arm of Flesh; A Sport and a Pastime; Light Years; Solo Faces; Dusk and Other Stories; Still Such; Burning the Days; Last Night; There and Then: The Travel Writing of James Salter; All That Is; Collected Stories; Don't Save Anything

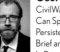

George Saunders
CivilWarLand in Bad Decline; I Can Speak; Pastoralia; The Very Persistent Gappers of Frip; The Brief and Frightening Reign of Phil; In Persuasion Nation; A Bee Stung Me, So I Killed All the Fish; The Braindead Megaphone; Fox 8; Tenth of December: Short Stories; Congratulations, by the way: Some Thoughts on Kindness; A Two-Minute Note to the Future; Mother's Day; Lincoln in the Bardo

Roberto Saviano
Gomorrah: A Personal Journey into the Violent International Empire of Naples' Organized Crime System; Beauty and the Inferno; Zero Zero Zero; The Piranhas

Elissa Schappell
Use Me; Blueprints for Building Better Girls

Nicole Sealey
The Animal After Whom Other Animals Are Named; Ordinary Beast (Art: Split Level by Derrick Adams)

Taiye Selasi
Ghana Must Go

Vijay Seshadri
Wild Kingdom; The Long Meadow; 3 Sections: Poems

Elif Shafak
The Saint of Incipient Insanities; The Gaze; The Flea Palace; The Forty Rules of Love: A Novel of Rumi; Black Milk: On Writing, Motherhood, and the Harem Within; The Happiness of Blond People: A Personal Meditation on the Dangers of Identity; Honour; The Architect's Apprentice; Three Daughters of Eve

Rebecca Skloot
The Immortal Life of Henrietta Lacks

Patti Smith
Seventh Heaven; Early Morning Dream; A Useless Death; Witt; The Night; Ha! Ha! Houdini!; Babel; Woolgathering; Early Work; The Coral Sea; Patti Smith Complete: Lyrics, Reflections and Notes for the Future; Strange Messenger; Auguries of Innocence; Land 250; Trois; Just Kids; Hecatomb; M Train; Devotion

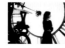

Zadie Smith
White Teeth; The Autograph Man; On Beauty; Changing My Mind: Occasional Essays; Stop What You're Doing and Read This!; NW: A Novel, Swing Time; Fences: A Brexit Diary; Feel Free: Essays

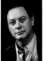

Laura J. Snyder
Reforming Philosophy: A Victorian Debate on Science and Society; The Philosophical Breakfast Club: Four Remarkable Friends Who Transformed Science and Changed the World; Eye of the Beholder: Johannes Vermeer, Antoni van Leeuwenhoek, and the Reinvention of Seeing

Andrew Solomon
The Irony Tower: Soviet Artists in a Time of Glasnost; A Stone Boat; The Noonday Demon: An Atlas of Depression; Far From the Tree: Parents, Children and the Search for Identity; Far and Away: How Travel Can Change the World

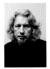

Vladimir Sorokin

The Queue; Pelmeni; The Hut; Russian Grandmother; Confidence; Dismorphomania; Anniversary; The Norm; The Post-Nuptial Journey; Four Stout Hearts; A Novel; Marina's Thirtieth Love; Cabbage Soup; Dostoevsky-Trip; The First Saturday Workday; Happy New Year; Blue Salo; The Feast; Lyod; Bro; 23,000; Day of the Oprichnik; Swimming In; Kremlin Made of Sugar; Telluria; The Blizzard

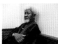

Wole Soyinka

Keffi's Birthday Treat; The Invention; The Swamp Dwellers; A Tale of Two; A Quality of Violence; The Lion and the Jewel; The Trials of Brother Jero; A Dance of the Forests; Egbe's Sworn Enemy; My Father's Burden; Madame Etienne's Establishment; Telephone Conversation; The Strong Breed; The Interpreters; Before the Blackout; Kongi's Harvest; The Road; Idanre and Other Poems; A Big Airplane Crashed into the Earth; A Shuffle in the Crypt; Madmen and Specialists; The Man Dies: Prison Notes; Season of Anomy; The Bacchae of Euripides; Camwood on the Leaves; Jero's Metamorphosis; Death and the King's Horseman; Ogun Abibiman; Myth, Literature and the African World; Opera Winyosi; Aké: The Years of Childhood; Requiem for a Futurologist; Sixty-Six; A Play of Giants; Childe Internationale; Mandela's Earth and Other Poems; Ibadan: The Penkelemes Years: A Memoir 1946–65; Isara: A Voyage Around Essay; From Zia with Love; The Blackman and the Veil: Beyond the Berlin Wall; Art, Dialogue and Outrage: Essays on Literature and Culture; The Beatification of Area Boy; The Open Sore of a Continent: A Personal Narrative of the Nigerian Crisis; Early Poems; The Burden of Memory, the Muse of Forgiveness; King Baabu; Samarkand and Other Markets I Have Known; Salutation to the Gut; The Credo of Being and Nothingness; The Deceptive Silence of Stolen Voices; Climate of Fear: The Quest for Dignity in a Dehumanized World; You Must Set Forth at Dawn; New Imperialisms; Alapata Apata; Of Africa

Rob Spillman

All Tomorrow's Parties

Gloria Steinem

The Thousand Indias; The Beach Book; Outrageous Acts and Everyday Rebellions; Marilyn: Norma Jeane; Revolution from Within: A Book of Self-Esteem; Moving Beyond Words; Doing Sixty & Seventy; My Life on the Road

Tom Stoppard

A Walk on the Water; The Gamblers; If You're Glad I'll be Frank; Lord Malquist and Mr. Moon; Rosencrantz and Guildenstern Are Dead; Enter a Free Man; The Real Inspector Hound; Albert's Bridge; After Magritte; Dogg's Out Pet; Jumpers; Artist Descending a Staircase; Travesties; Dirty Linen and New-Found-Land; 15-Minute Hamlet; Every Good Boy Deserves Favour; Night and Day; Dogg's Hamlet, Cahoot's Macbeth; Undiscovered Country; On The Razzle; The Real Thing; Rough Crossing; Dalliance; Hapgood; Arcadia; The Plays for Radio, 1964–1991; Indian Ink; The Invention of Love; The Coast of Utopia; Rock 'n' Roll; The Hard Problem

Emma Straub

Fly Over State; Other People We Married; Laura Lamont's Life in Pictures; The Vacationers; Modern Lovers

Donna Tartt

The Secret History; The Little Friend; The Goldfinch

Neal Thompson

Light This Candle: The Life and Times of Alan Shepard; Driving with the Devil: Southern Moonshine, Detroit Wheels, and the Birth of NASCAR; Hurricane Season: A Coach, His Team, and Their Triumph in the Time of Katrina; A Curious Man: The Strange and Brilliant Life of Robert "Believe It or Not" Ripley; Kickflip Boys: A Memoir of Freedom, Rebellion, and the Chaos of Fatherhood

Sarah Thornton

Club Cultures: Music, Media, and Subcultural Capital; Seven Days in the Art World; 33 Artists in 3 Acts

Colm Tóibín

Martyrs and Metaphors: Letters from the New Island; The South; The Trial of the Generals: Selected Journalism, 1980–1990; Homage to Barcelona; Dubliners; The Heather Blazing; Bad Blood: A Walk Along the Irish Border; The Sign of the Cross: Travels in Catholic Europe; The Story of the Night; The Blackwater Lightship; Love in a Dark Time: And Other Explorations of Gay Lives; Lady Gregory's Toothbrush; The Master; Mothers and Sons; The Use of Reason; Sean Scully: Changes and Horizontals; Ireland: On the Edge of Europe; Brooklyn; The Empty Family; All a Novelist Needs; A Guest of the Feast; The Testament of Mary; New Ways to Kill Your Mother: Writers and Their Families; Water/Colour; Nora Webster; On Elizabeth Bishop; House of Names

Danielle Trussoni

Falling Through the Earth: A Memoir; Angelology; Angelopolis; The Fortress: A Love Story

Tony Tulathimutte

Remote Research; Private Citizens

Vanessa Veselka

Zazen; The Fort of Young Saplings

Enrique Vila-Matas

Bartleby & Co.; Montano's Malady; Never Any End to Paris; Dublinesque; A Brief History of Portable Literature; The Illogic of Kassel; Because She Never Asked; Vampire in Love

Binyavanga Wainaina

One Day I Will Write About This Place: A Memoir

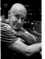

Anne Waldman

On the Wing; O My Life!; Up Through the Years; Giant Night: Selected Poems; Baby Breakdown; Icy Rose; No Hassles; Holy City; Light and Shadow; Spin Off; The West Indies Poems; Life Notes: Selected Poems; The Contemplative Life; Fast Speaking Woman; Sun the Blond Out; Fast Speaking Woman and Other Chants; Journals and Dreams; Hotel Room; Shaman/Shamane; To a Young Poet; Countries; First Baby Poems; Cabin; Makeup on Empty Space; Skin Meat Bones; Blue Mosque; The Romance Thing; Tell Me About It; Helping the Dreamer: New and Selected Poems 1966–1988; Not a Male Pseudonym; Lokapala; Fait Accompli; Troubairitz; Iovis: All is Full of Jove; Kill or Cure; Homage to Allen G; Iovis II; Marriage: A Sentence; Vow to Poetry: Essays, Interviews, & Manifestos; War Crime; [Things] Seen Unseen; Dark Arcana/Afterimage or Glow; In the Room of Never Grieve: New & Selected Poems 1985–2003; Structure of the World Compared to a Bubble; Beat Roots; Outrider; Red Noir; Nine Nights Meditation; Manatee/Humanity; Soldateque/Soldiering with Dreams of Wartime; The Iovis Trilogy; Gossamurmur; Aubaderrying; Jaguar Harmonics; Voice's Daughter of a Heart Yet to Be Born; Extinction Aria

Jesmyn Ward

Where the Line Bleeds; Salvage the Bones; Men We Reaped: A Memoir; The Fire This Time: A New Generation Speaks about Race; Sing, Unburied, Sing

Irvine Welsh

Trainspotting; The Acid House; Marabou Stork Nightmares; Ecstasy: Three Tales of Chemical Romance; Filth; Glue; Porno; The

Bedroom Secrets of the Master Chefs; Babylon Heights; You'll Have Had Your Hole; If You Liked School, You'll Love Work; Crime; Reheated Cabbage; Skagboys; The Sex Lives of Siamese Twins; A Decent Ride; The Blade Artist; T2 Trainspotting; Dead Men's Trousers

Colson Whitehead
The Intuitionist, John Henry Days, The Colossus of New York; Apex Hides the Hurt, Sag Harbor, Zone One, The Noble Hustle: Poker, Beef Jerky and Death; The Underground Railroad

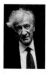

Elie Wiesel
And the World Remained Silent; Night; Dawn; The Accident; The Town Beyond the Wall; The Gates of the Forest; The Jews of Silence: A Personal Report of Soviet Jewry; Legends of Our Time; A Beggar in Jerusalem; One Generation After; The Oath; Zalmen, or the Madness of God; A Jew Today; The Trial of God; The Testament; The Golem; The Fifth Son; Twilight; From the Kingdom of Memory: Reminiscences; The Forgotten; All Rivers Run to the Sea: Memoirs; King Solomon and His Magic Ring; And the Sea Is Never Full: Memoirs; The Judges; The Time of the Uprooted; A Mad Desire to Dance; Rashi; The Sonderberg Case; Open Heart; Hostage

Phillip B. Williams
Bruised Gospels: Poems; Burn; Thief in the Interior

Tom Wolfe
The Kandy-Kolored Tangerine-Flake Streamline Baby; The Pump House Gang; The Electric Kool-Aid Acid Test; Radical Chic & Mau-Mauing the Flak Catchers; The Painted Word; Mauve Gloves & Madmen, Clutter & Vine; The Right Stuff; In Our Time; From Bauhaus to Our House; The Purple Decades; The Bonfire of the Vanities; A Man in Full; Hooking Up; I Am Charlotte Simmons; Back to Blood; The Kingdom of Speech

Jacqueline Woodson
Last Summer with Maizon; The Dear One; Martin Luther King Jr. and His Birthday; Maizon at Blue Hill; Between Madison and Palmetto; I Hadn't Meant to Tell You This; Book Chase; From the Notebooks of Melanin Sun; Autobiography of a Family Photo; The House You Pass on the Way; We Had a Picnic This Sunday Past; If You Come Softly; Lena; Miracle's Boys; Sweet, Sweet Memory; The Other Side; Visiting Day; Our Gracie Aunt; Hush; Coming Home Soon; Behind You; Show Way; Feathers; After Tupac and D Foster; Peace Locomotion; Locomotion; Pecan Pie Baby; Beneath a Meth Moon; Each Kindnes; This Is the Rope; Brown Girl Dreaming; Another Brooklyn

John Wray
The Right Hand of Sleep; Canaan's Tongue; Lowboy; The Lost Time Accidents; Godsend

Sunil Yapa
Your Heart Is a Muscle the Size of a Fist

Liao Yiwu
The Fall of the Holy Temple; The Corpse Walker; God Is Red: The Secret Story of How Christianity Survived and Flourished in Communist China; Earthquake Insane Asylum; For a Song and a Hundred Songs: A Poet's Journey Through a Chinese Prison

Kevin Young
Jelly Rolls: A Blues; To Repel Ghosts: The Remix; Black Maria; For the Confederate Dead; Dear Darkness; Ardency: A Chronicle of the Amistad Rebels; The Grey Album: On the Blackness of Blackness; Book of Hours; Blue Laws: Selected & Uncollected Poems 1995–2015; Bunk: The Rise of Hoaxes, Humbug, Plagiarists, Phonies, Post-Facts, and Fake News; Brown

Alejandro Zambra
Bonsai; The Private Lives of Trees; Ways of Going Home; My Documents; Multiple Choice

ACKNOWLEDGMENTS

To my family, for your love to help me find my place and chase my dreams.

To Salman Rushdie, for your benevolence and for championing all who write, for championing me, for being my friend.

To Eric Simonoff, for believing in your photographer as much as you do your authors.

To Becky Koh and J. P. Leventhal, for your passion and vision to assemble this team of (pictures of) superheroes of letters, to see their stories through mine. You are my living reminders that dreams do come true.

To Antonio Aiello, Arielle Anema, Kwame Anthony Appiah, Kim Chan, Ron Chernow, Markus Dohle, Ana Djordjevic, Sarah Edkins Lien, May Zhee Lim, Peter Godwin, Steven Isenberg, Linda Morgan, Suzanne Nossel, Deji Olukotun, Jakab Orsos, Lily Philpott, Andrew Proctor, Francine Prose, Chip Rolley, Clarisse Rosaz Shariyf, Katherine Rothschild, Larry Siems, Andrew Solomon, Rob Spillman, Beth Weinstein, Michael Welch, and all at PEN America, for the introduction to a world of vital voices, the journey to share and grow in treasuring them, and the opportunity to support your defense of the constitutional right to free expression.

To Eddie Adams, Yuko Arakawa, Terry deRoy Gruber, Andrew Eccles, Greg Gorman, Marco Guerra, Heinz Holba, Antonin Kratochvil, Ed Lefkowitz, Irene Marie, Barbara Nitke, Platon, Laurin Raiken, Jerry Shiek, Akos Simon, and Michael Williamson, for opening my eyes and helping me learn to see. Class is in session every day.

To Kathrin DiPaola, John Foley, Yasuko Gingerich, Lauren Klain Carton, Ruaridh Stewart, and Ulrich Wittmaack, for your grace and confidence to take an early chance on me and share the rising road with you ever since then.

To Meakin Armstrong, Reagan Arthur, Harold Augenbraum, Jin Auh, Corinna Barsan, Kathy Belden, Millicent Bennett, Jill Bialosky, Tom Bishop, Louise Brockett, Paul Buckley, Amanda Bullock, Lee Boudreaux, Kimberly Burns, Alicia Caballero Castro, Ryan Chapman, Sabina Ciechowski, Florence Combes, Kathryn Court, Colin Dickerman, Jynne Dilling Martin, Noah Eaker, Carola Feist, Seth Fishman, Katie Freeman, Pilar Garcia-Brown, Ben George, Anne Godoff, Francine Goldenhar, Susan Golomb, Nan Graham, Steve Grimwade, Darren Haggar, Beth Harrison, Keith Hayes, Merrilee Heifetz, Hollis Heimbouch, Violaine

Huisman, Alina Jahrmarkt, Lucinda Karter, Michael Kelleher, Kirby Kim, Nicholas Latimer, Christian Lewis, Caro Llewellyn, Lisa Lucas, Valérie Maréchal, Paul Morris, Samuel Nicholson, Judy Ng, Nuno Pereira De Sousa, Michael Pietsch, Andrew Proctor, Mario Pulice, Julia Reidhead, David Remnick, Michael Reynolds, Sandy Rouse, Marysue Rucci, Rebecca Saletan, Allison Saltzman, Ben Samuel, Bernard Schwartz, Jeff Seroy, Leslie Shipman, Ursula Sigon, Molly Silberberg, Noreen Tomassi, Binky Urban, Helen Vick, Matt Weiland, and so many more, for the support that turns community into family.

To Teodora Altomare, Michiko Boorberg, Jason Bye, Seevon Chau, Vanessa DeFlache, Kika Cristina Espejo, Sophia Flores, Katelyn Fournier, Aljaz Fuis, Alex Harris, Zackery Hobler, Julian Hom, Ajia Hunter, Elizabeth Ibarra, Irene Kim, Chika Kobari, Prince Lang, Michael Larkey, Cherry Le, Molly Leon, Steven Lopez, JC McIlwaine, Matthew Morocco, Paul Quitoriano, Jenna Pinch, Andrew Segreti, Harleigh Shaw, Sami Sneider, Ashley Solter, Mandy Strong, Anthony Tran, Oliver Tucker, and Maria Uminski, for giving your time and talents to help cast my sitters in their best lights.

To Atlas Contact, Belfond, Bloomsbury, Creative Artists Agency, Crown, Farrar, Strauss, and Giroux, Flatiron Books, Gernert Company, Granta, Grove Atlantic, Gyldendal, HarperCollins, ICM Partners, Janklow & Nesbitt, Knopf Doubleday, Little, Brown and Company, MacMillan, Arnoldo Mondadori, W. W. Norton & Company, Riverhead, Penguin Random House, Rowohlt Verlag, Simon & Schuster, Sterling Lord Literistic, William Morris Endeavor, Writers House, the Wylie Agency, and many more, for entrusting me to speak to your heroes' stories in pictures.

To the Authors Guild Foundation, Brooklyn Academy of Music, Center for Fiction, French Cultural Services, Lapham's Quarterly, National Book Foundation, New York Public Library, Onassis Foundation, The Story Prize, The Giles Whiting Foundation, Windham-Campbell Prizes, and Words Without Borders, for the chance to help celebrate and advocate for the vitality of storytelling and storytellers.

And to the literary luminaries on and beyond these pages. The great world doesn't spin without you.

Black Dog & Leventhal Publishers
Hachette Book Group
1290 Avenue of the Americas
New York, NY 10104

www.hachettebookgroup.com
www.blackdogandleventhal.com

First Edition: October 2018

Black Dog & Leventhal Publishers is an imprint of Running Press, a division of Hachette Book Group.
The Black Dog & Leventhal Publishers name and logo are trademarks of Hachette Book Group, Inc.

The publisher is not responsible for websites (or their content) that are not owned by the publisher.

The Hachette Speakers Bureau provides a wide range of authors for speaking events.
To find out more, go to www.HachetteSpeakersBureau.com or call (866) 376-6591.

Print book interior design by Elizabeth Driesbach

Library of Congress Control Number: 2018934589
ISBNs: 978-0-316-51515-3 (hardcover); 978-0-316-51513-9 (ebook)

Printed in China

APS

10 9 8 7 6 5 4 3 2 1